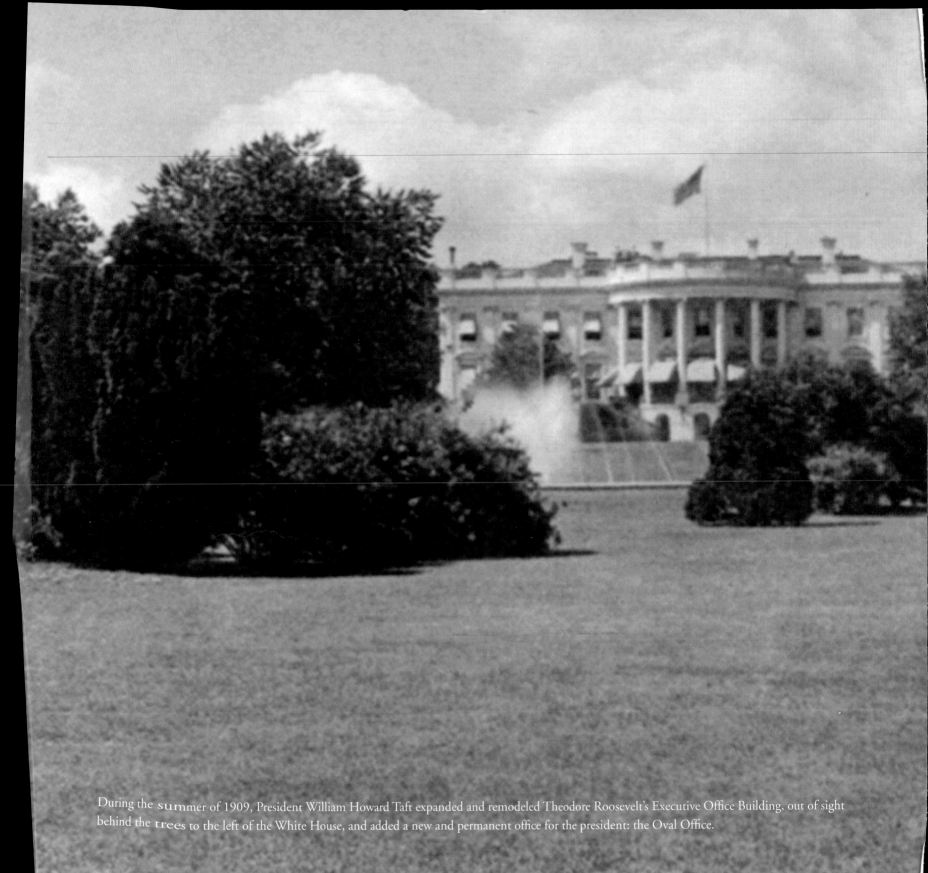

During the summer of 1909, President William Howard Taft expanded and remodeled Theodore Roosevelt's Executive Office Building, out of sight behind the trees to the left of the White House, and added a new and permanent office for the president: the Oval Office.

HISTORIC PHOTOS OF
THE WHITE HOUSE

TEXT AND CAPTIONS BY EMILY J. AND JOHN S. SALMON

TURNER
PUBLISHING COMPANY

HISTORIC PHOTOS OF
THE WHITE HOUSE

Turner Publishing Company
200 4th Avenue North • Suite 950
Nashville, Tennessee 37219
(615) 255-2665

www.turnerpublishing.com

Historic Photos of the White House

Copyright © 2008 Turner Publishing Company

Library of Congress Control Number: 2008904906

ISBN-13: 978-1-59652-504-7

Printed in the United States of America

08 09 10 11 12 13 14—0 9 8 7 6 5 4 3 2 1

CONTENTS

ACKNOWLEDGMENTS...VII

PREFACE...VIII

FROM POLK TO WILSON
 (1846–1919) ...1

FROM HARDING TO COOLIDGE
 (1920–1929) ..51

FROM HOOVER TO TRUMAN
 (1930–1952) ..97

FROM EISENHOWER TO CARTER
 (1953–1977)...157

NOTES ON THE PHOTOGRAPHS ...200

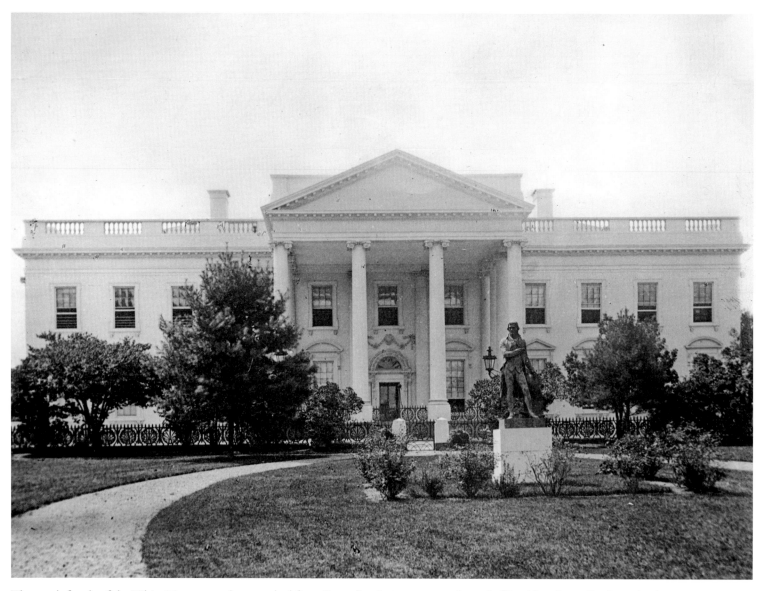

The north facade of the White House was photographed from Pennsylvania Avenue near the end of President James Buchanan's administration, probably in 1860. President James K. Polk had installed the statue of Thomas Jefferson on the North Lawn in 1848; it was moved to the Capitol in 1873. Washington was a city largely Southern in its sympathies, sandwiched between the slaveholding states of Virginia, which seceded from the Union, and Maryland, which almost seceded. Even before president-elect Abraham Lincoln took office in March 1861, rumors of plots to seize or assassinate him and overthrow the government swept the capital. After the bombardment of Fort Sumter in South Carolina in April and the stoning of Massachusetts troops in Baltimore by a secessionist mob the same month, the rumors only grew stronger.

ACKNOWLEDGMENTS

With the exception of cropping images where needed and touching up imperfections that have accrued over time, no other changes have been made to the photographs in this volume. The caliber and clarity of many photographs are limited by the technology of the day and the ability of the photographer at the time they were made.

This volume, *Historic Photos of the White House,* is the result of the cooperation and efforts of many individuals, organizations, and corporations. It is with great thanks that we acknowledge the valuable contribution of the following for their generous support:

Franklin D. Roosevelt Presidential Library
Harry S. Truman Library
John F. Kennedy Presidential Library and Museum
Lyndon Baines Johnson Library and Museum
Nixon Presidential Library and Museum
Library of Congress
National Archives and Records Administration

PREFACE

"It is the most famous and highly cherished building in the whole country. . . . Indeed the White House is a shrine, not only because it houses the Chief Executive of the Nation but for what it represents in the hearts of the people." So wrote Secretary of the Interior Harold L. Ickes to President Harry S. Truman in 1946, when plans were announced to enlarge the West Wing office building. Truman abandoned the plan amid the ensuing furor, when the public (incorrectly) feared that the White House itself would be altered. The outcry reflected the degree to which the White House is a symbol of the nation.

The White House and its grounds constitute an urban estate, sheltering the president and his family. They also serve as an office, an entertainment center, a meeting place, a lecture hall, a parade ground, a helicopter pad, and a magnet for demonstrations. The people who live and work at the White House are so often seen in their official roles that it is easy to forget that they also have private lives and are subject to the same joys and sorrows as the rest of us. People have been buried from the White House, including several presidents and at least one child. Weddings have been held there, and children have grown up there, gone to school there, and attempted to have something resembling normal lives there. Pomp and circumstance, gossip and intrigue, romance and heartbreak, war and peace, also are parts of the White House story.

The White House itself has had a life as well. It has been burned to the walls once and rebuilt on the inside twice. It has been restored with loving care on the one hand and threatened with demolition on the other. Wings and porticoes have been added to it, the South Portico has been altered, the attic has been raised, the basement has been lowered, and many other changes have taken place that are less visible. Yet through all the alterations, the building has somehow seemed solid and steady, able to accept the changes, adapt to them, and make them a part of its life experience. Perhaps what the White House "represents in the hearts of the people," as Secretary Ickes wrote, is America itself.

This volume contains historic photographs of the White House and many of its occupants taken between the years 1846 and 1977. The images cover most of the presidential administrations between James Knox Polk and Jimmy Carter. They

show official meetings, private moments, instances of tragedy, occasions of happiness, and some of the changes that the White House has undergone. A comprehensive story would require many thousands of photographs and millions of words. We hope that the 200 or so images in this book, along with the brief captions and chapter introductions, will at least give you the flavor of the place and its occupants and encourage you to read more on the subject.

—*Emily J. and John S. Salmon*

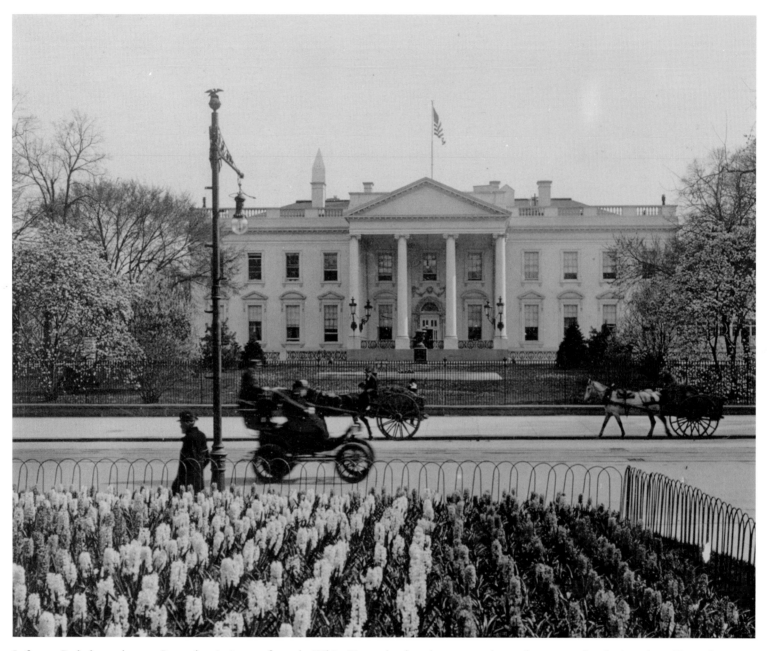

Lafayette Park, located across Pennsylvania Avenue from the White House, has long been a popular garden spot and gathering place. Planned as part of the pleasure grounds surrounding the residence, the area was first called "President's Park." It was separated from the White House grounds in 1804 when President Thomas Jefferson had Pennsylvania Avenue cut through, and it became a public park. The park was named in honor of the Marquis de Lafayette in 1824, when the French hero returned to the United States on a tour. This photograph of hyacinths growing in the park was taken about 1906.

FROM POLK TO WILSON

(1846–1919)

After the American Revolution, the Founding Fathers searched for a site for the new country's capital. Philadelphia, New York, and other places in the North had served the purpose at various times, but the Southern states preferred a site farther south, and it was agreed that the capital should be newly constructed and not part of any existing metropolis. A suitable spot was found on the Potomac River, not far from the home of George Washington, and in 1791 he and French architect Pierre Charles L'Enfant selected the locations for such important buildings as the Capitol and the "President's House," as it was first known. An architectural design competition was held, and James Hoban's plan was chosen. It proposed a rectangular two-story building on a high basement; the plan allowed for the addition of wings if necessary.

It would not be accurate to say that the President's House was "completed" by the time the first occupants—John and Abigail Adams—arrived in November 1800. Construction was ongoing, the grounds were covered in workmen's shacks, and the walls were unplastered. The Adamses made the best of it, and the house was essentially completed by the time the next president, Thomas Jefferson, took office in March 1801.

British forces burned the house in August 1814, during the War of 1812. The walls stood, thanks to a rainstorm that extinguished the flames. Hoban oversaw the reconstruction of the interior, and President James Monroe moved in during the autumn of 1817. His daughter Maria was the first daughter of a president to be married in the White House. The term "White House," incidentally, was derived from its whitewashed walls and was in use by 1809.

The first photographs of the White House were taken in 1846, during James Knox Polk's administration. Some of the most historic images date to the administration of Abraham Lincoln during the Civil War, and it was in February 1862 that his son Willie died in the White House, devastating Lincoln. Subsequent presidents directed other wars from the White House. But the residence also was the site of parties, weddings, the celebrated Easter Egg Roll, and other pleasant occasions. As America's role in world affairs grew larger, so did the White House, with an office wing added and other buildings constructed nearby. By the end of World War I, the White House looked much as it does today.

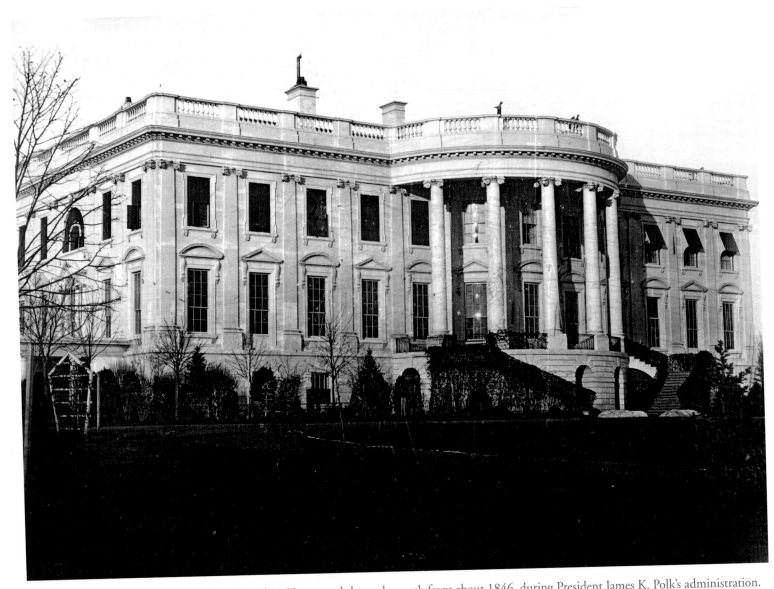

This is the earliest-known photograph of the White House, and shows the south front about 1846, during President James K. Polk's administration. The architect of the White House, James Hoban, added the portico in 1824. John Plumbe, a Washington photographer, took the picture, which is a daguerreotype. Plumbe photographed other government buildings in Washington, including the Capitol and the main Post Office.

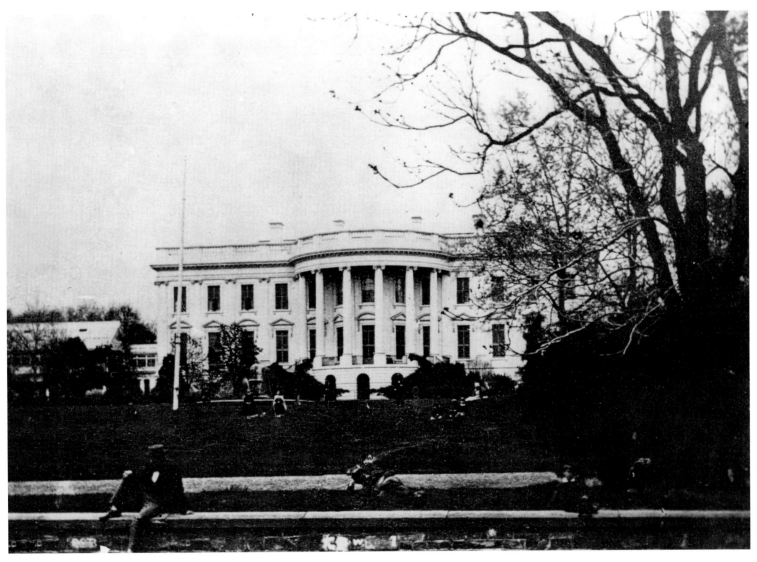

The south front of the White House was photographed sometime during the Civil War. By then, the daguerreotype was fading in popularity, replaced by the glass-plate negative from which many inexpensive paper prints could be made. Introduced in 1851, the so-called "wet-plate process," which required an on-hand supply of various chemicals, was cumbersome. During the war, photographers followed the armies, taking pictures and developing them in "darkroom wagons." The risk of breaking the glass plates was great, but if handled carefully they would survive to produce large numbers of prints almost as detailed as daguerreotypes.

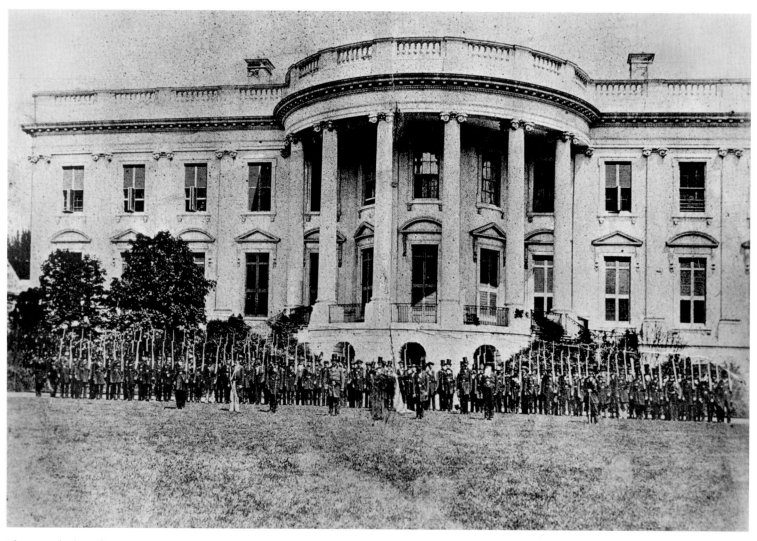

Photographed on the South Lawn of the White House in April 1861, soon after the inauguration of Abraham Lincoln as president, a military unit believed to be the Cassius M. Clay Battalion stands guard. Clay, a Kentucky abolitionist and newspaper editor, and Senator James H. Lane of Kansas were in Washington at the Willard Hotel near the White House during the secession crisis early in 1861. The pair made incendiary pro-Union speeches at the hotel, despite confrontations with angry secessionists. At the time, there were virtually no United States Army troops in Washington, and when Confederate forces bombarded Fort Sumter in April, fears grew that the city would be attacked next. Clay and Lane recruited two units of volunteers from among the office-seekers that crowded the capital: the Clay Battalion and the Frontier Guard. Clay's men marched off to guard the Capitol itself, while the Frontier Guard occupied the White House and bivouacked on April 18 in the East Room. When regular army troops began arriving in the city a short time later, the two units disbanded.

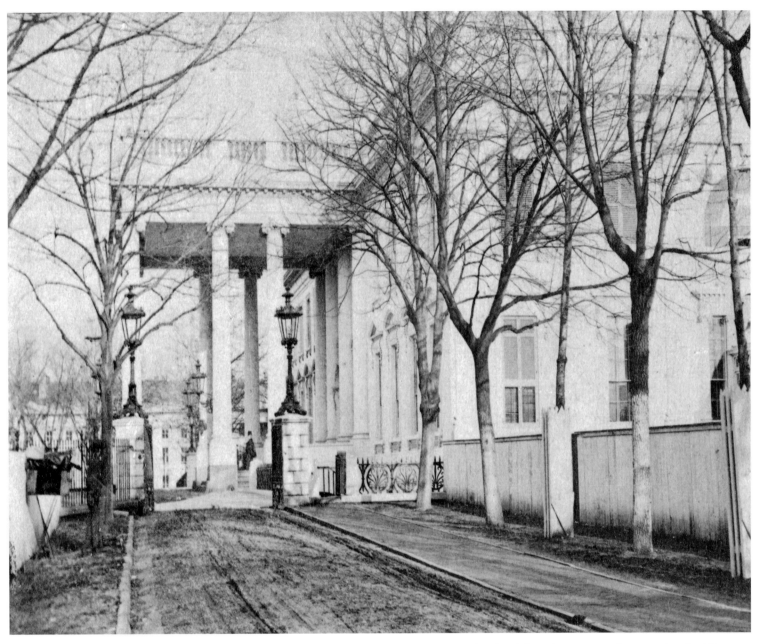

White House architect James Hoban completed the portico for the north or main facade of the White House, shown in this Civil War–era photograph, in 1830. It formed a porte cochere, affording shelter to visitors as they left their coaches and walked to the front entrance.

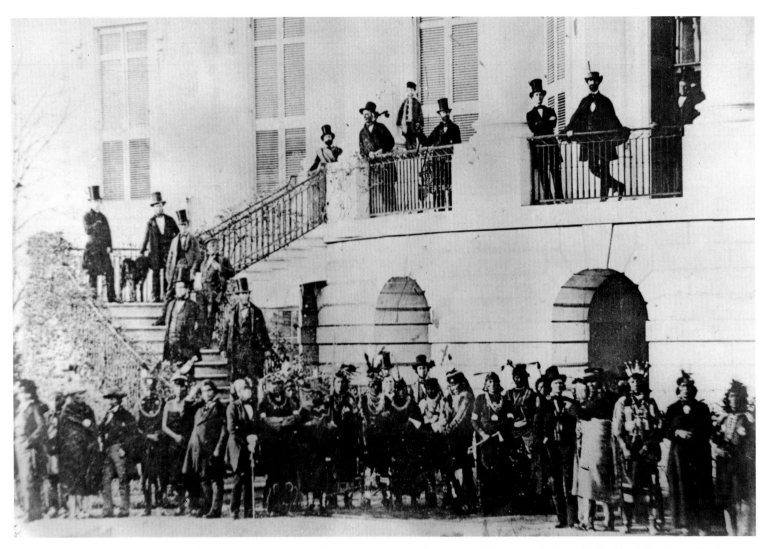

This Civil War–era photograph may have been taken on March 27, 1863, when a delegation of American Indian chiefs visited President Abraham Lincoln in the East Room of the White House. The delegation included Lean Bear, War Bonnet, and Standing Water (Cheyenne); Yellow Buffalo, Lone Wolf, Yellow Wolf, White Bull, and Little Heart (Kiowa); Spotted Wolf and Nevah (Arapaho); Pricked Forehead and Ten Bears (Comanche); Poor Bear (Apache); and Jacob (Caddo). Lean Bear and Spotted Wolf made speeches to Lincoln through interpreters, and Lincoln made a speech to them in return.

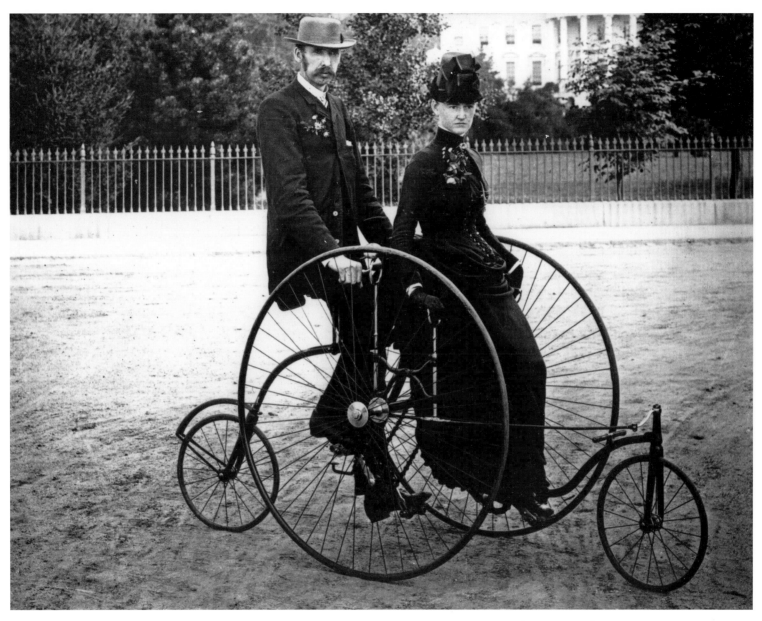

The "high" or "ordinary" bicycle was invented about 1871. The pedals of early bicycles were attached directly to the front wheel; the larger the wheel, the farther the bicycle traveled on a single rotation of the pedals. This model, built for a gentleman and his female passenger, was photographed in front of the south facade of the White House in 1886.

A large crowd of children and parents are shown gathered in front of the south facade of the White House for the annual Easter Egg Roll in this 1889 photograph. The White House egg roll was only a decade-old tradition at that point, having begun in 1878 during the administration of President Rutherford B. Hayes. Before then, rolls had been held on the Capitol grounds annually beginning about 1872, but in 1876 Congress passed a Turf Protection Law that banned rambunctious children to prevent their tearing up the grounds. The event was rained out in 1877, but when fair weather arrived at Easter 1878, Congress notified the public that the roll would not be permitted. President and Mrs. Hayes allowed the roll to take place on the White House lawn, and it has been held there ever since.

Little girls are seen gathering eggs in this photograph of the 1889 White House Easter Egg Roll, during President Benjamin Harrison's occupancy. Vendors sold souvenirs and food to the visitors, which may account for some of the litter.

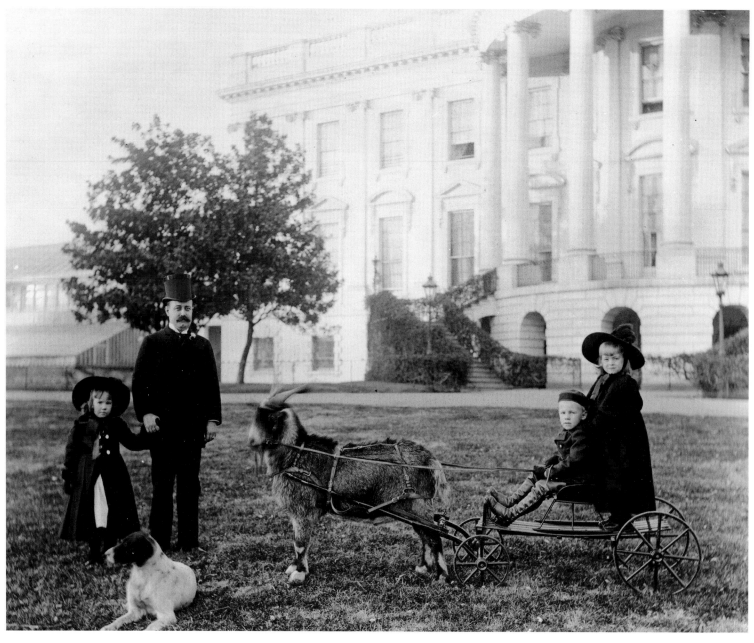

President Benjamin Harrison's son, Russell Harrison, posed in this photograph with his daughter, Marthena Harrison, and his nephew and niece, Benjamin Harrison McKee (known as Baby McKee) and Mary McKee. The goat was called His Whiskers. One day, the story goes, while pulling the children in the cart, His Whiskers bolted through the White House gates and the president himself chased him down.

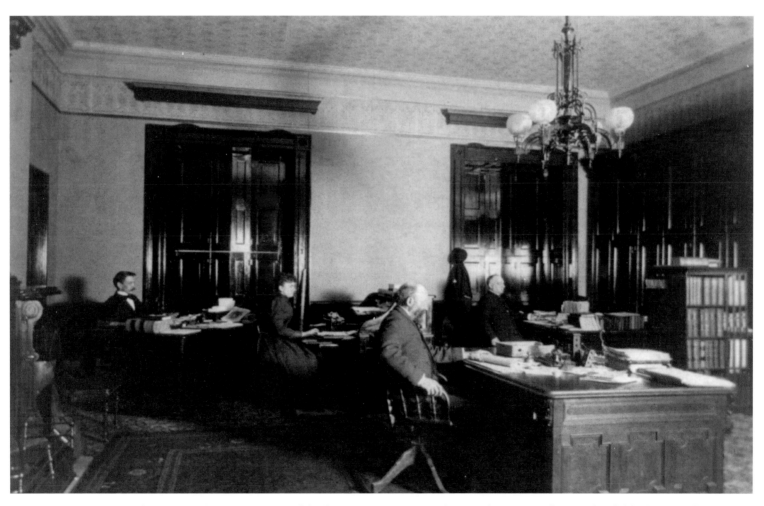

Frances Benjamin Johnston (1864–1952) was one of the first American women photographers to gain fame in that field. She opened a studio in Washington, D.C., before 1890 and began a career in photojournalism and portrait photography. One of her subjects was the White House, which she photographed many times in the late nineteenth and early twentieth centuries. This image shows a group of White House employees at their desks.

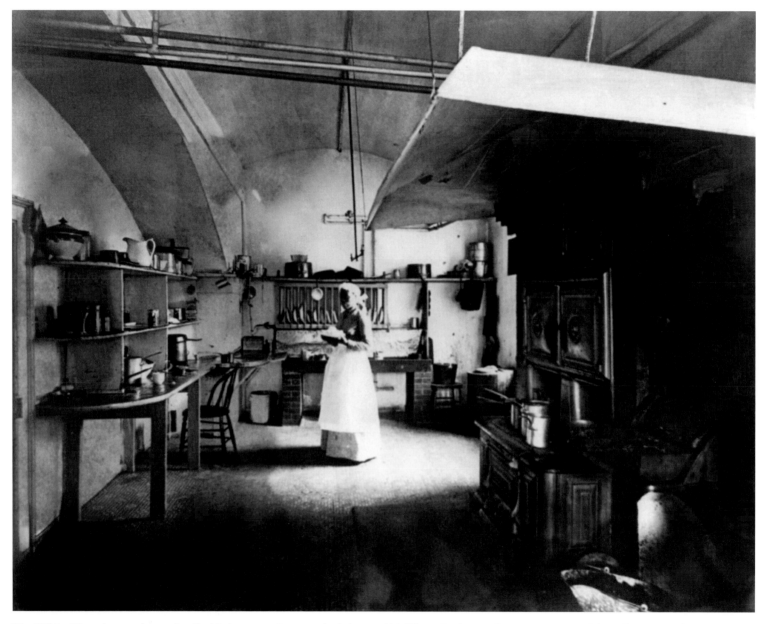

The White House's everyday, or family, kitchen was photographed about 1890. There, in the northwestern corner of the White House basement, cook Dolly Johnson prepared traditional American fare for President Benjamin Harrison's family. The basement or ground floor also contained the main kitchen, pantries, servants' rooms, and laundry.

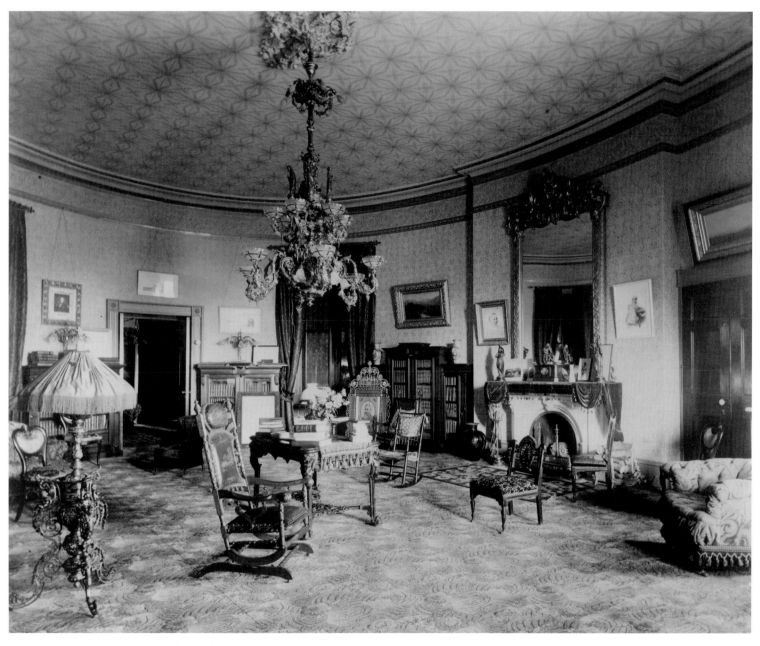

The oval room on the second floor of the White House has served mostly as a library, study, or family parlor. Frances Benjamin Johnston took this photograph in 1890, when it was furnished as a sitting room or parlor for President Benjamin Harrison and his family. Behind the camera position, windows provide views of the South Lawn and the Mall.

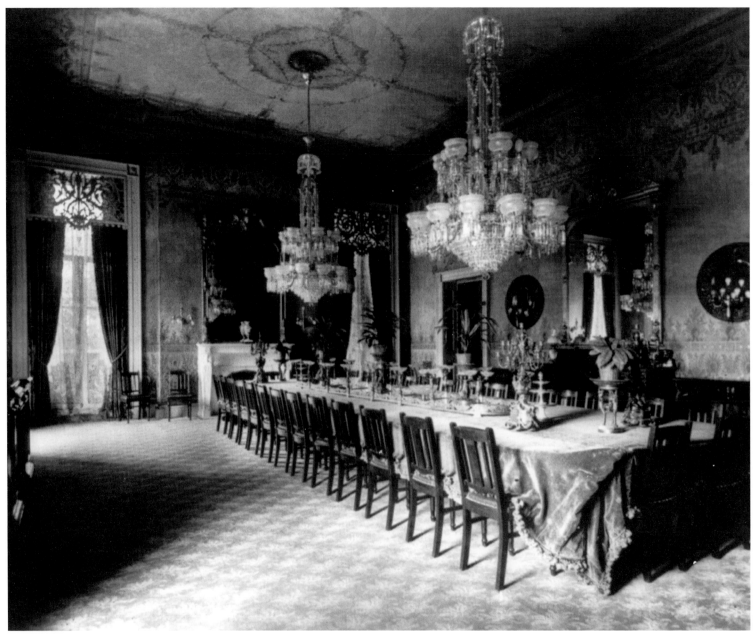

This photograph shows the State Dining Room as it appeared in 1893. Louis C. Tiffany and Company had executed some of the decoration in the room, such as the window grille, a decade earlier during the administration of President Chester A. Arthur. The chandeliers had been converted to electricity before this picture was taken.

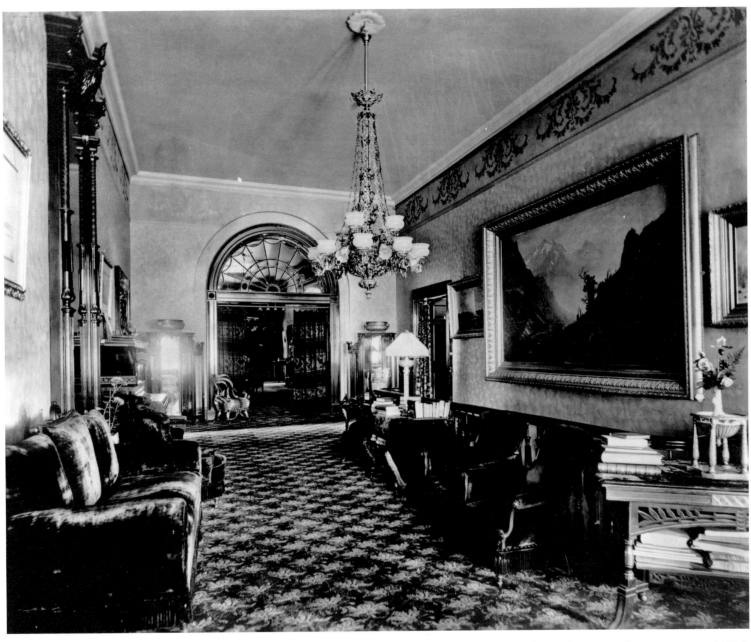

Frances Benjamin Johnston photographed the east corridor or hall on the ground floor of the White House between 1889 and 1906.

Because of the demand for fresh flowers and produce in the White House, and also to serve as a quiet, leafy retreat from the noise of the city, a greenhouse or conservatory was constructed in 1857, when James Buchanan was president. Subsequent presidents enlarged the building and added others, until by late in the century the conservatory complex covered much of the grounds west of the White House. This image, taken in 1897, shows potted azaleas in one of the buildings.

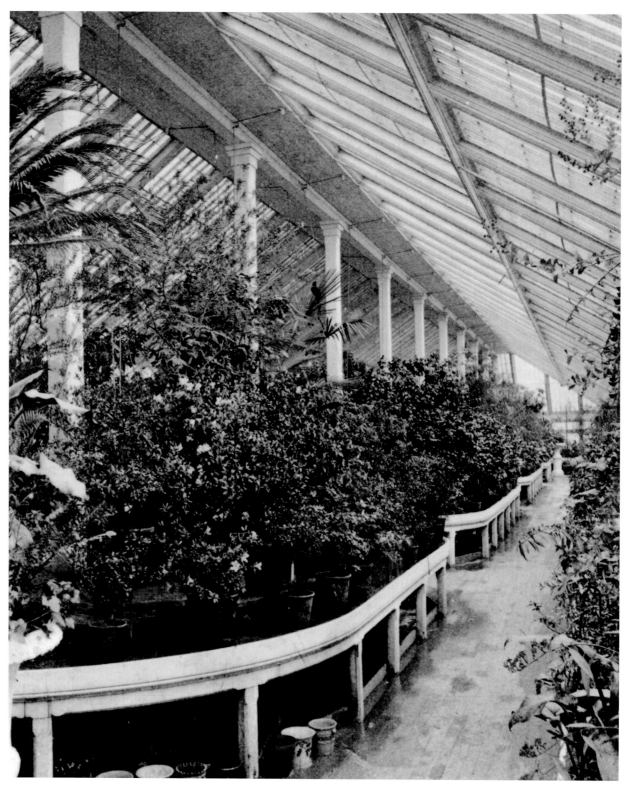

Frances Benjamin Johnston photographed these street vendors near the White House during the 1898 Easter Egg Roll. Then as now, food vendors played an important role in serving visitors as well as Washington office workers.

In 1898, during President William McKinley's administration, war erupted between the United States and Spain over the ongoing civil war in Cuba. When USS *Maine,* sent to the island nation, blew up mysteriously in Havana's harbor, the public clamor for war overwhelmed McKinley, who was opposed. During the short war, Lieutenant Colonel Theodore Roosevelt gained national fame for leading a charge up San Juan Hill. In this photograph, volunteers for the war march beneath the North Portico of the White House in the summer of 1898.

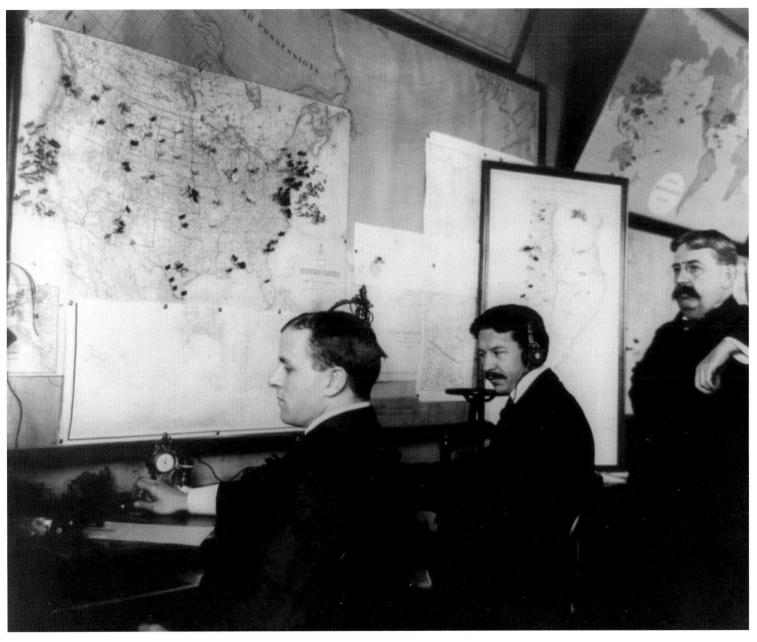

During the Spanish-American War, this room in the southeastern corner of the second floor of the White House became President William McKinley's War Room, with telegraphs and maps for keeping track of events in Cuba and elsewhere. This image shows E. C. Heasley and Jules A. Rodier working there under the supervision of Major Benjamin F. Montgomery, the chief office clerk and telegraph operator.

Sometimes, a presidential host has found the State Dining Room to be too small or otherwise unsuitable for a formal dinner. In this case, in 1898, a long corridor was transformed for the occasion.

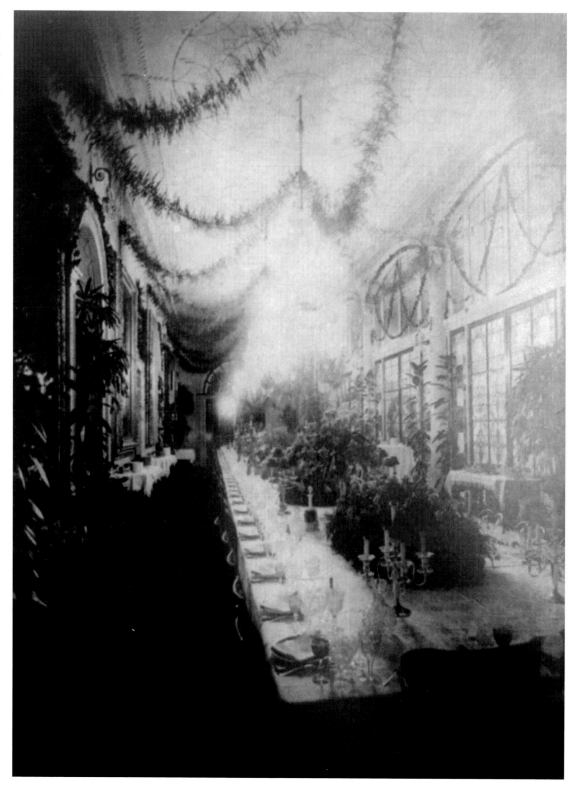

Children were photographed playing on the White House lawn during the Easter Egg Roll in 1898. Several of the conservatory buildings are visible behind them, and looming in the background is the State, War, and Navy Building. Known today as the Eisenhower Executive Office Building, this National Historic Landmark was constructed between 1871 and 1888. Alfred B. Mullett, supervising architect, designed it in the French Second Empire style, quite a departure from the variations on the Classical Revival style employed for most government buildings in the capital. Mark Twain and President Harry S. Truman both detested it.

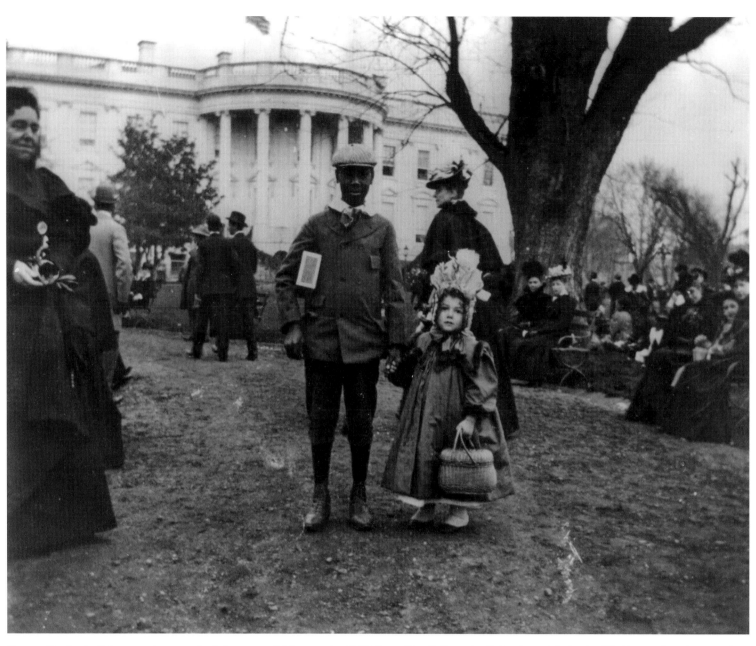

Frances Benjamin Johnston photographed these two children at the 1898 Easter Egg Roll on April 11. An article in the *Washington Post* the next day reported that President and Mrs. McKinley watched the festivities from the South Portico. According to the newspaper, "thousands upon thousands of eggs were broken on the grass of the White Lot yesterday, not to mention some few that were taken home after the performance was over . . . and as the crowd of youngsters was democratic in the extreme, making no distinction as to race, sex, or previous condition, they mixed it up pretty generally."

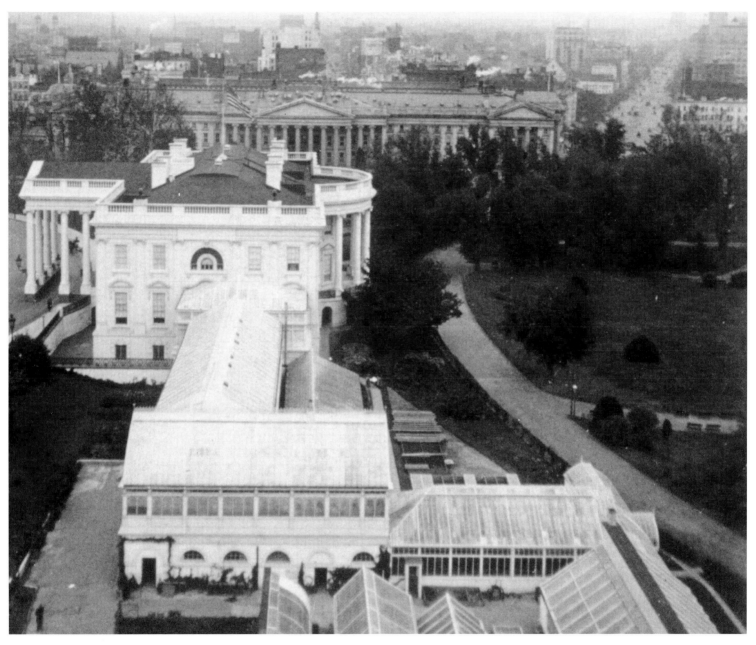

Taken about 1900, this view shows the White House conservatories, the White House, and the Treasury Building beyond the grounds. Pennsylvania Avenue angles off into the distance at right.

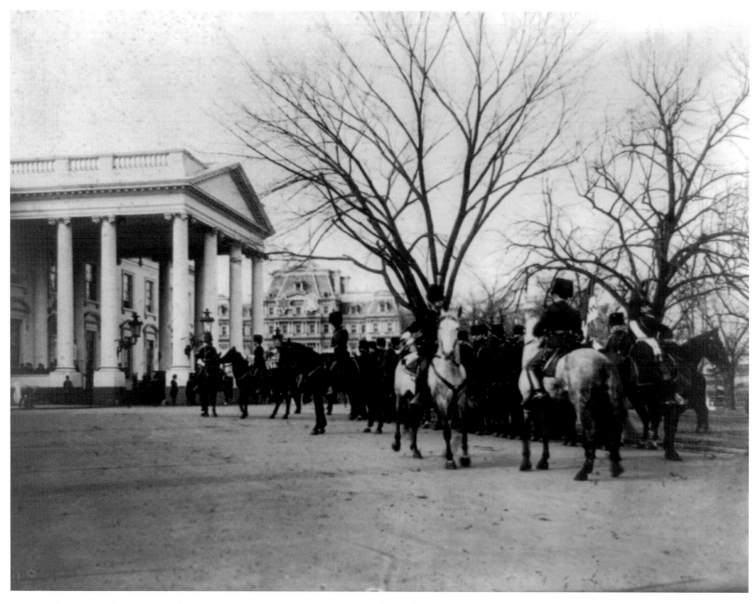

Presidential security had improved greatly since the days of Abraham Lincoln by the time this turn-of-the-century photograph was taken. The White House grounds were well guarded, although the cavalrymen shown here are about to serve as an escort to the president.

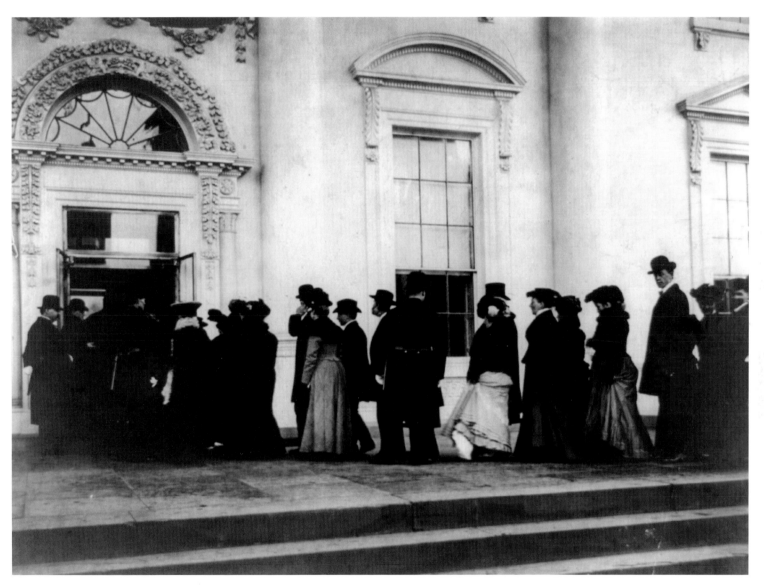

Throughout much of the nineteenth century, the public was admitted to the White House grounds and even into the residence itself for a variety of receptions, ceremonies, parades, and special events. One of the most famous or infamous events occurred during President Andrew Jackson's last reception in 1837, when the doors were opened to all comers. A huge and near-riotous crowd roamed uncontrolled through the building, and a giant cheddar-cheese wheel sent to Jackson by an admirer and said to have weighed 1,400 pounds was devoured in the front hall. These visitors, waiting in line at the White House to attend a New Year's Day reception around the turn of the century, appear to be far more sedate.

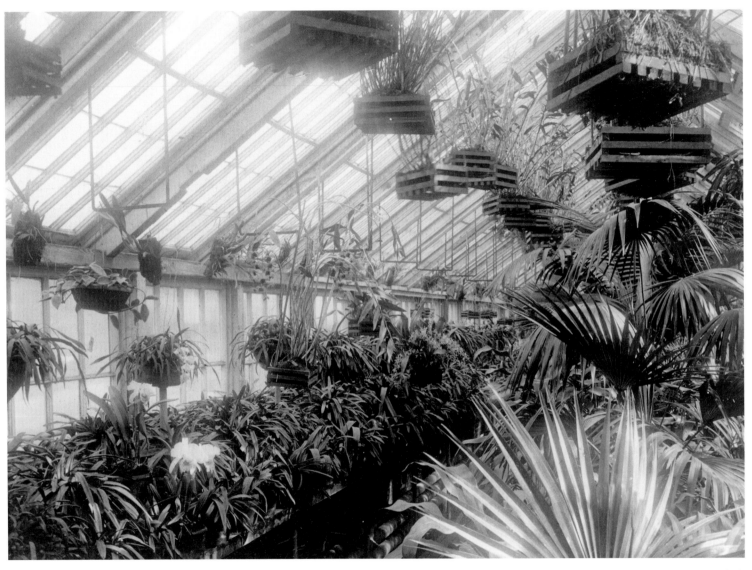

The White House conservatories remained popular with the residence's occupants well into the twentieth century. This photograph shows the orchid house before 1903.

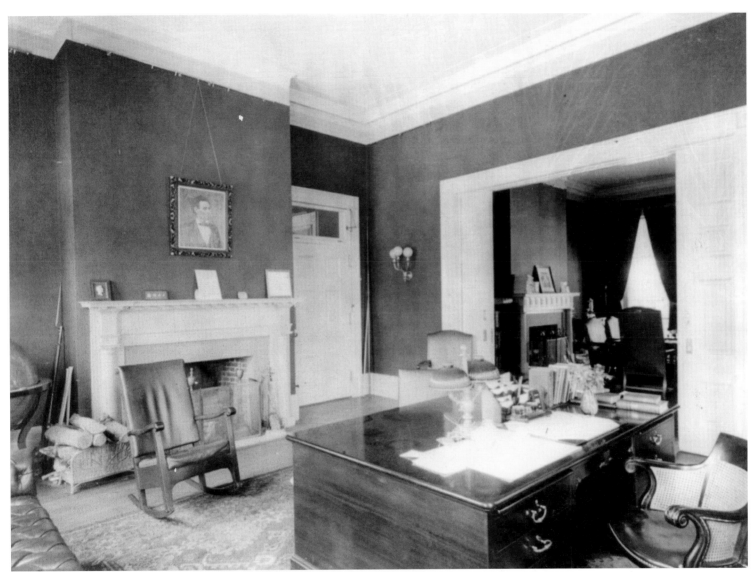

President Theodore Roosevelt carried out an extensive rehabilitation of the White House in 1902 that included the construction of a one-story office building in the place of the old conservatories. The forerunner of today's West Wing, the new building contained a number of offices including one for the president, shown here, that were intended to replace the cramped offices in the White House proper. Although Roosevelt found the new office comfortable, several older senators accustomed to conferring with presidents in the White House itself disliked the new room intensely, and Roosevelt often humored them by retreating to the residence for meetings.

During the administration of President Theodore Roosevelt, he and his wife, Edith, gave hundreds of dinners, receptions, and parties such as this one on the South Lawn about 1905. Mrs. Roosevelt was a stickler for protocol and made herself the grand dame of Washington society. She held several garden parties each spring beginning in 1903. Most of the women wore white or other light colors, and the participants enjoyed Mrs. Roosevelt's gardens, in which she took great pride. "A White House garden-party in the spring is a pretty sight," a writer noted. "The bright dresses of the ladies, with their gay parasols, and the tents for refreshments, make a pretty and picturesque scene against the background of well-kept lawns."

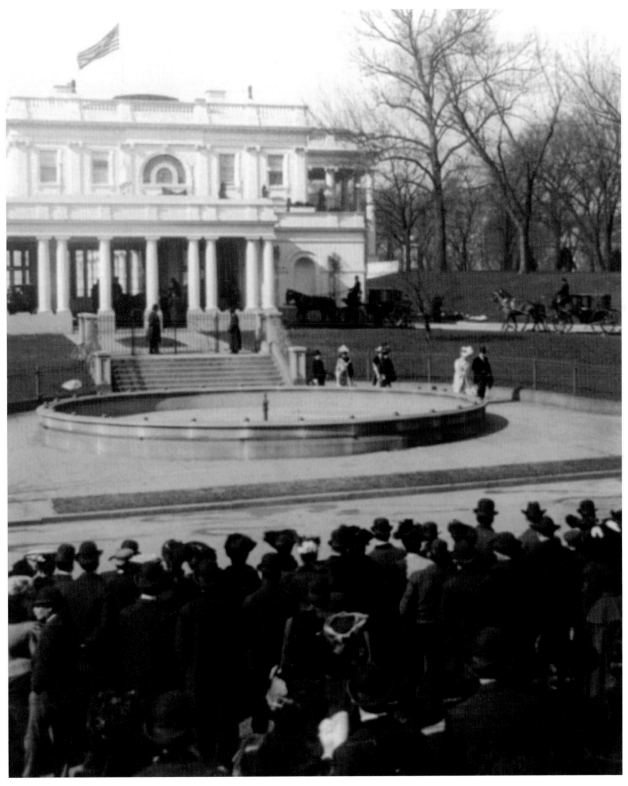

Perhaps the grandest event held at the White House during Roosevelt's presidency was the marriage of daughter Alice Roosevelt to Nicholas Longworth on February 17, 1906—the most spectacular occasion in anyone's memory. Seven hundred guests attended, and the crowd in the foreground assembled to watch them arrive and depart.

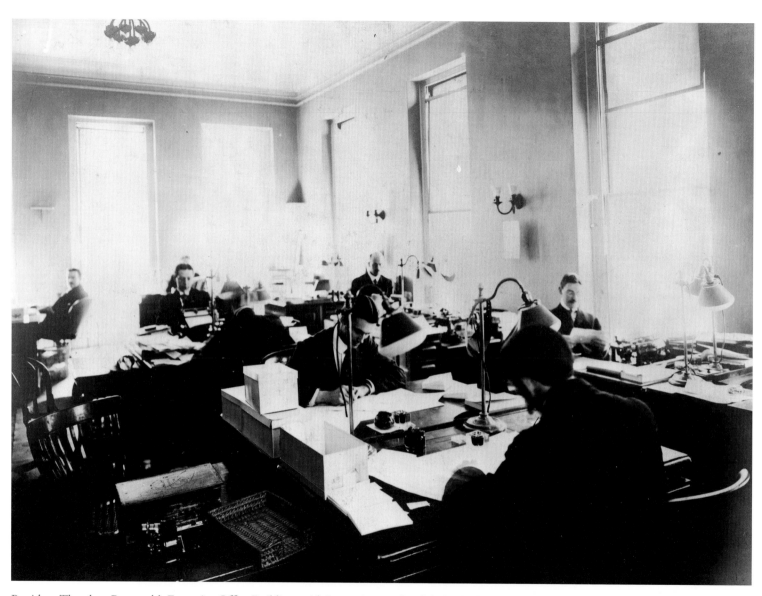

President Theodore Roosevelt's Executive Office Building, with its spacious and well-lighted offices, was a far more comfortable place for the ever-growing staff to work. This photograph, taken about 1906, shows the employees of the business office at their desks.

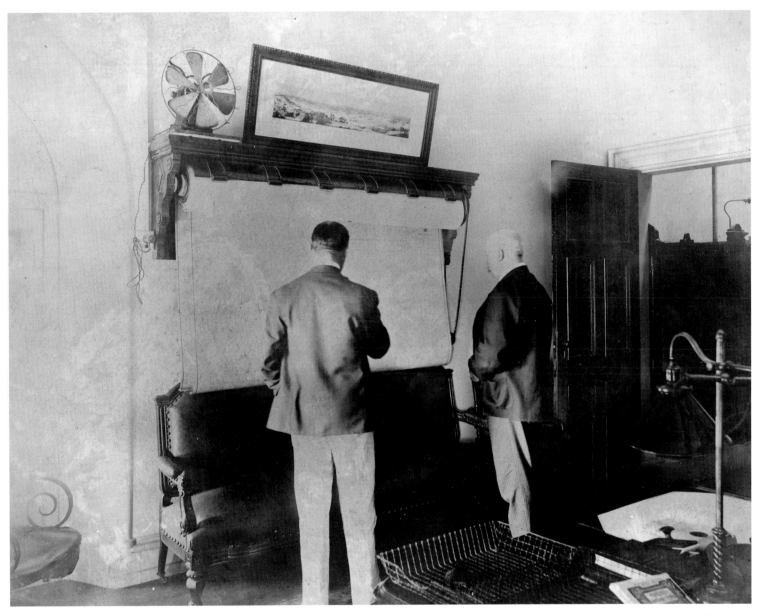

For many years, presidential security was not high on the government's agenda, even after the assassinations of Presidents Lincoln, Garfield, and McKinley. The Secret Service took a larger role after the Spanish-American War, especially during President Theodore Roosevelt's tenure, at the urging of Mrs. Roosevelt. The president, however, proved a difficult man to manage, often dodging his guards or sending them away when his wife was not around. Here, United States Secret Service Chief John E. Wilkie, at left, examines a map in his White House office in 1906.

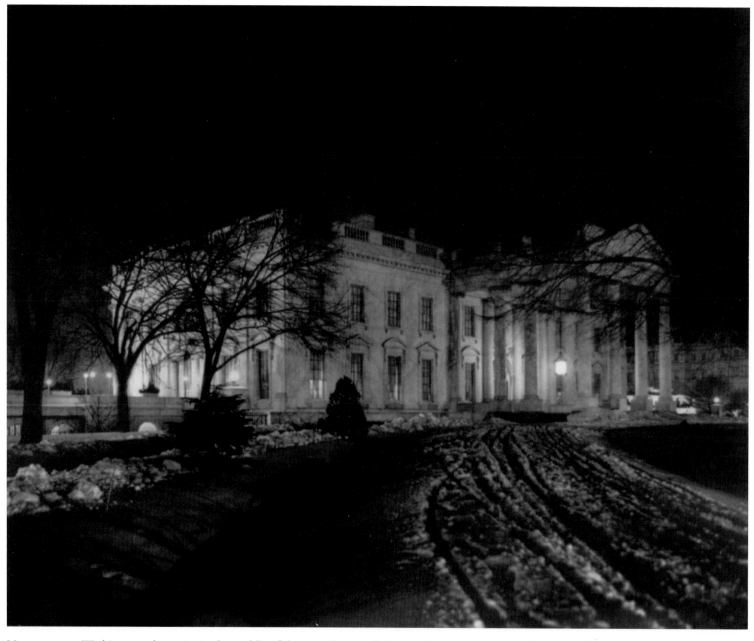

Newcomers to Washington who arrive in the middle of the capital's typically hot and humid summer may find it hard to believe that winter will ever come. Usually it even snows several times, as this night scene photographed in 1907 illustrates.

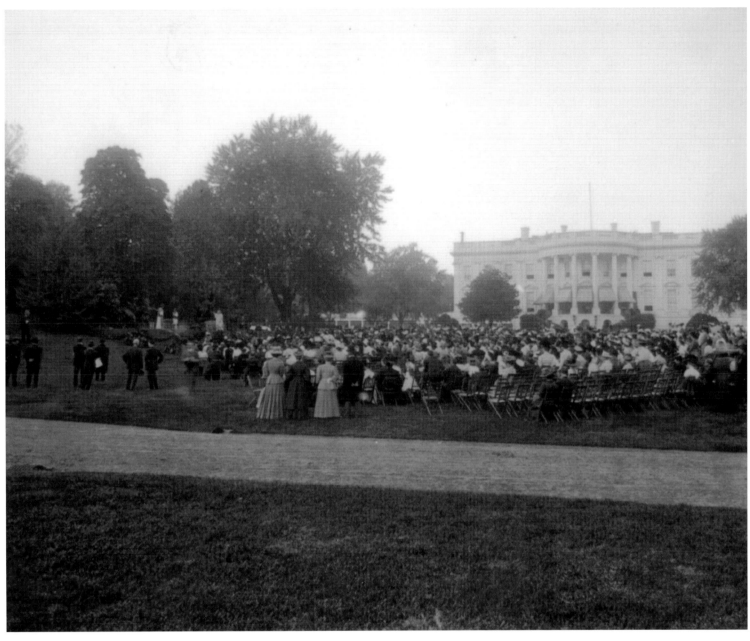

Among the entertainments that the Roosevelts offered periodically were pageants or plays on the South Lawn of the White House, such as this one in 1908. When William Howard Taft took office in 1909, he and his wife continued the practice.

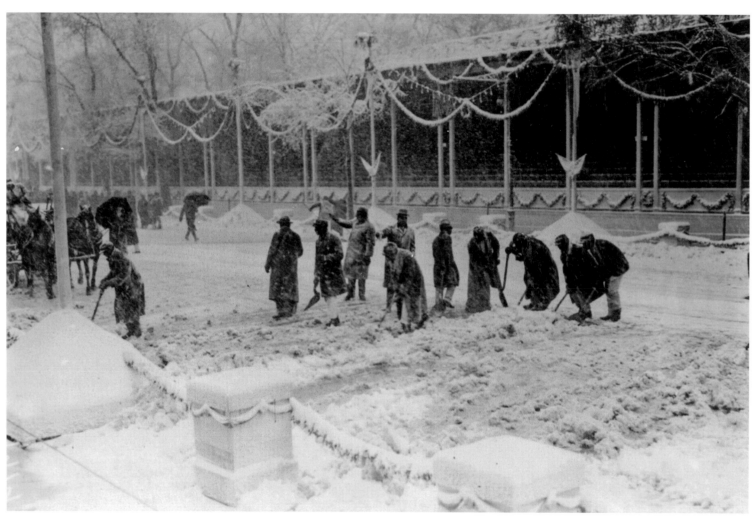

Relations between Theodore Roosevelt and his successor and friend, William Howard Taft, cooled considerably over political differences before Taft assumed the office. Nevertheless, Roosevelt and his wife invited the Tafts to the White House to spend the night before Taft's inauguration. The next morning, March 4, 1909, they all awoke to find that the weather had turned colder than the relationship between the two men. A snow-and-ice storm had struck the capital, and workers were in the streets early to shovel a path along the inaugural parade route. The inaugural ceremony itself was moved inside the Capitol.

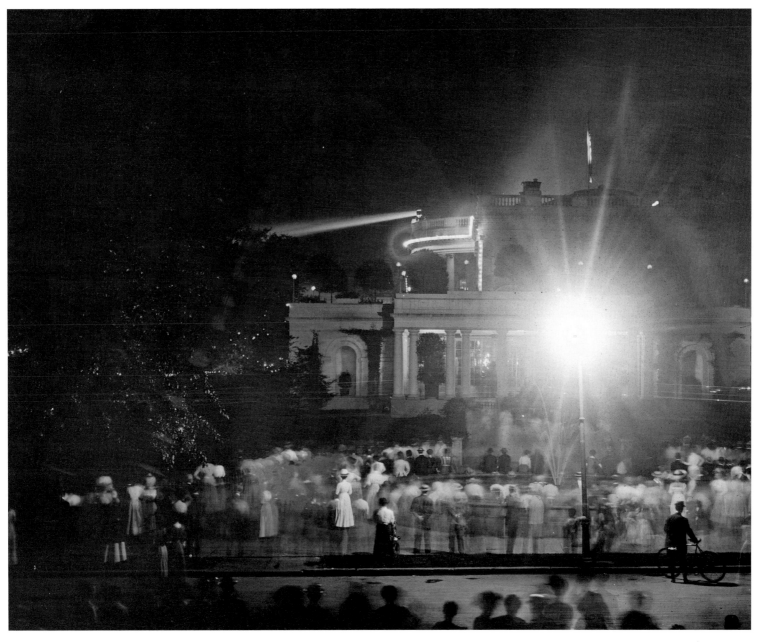

For perhaps the first time in history, the White House was illuminated at night on June 19, 1911—the occasion of the silver wedding anniversary of William Howard Taft and his wife, Helen. Mrs. Taft had decided on a grand illumination of the White House for the 8,000 guests invited to the party, and on June 18, the electric lights were turned on for the president's assessment. He decided there were too few, and strands of lights used to illuminate ships in Norfolk and Annapolis were freighted by rail to Washington the next day. When the lights were turned on again on June 19, the results were breathtaking. The large American flag on the roof was illuminated, and whirling electric fans concealed from view made it wave. Delighted, President Taft ordered the grounds open to the public the next night and the lights turned on again. This photograph shows the fountain and eastern entrance to the White House grounds.

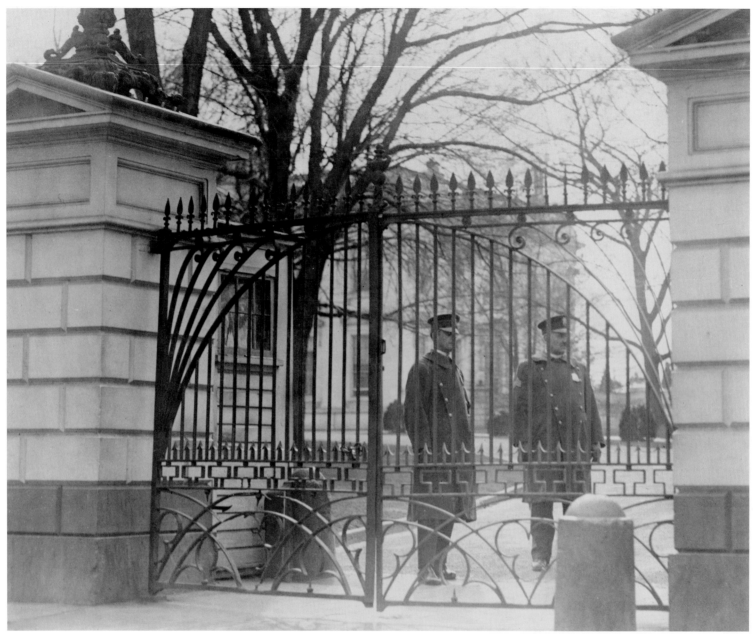

For many years, the northwestern gate shown here after 1913 during President Woodrow Wilson's administration was the principal entrance to the White House grounds from Pennsylvania Avenue. The gate was generally open except at night. During World War I, the White House was closed to the public, and armed guards patrolled the grounds constantly.

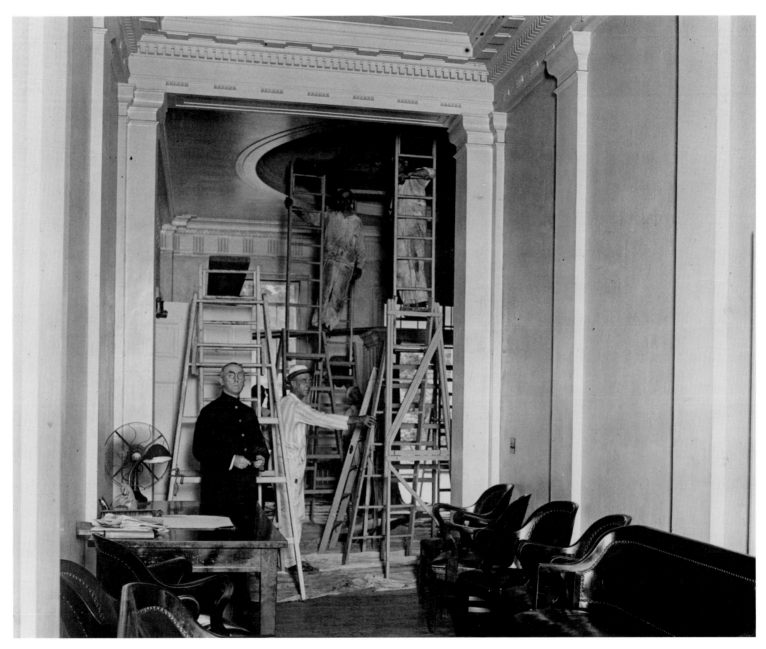

This undated photograph, likely taken between 1909 and 1932, shows workmen in a hallway in the executive offices. Routine maintenance was constantly required in the old building, although major alterations tended to be made by new occupants shortly after they moved in. Theodore Roosevelt undertook major repairs in 1902, William Howard Taft expanded the Executive Office Building and added the Oval Office in 1909, and President Woodrow Wilson and his wife, Ellen, made improvements to the family quarters beginning in the summer of 1913.

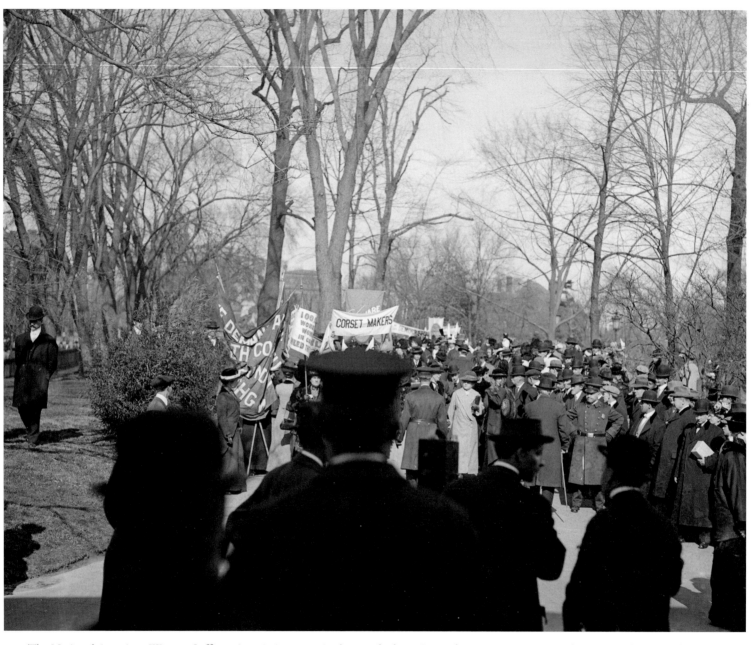

The National American Woman Suffrage Association organized a parade down Pennsylvania Avenue on March 3, 1913, the day before President Woodrow Wilson's inauguration, to promote the campaign for the right of women to vote. Anti-suffrage men attempted to break up the parade, causing a virtual riot. The woman suffrage leaders were not deterred, and in 1914 Alice Paul of the Congressional Union organized a gathering of working women for a march on the White House. Photographed here on February 2, the march took place without incident, and a delegation met with the president, who refused to commit himself or the Democratic Party to the cause of woman suffrage.

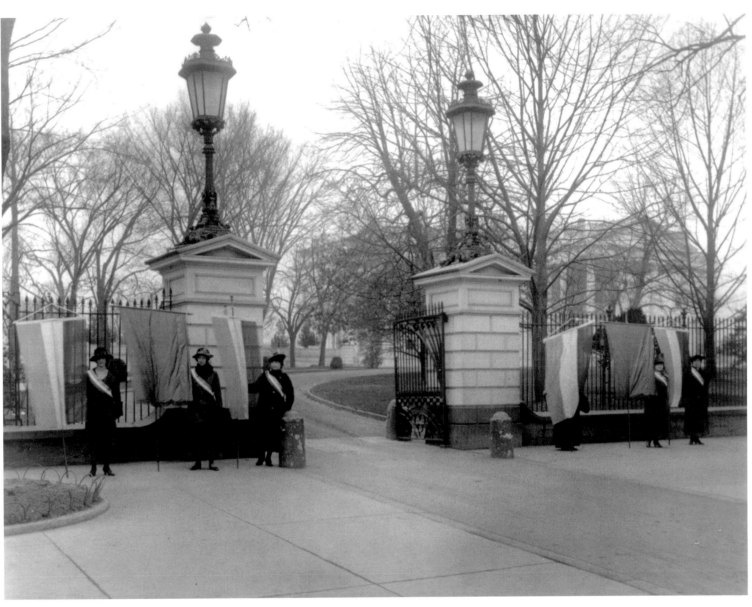

In January 1917, supporters of the woman suffrage movement began to picket the White House around the clock, despite bitter cold and occasional snow. The *Washington Post* interviewed one of them, Hazel Hunkins, a 23-year-old Vassar College graduate and chemistry teacher from Billings, Montana. She discussed her experiences on the picket line, including her dealings with the occasional flirtatious young man "who ought to be full grown in his thoughts, but who isn't, who stops to make some remark that he alone thinks is clever." Some passers-by were sympathetic to the cause, while others were opposed and even angered that women would demonstrate in public. "After all is said and done," said Hunkins, "we enjoy the experience, and being firm in our convictions of the justice of our cause, we are happy in whatever sacrifices we make in standing the cold or the fatigue of long vigils."

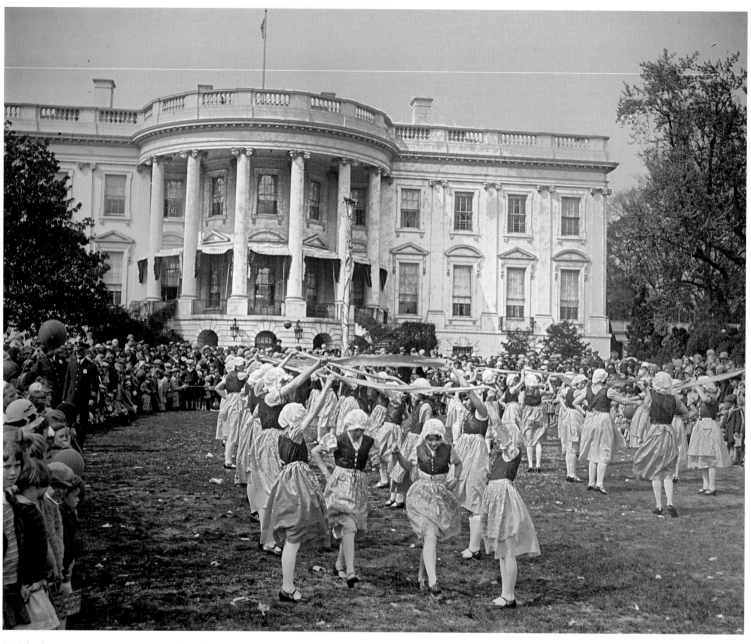

Besides lawn parties, Easter Egg Rolls, plays, and concerts, the South Lawn has been used for outdoor pageants and May Day celebrations. This event was photographed sometime between 1909 and 1923.

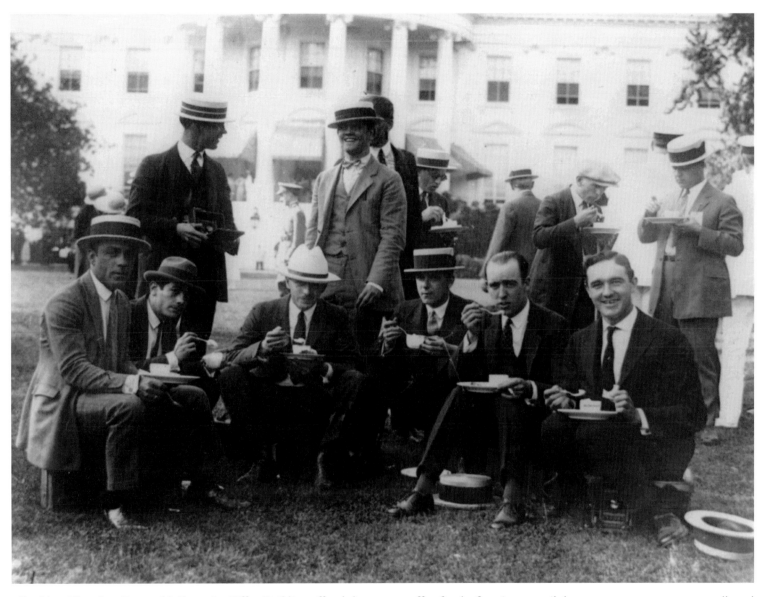

President Theodore Roosevelt's Executive Office Building offered the press an office for the first time—until then, newspaper reporters were allowed to lurk in certain hallways of the White House itself. The press corps grew in the years that followed, and photographers hovered around the White House grounds as well. Here, a group of photographers find themselves the subject of a snapshot while eating lunch on the South Lawn.

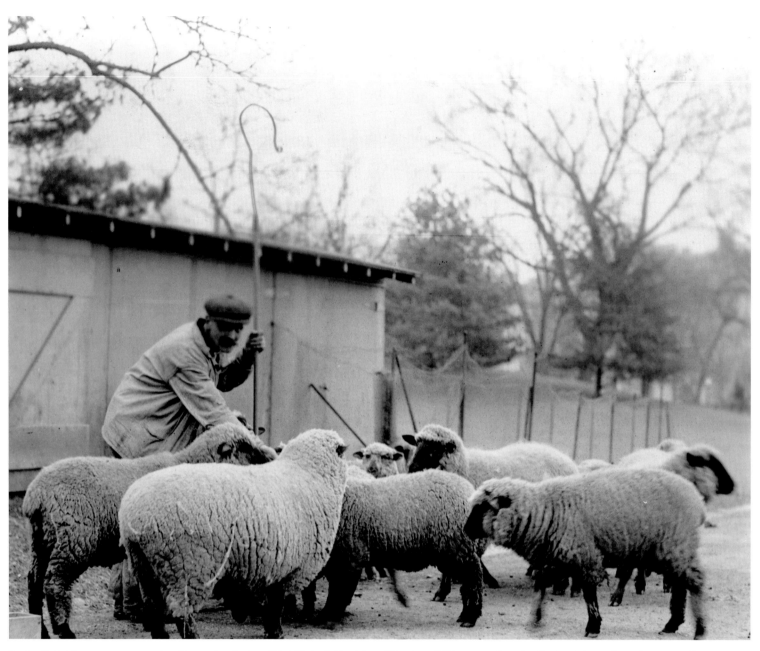

In April 1918, to set an example of austerity during World War I, President Woodrow Wilson purchased a flock of sheep from farmer William Woodward of Bowie, Maryland. Twelve adult sheep and four lambs were employed as grass-trimmers on the South Lawn of the White House. One of the sheep, unused to city life and frightened by passing automobiles, became nervous and ill but soon recovered. Wool was shorn from several of the adults, packaged into two-pound lots, and auctioned off in each of the states to raise money for the Red Cross. Mrs. Luther H. Jenkins bid $200 for the wool sent to Virginia, and won. By March 1919, the flock had increased in size to 26 and was ready for another shearing.

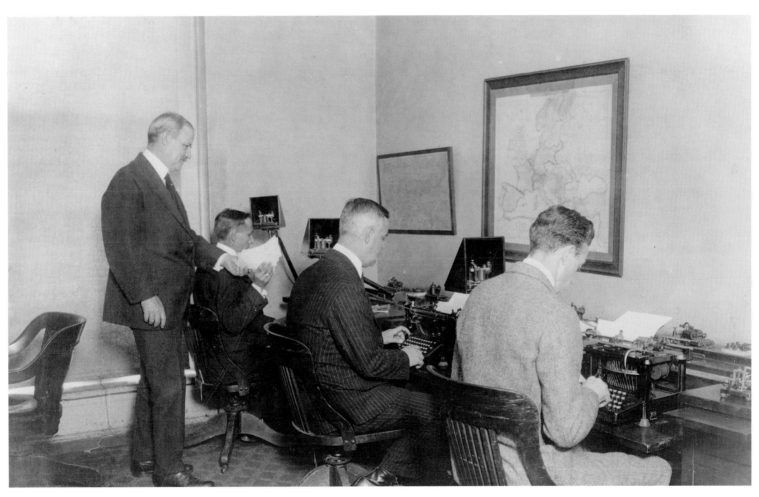

The Executive Office Building, constructed in 1902 under President Theodore Roosevelt and expanded in 1909 by President William Howard Taft, had a telegraph, or wire, room. The first telegraph room was installed in the White House in 1866, and the first telephones were installed there in 1879. In 1915, the first transcontinental telephone call was made from the Oval Office. These employees were photographed between 1909 and 1932 in the wire room, which was relocated several times in the Executive Office Building.

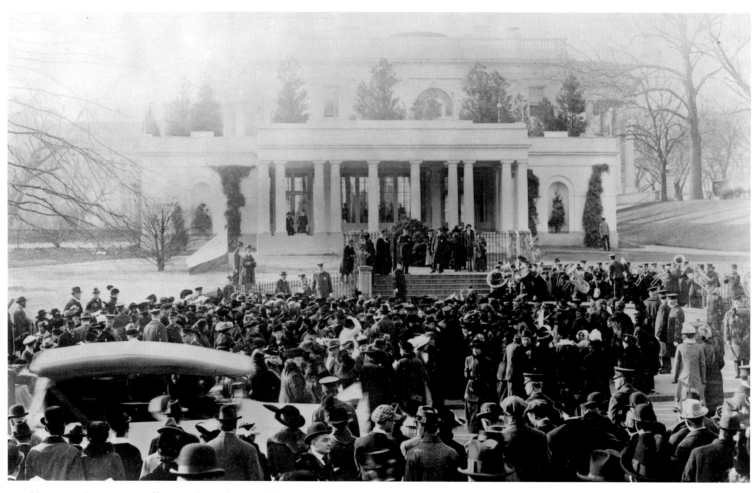

In addition to the woman suffrage pickets who stood by the Pennsylvania Avenue gates to the White House beginning in January 1917, suffragists held rallies at other points around the building. This assembly, accompanied by a band, took place at the eastern entrance to the grounds.

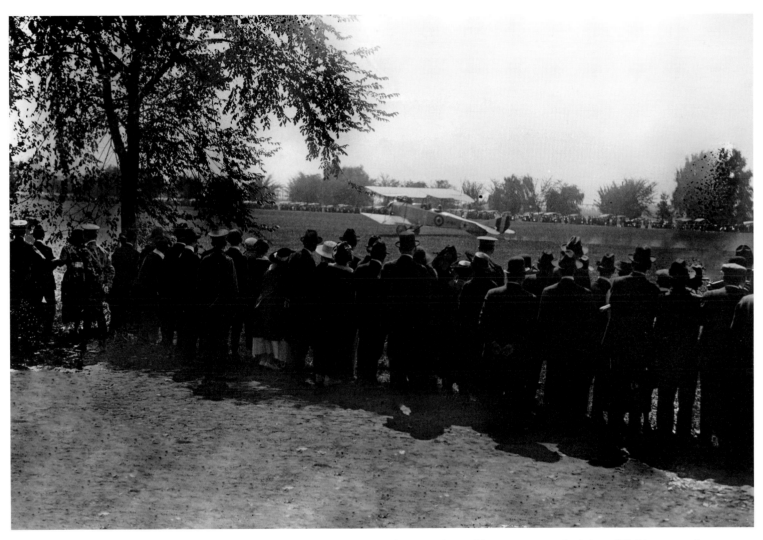

In 1917, during World War I, three Italian airplanes flew by invitation from Langley Field in Hampton, Virginia, to Washington to demonstrate the possibilities of military flight. On September 22, as reported in the *Washington Post* the next day, "Daring Italian military aviators, in two battle planes of lightning speed, and a giant bombing plane carrying ten passengers, gave official Washington a marvelous example of what the American aviation corps must do to strike Germany through the air." Landing on the Mall near the White House and performing stunts for a crowd there, one of the biplanes, piloted by Lieutenant Ballerini, carried Franklin K. Lane, Jr., son of the Secretary of the Interior, as an observer.

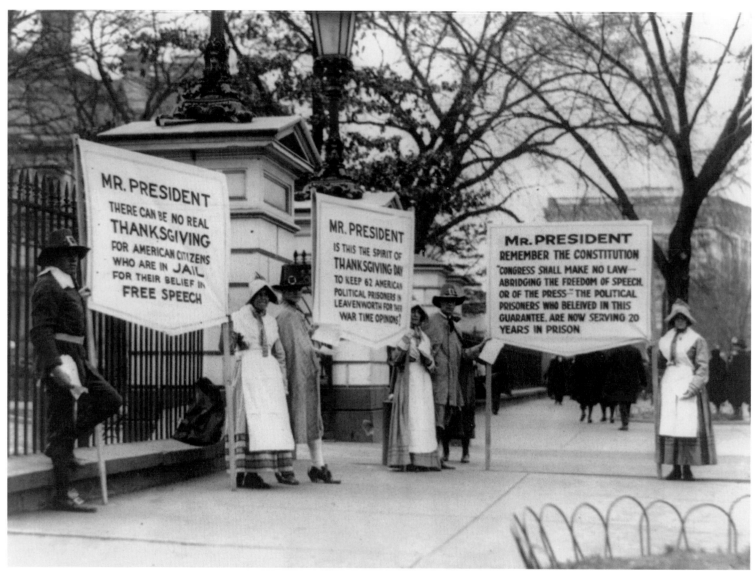

President Woodrow Wilson had opposed America's entry into the primarily European conflict known today as World War I, but asked Congress for a declaration of war in 1917 following several German attacks on American interests. Many Americans, however, remained adamant in their opposition to the war, and Congress responded with a series of laws called the Espionage and Sedition Acts. During the war, more than 2,000 men and women were convicted of "disloyal" speech under the acts, and more than half were imprisoned. These costumed picketers are protesting outside the White House gates at Thanksgiving, probably between 1918 and 1920, the year most of the prisoners were released.

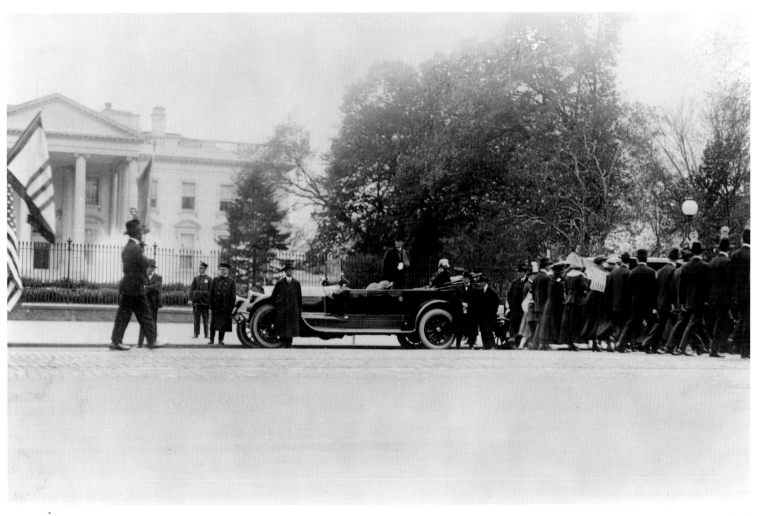

A parade of an estimated 50,000 participants marched past the White House on Pennsylvania Avenue on April 27, 1918, in support of the sale of Liberty Bonds to finance the war. President Woodrow Wilson, standing in an open automobile, and Mrs. Wilson, seated in the car, reviewed the parade as it passed by. Many of the marchers represented government offices, such as the Navy, War, and Interior Departments. Schools, department stores, and banks also took part. The reason for Wilson's left arm being in a sling is not known, although he suffered from ill health, including periodic mini-strokes, that sometimes weakened his arm.

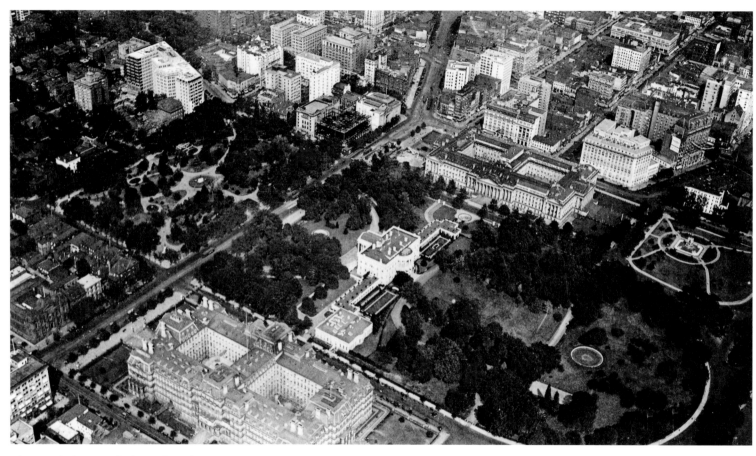

This aerial photograph shows the White House and vicinity in 1919. The State, War, and Navy Building (now called the Eisenhower Executive Office Building) is at bottom left, with the West Wing and White House beyond it. The Treasury Department is just beyond the eastern gate of the White House. At center-left, just north of Pennsylvania Avenue, is Lafayette Park.

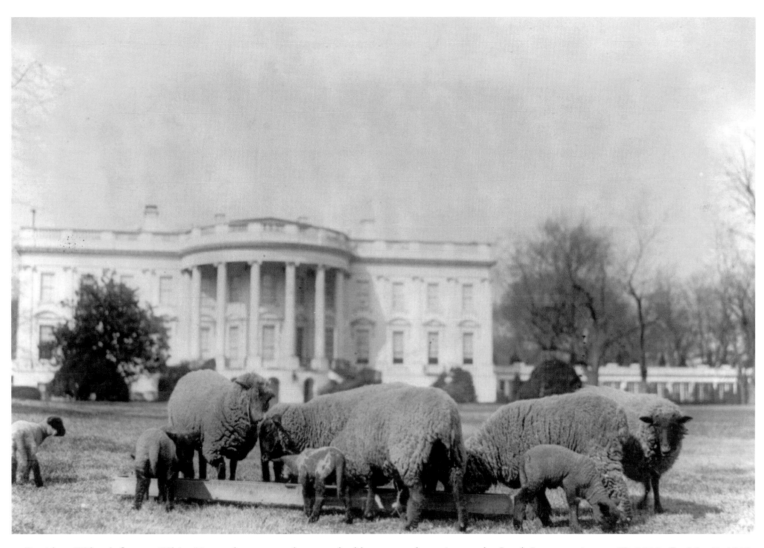

President Wilson's famous White House sheep were photographed here at work grazing on the South Lawn on August 29, 1919. On May 7, 1920, the *Washington Post* reported, "President Wilson made preparations yesterday to turn his flock of sheep loose to graze on the front lawn of the White House. Up to this time the flock, which numbers 48, of which 21 are lambs born this spring, have been confined to the rear, which, as a pasture, is fairly well worn out." In August 1920, the sheep were retired from duty; some were sold and others were returned to William Woodward's Maryland farm, their birthplace. By September 30, all were gone, much to the relief of the White House groundskeepers.

On July 18, 1920, Governor James M. Cox of Ohio, Democratic Party nominee for the presidency, and his running mate, Assistant Secretary of the Navy Franklin D. Roosevelt, arrived at the White House to confer with President Woodrow Wilson. Roosevelt is dressed in white slacks and shoes; Cox is standing to the left of Roosevelt. President Wilson had suffered a major stroke on October 3, 1919, which severely disabled him—a fact that was carefully concealed from the public. Cox and Roosevelt lost the general election in a landslide to Warren G. Harding and his running mate, Calvin Coolidge.

FROM HARDING TO COOLIDGE

(1920–1929)

After the slaughter of World War I, the nation turned for leadership to Warren G. Harding, the man who "looked like a president" and who famously promised a "return to normalcy." He took office in March 1921, and the White House turned from the austerity of the war years to resume an exuberant social pace. An affable, tobacco-chewing Ohio politician, Harding and his wife, Florence Kling Harding, entertained lavishly and well. Mrs. Harding made frequent trips to Walter Reed Hospital, where she visited the sick and wounded veterans. Slowly, however, rumors of corruption amid Harding's political appointees began to overwhelm the president. Neither he nor his wife was in the best of health—she suffered from a kidney ailment—and President Harding died suddenly on August 2, 1923, in a San Francisco hotel while returning from a trip to Alaska.

Vice President Calvin Coolidge became president on Harding's death. The new president's father, who was a notary, administered the oath of office the next morning in Coolidge's boyhood home in Plymouth Notch, Vermont, where he was vacationing. Coolidge could not have been more different from Harding: dour instead of affable, and notoriously quiet— "Silent Cal." The silence was intentional. As Coolidge explained, briefly, "You have to stand every day three or four hours of visitors. Nine-tenths of them want something they shouldn't have. If you keep dead still they will run down in three or four minutes. If you even cough or smile they will start up all over again."

Coolidge's wife, Grace Coolidge, was as outgoing and personable as he was not. She enjoyed entertaining and was known for her ability to put strangers at ease with small talk. Comedian Will Rogers, who visited the Coolidges in the White House, pronounced her "plumb full of magnetism." The president had his witty side, too, which usually involved his elaborate attempts to elude his guard, Edmund Starling, and escape the grounds for solitary walks. Eventually, the public grew fond of the quiet little president. Cartoonists enjoyed drawing him, especially when Coolidge at first refused to leave the White House on his last day in office, a rainy day. He was about to depart for Herbert Hoover's inauguration on March 4, 1929, when one of his rubber overshoes went missing. Coolidge sat down and refused to move until it was found. At last it was located, and the events of the day proceeded.

Madame Marie Curie, with her husband, Pierre Curie, conducted the studies and research that led to the isolation of polonium, named after the country of Madame Curie's birth, and radium in 1898. On May 20, 1921, President Warren G. Harding, seen here escorting Madame Curie down the steps to the south grounds of the White House, presented her, on behalf of the women of America who had raised the money, with $100,000 worth of radium for her use in research to find cures for various diseases.

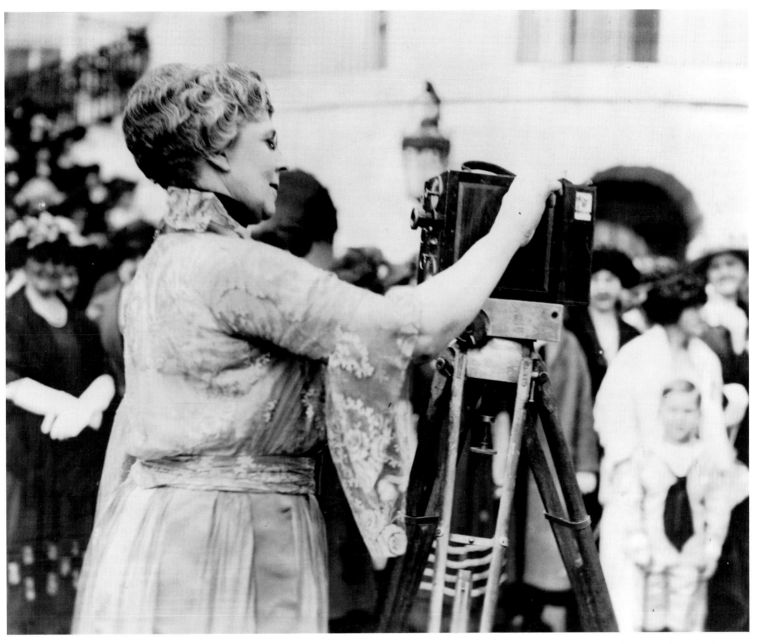

On April 8, 1922, First Lady Florence Kling Harding was photographed trying out a movie camera on the lawn at the White House. A group of women standing in the background watch with amusement. The *Washington Post* recorded the moment but gave no explanation for the circumstances of the event.

During the summer of 1921, various bands performed for a series of open-air concerts in Washington, D.C., including the Fort Myer band, the Boy Scouts band, and others. Seen here on July 16 is the United States Marine Band presenting a concert on the grounds of the White House, visible in the background. The program included "Siegfried's Funeral March" from *The Ring of the Nibelungen* by Richard Wagner, "Prelude in G Minor" by Sergey Rachmaninoff, and "The Star-Spangled Banner."

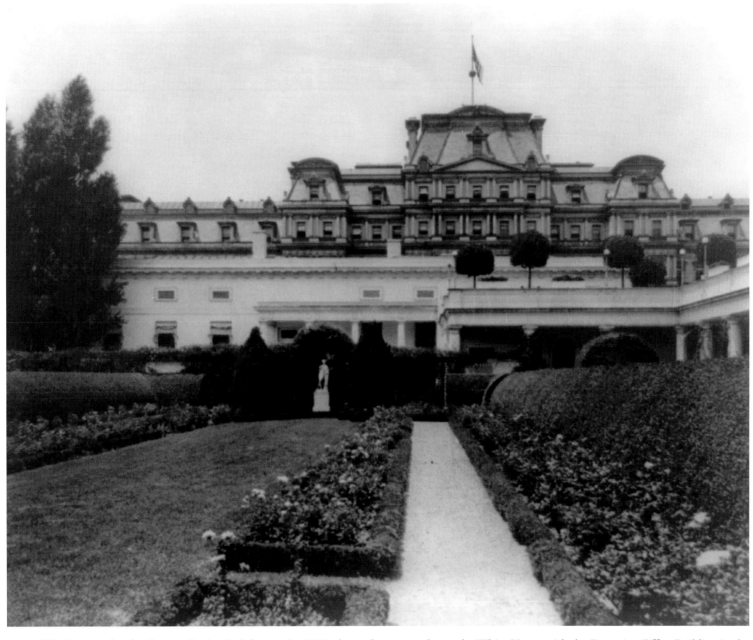

This image, taken by Frances Benjamin Johnston in 1921, shows the rose garden at the White House with the Executive Office Building in the background. In the 1910s, Johnston had begun concentrating her photographic endeavors on gardens and estates.

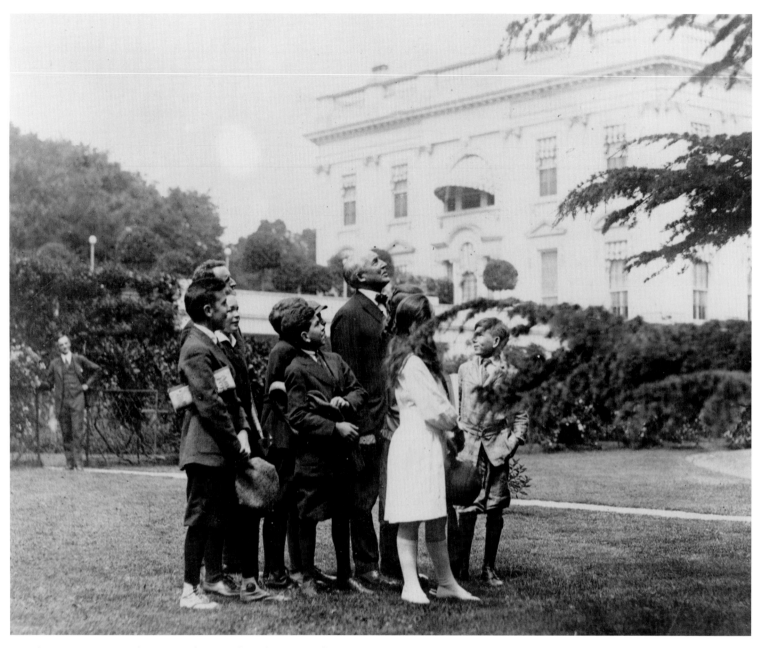

President Warren G. Harding is seen here on the White House lawn pointing out an owls' nest to a group of nature-study students from John Burroughs School in May 1921. The night watchman at the White House had found three young owls, described as "promising rat killers," and notified the president of their presence. The *Washington Post* noted the suggestion had been made that the owls might "grow into an agency for the destruction of all sorts of pests about the White House, but there was no reference to office-seekers." After Harding appointed the children a "jury" to decide their fate, the owls were allowed to remain on the grounds. Fifteen-year-old Jimmie Bradley, foreman of the jury, followed up the verdict by successfully addressing the House Committee on the District of Columbia to "demand continuation of appropriations for nature study in the schools."

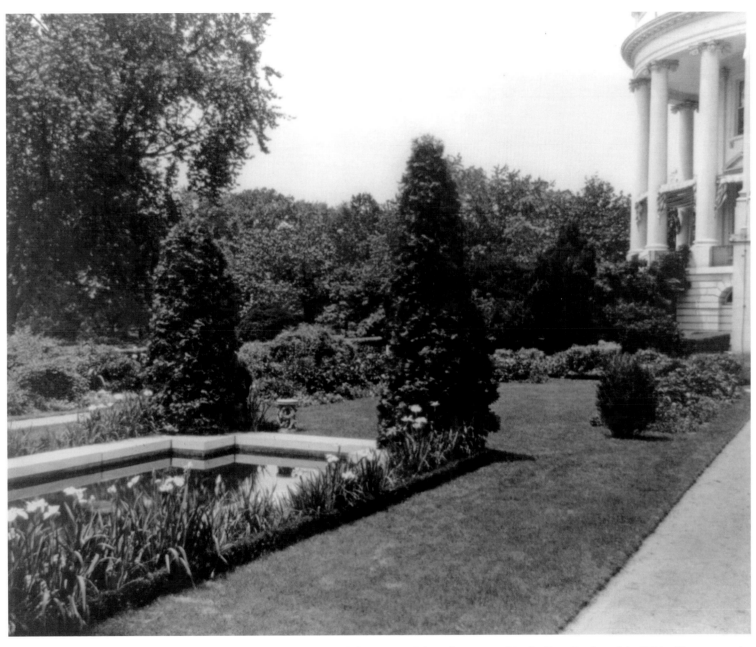

Photographer Frances Benjamin Johnston captured this image of the reflecting pool in the East Garden of the White House near the portico in 1921. In 1913, First Lady Ellen Axson Wilson had the landscape architect Beatrix Farrand landscape the East Garden, which retains almost the exact form today.

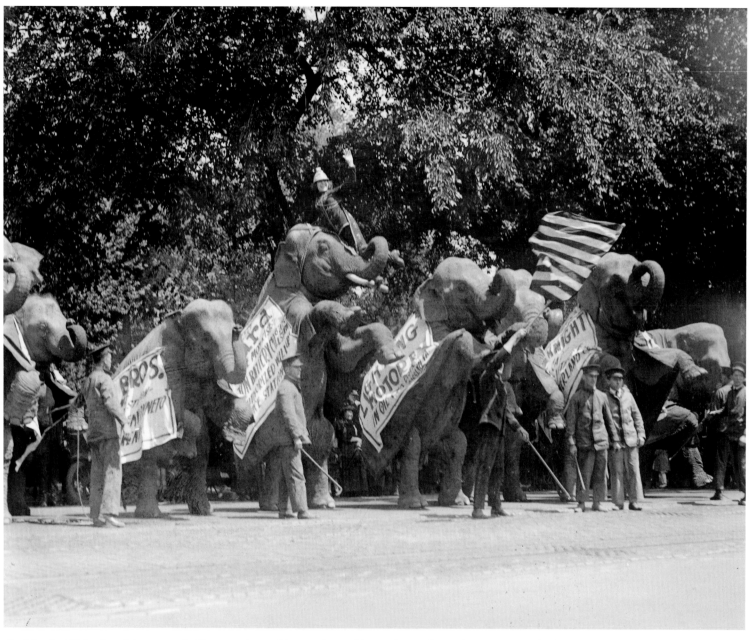

On May 9, 1921, after eight years of a Democratic president and a world war, these John Robinson Circus elephants celebrate the return of the Grand Old Party to the White House. Performing a series of "unusual" stunts while passing the White House, the elephants paraded down Pennsylvania Avenue along with camels, horses with "fancy trappings," and cages full of wild animals before a crowd of business and professional people, schoolchildren, and others.

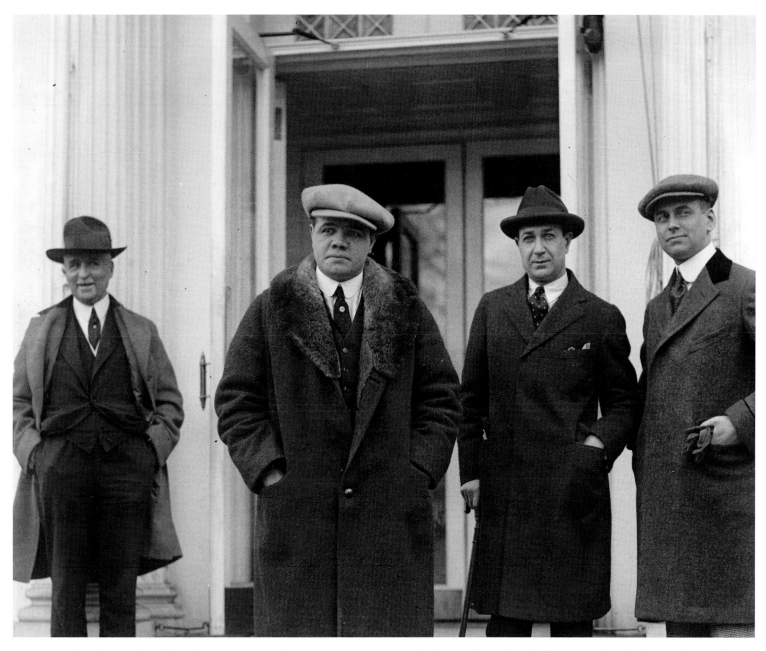

Among the visitors to the White House on December 6, 1921, was the man already regarded as "baseball's greatest hitter," George Herman "Babe" Ruth, who had been traded to the New York Yankees from the Boston Red Sox in 1920 after helping the Red Sox win three World Series. It would take another 86 years for Boston to throw off the "Curse of the Bambino" and win another World Series. During the 1921 season, Ruth set major league records with his totals of 59 home runs, 457 total bases, 171 runs batted in, and 177 runs scored while leading the Yankees to the World Series for the first of seven times that he would do so.

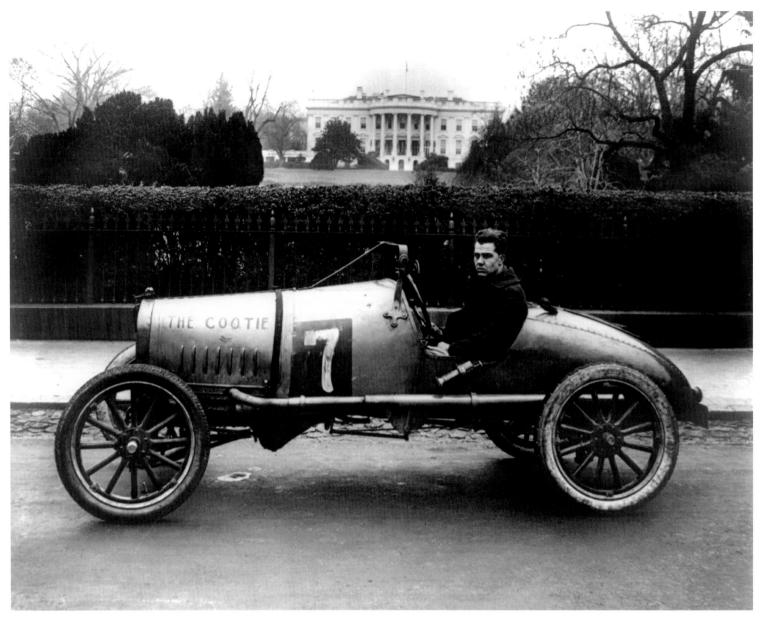

Seen here is a racing car named "The Cootie" and its driver sitting behind the White House sometime in 1922. The term "cootie" had come into the English language during World War I as a reference to body lice, and was derived from the Malay word *kutu* for the dog tick. The British navy had discovered the Malay word and revised it to cootie. In November 1917, the Americans serving in Europe received the new "cootie shirt"—"the latest thing in trench fashions"—which was vermin proof. The cheesecloth fabric had been dipped in creosote, which trapped the lice that could lead to typhus. In "honor" of the cootie, a group of veterans organized the Veterans of Foreign War's Military Order of the Cootie on September 17, 1920, at a veterans' encampment and gained almost 300 members by the end of the event. On January 20, 1922, Luzern Custer, of Dayton, Ohio, showed off his new "cootie car" in Washington, D.C., and nearly ran over a policeman with his "new demon of the roads." That car was a three-wheeled electric wheelchair that allowed Custer, who was an invalid, to tour Washington and see the sights.

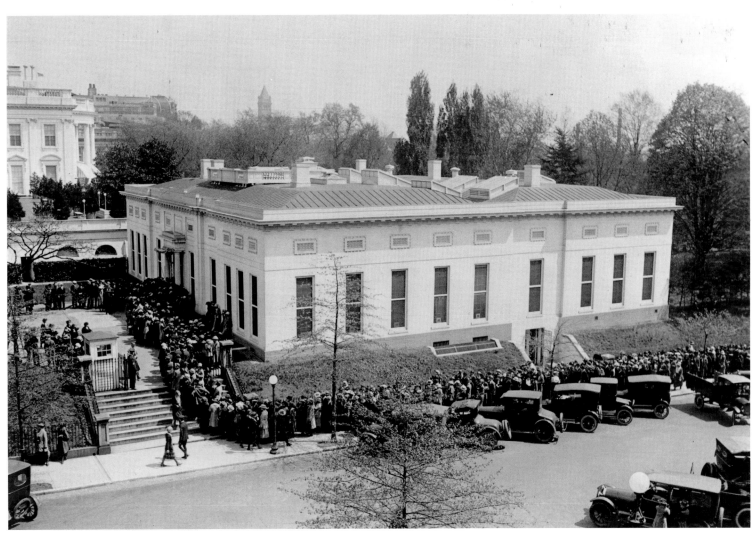

The National Photo Company operated during the administrations of Wilson, Harding, Coolidge, and Hoover, capturing current news events at the White House and the rest of Washington and providing them to its subscribers. This April 15, 1922, image shows the lines of visitors snaking around the executive offices en route to the White House for one of the very popular "public receiving" days.

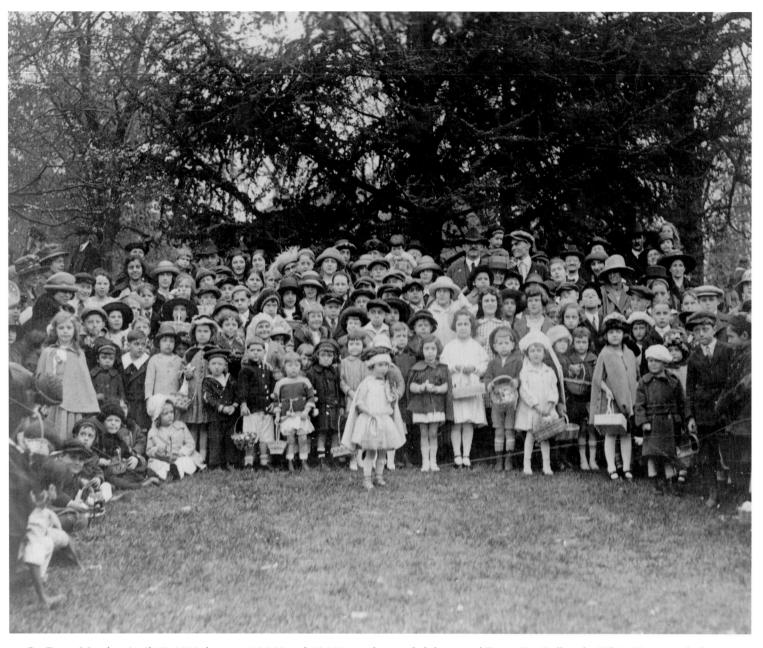

On Easter Monday, April 17, 1922, between 10,000 and 15,000 people attended the annual Easter Egg Roll at the White House, including 5,000 to 7,000 children. The morning events were only for children, so some little boys "benefited to a considerable extent financially," it was reported, by charging unattached adults a fee to escort them into the grounds. Seen here are the "bright faces of the youngsters" who "made a garden of smiles and color that vied with the magnificent gardens of flowers at the White House."

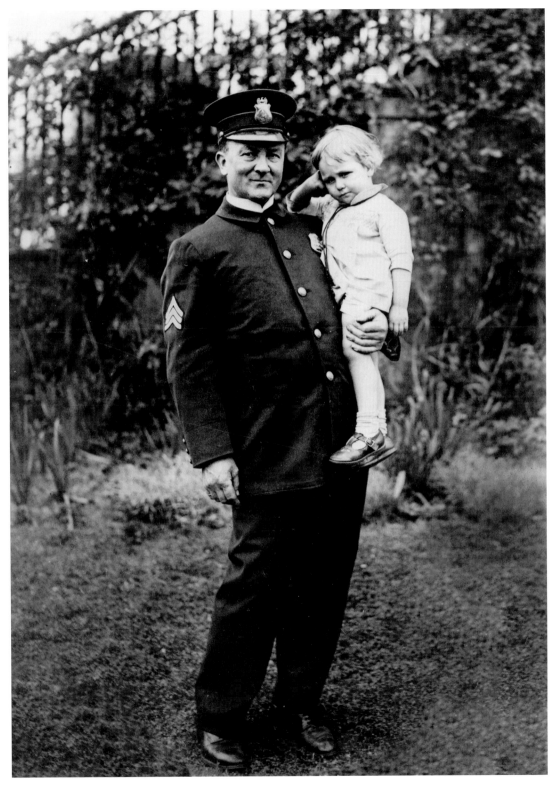

Shown here at the April 17, 1922, White House Easter Egg Roll is White House Police Force Sergeant James D. McQuade, holding one of the formerly happy Easter-egg rollers whose elders have gone missing. Described as one of the "tragedies" of the event, this disgusted-looking child was among eight youngsters who strayed from their parents and who Sergeant McQuade rounded up during the day. At a previously designated point manned by the good sergeant, the children's families were happily reunited with the "lost and found."

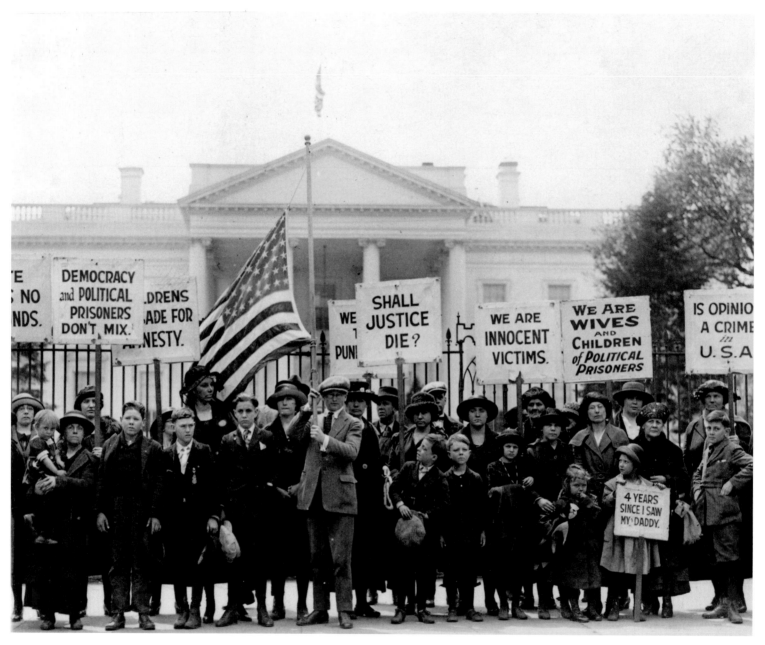

On April 29, 1922, a 37-member "children's crusade," consisting mostly of children younger than 12 and wives and mothers, arrived at the White House hoping to see President Harding and persuade him to release 114 political prisoners still being held for refusing to support the First World War. Several of the protesters, led by Mrs. Kate Richards O'Hare of the American Civil Liberties Union, were allowed to speak instead with the attorney general, who promised to review each case individually and free as many as he could, although he made no firm commitment.

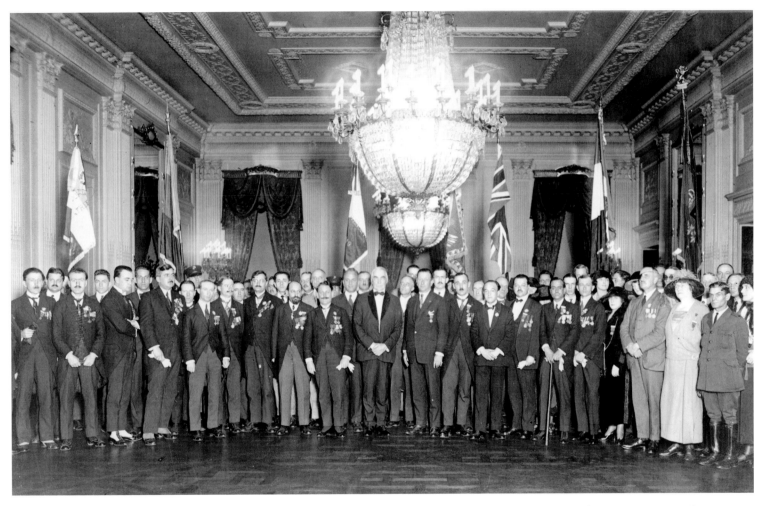

On October 11, 1922, a contingent of 40 European world war veterans from seven allied countries stopped in Washington en route to the American Legion Convention in New Orleans. The activities planned for them in the capital included a reception in the president's room at Union Station, a pilgrimage to the Tomb of the Unknown Soldier, a dinner at the Racquet Club hosted by the District Legion, and a reception at the White House, seen here in the East Room, with President Harding.

Shown here is a panoramic view of the North Portico of the White House as seen from the east in 1923. Thomas Jefferson added the colonnaded terrace on the left during his administration early in the 1800s.

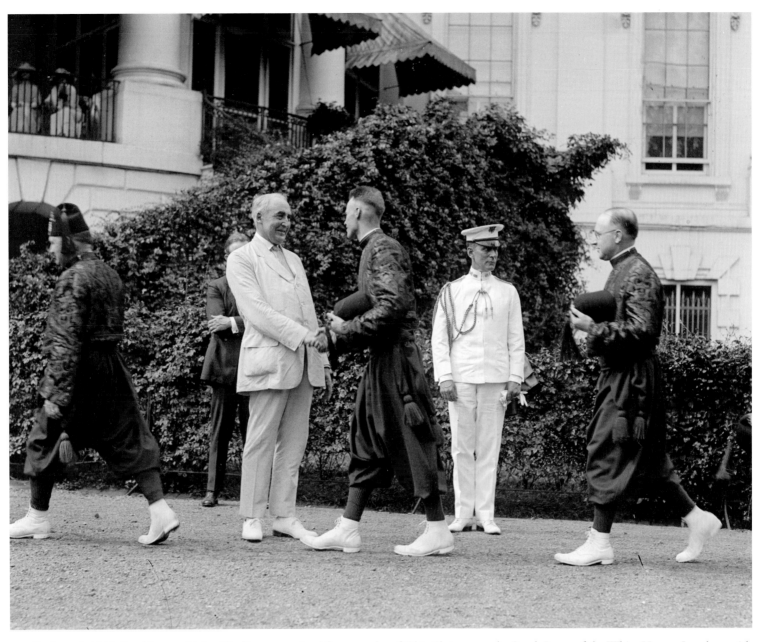

On June 6, 1923, President and Mrs. Harding entertained four temples of Ohio Shriners on the South Lawn of the White House. Seen here with President Harding are members of the Aladdin Shrine, of which Harding was a member. The bands the temples brought with them entertained Harding and his wife. Mrs. Harding called on one member of the Aladdins, the famous baritone Jack Richards, to sing "Honeymoon Time," followed by "My Hero," as "she looked admiringly at her husband," the press reported.

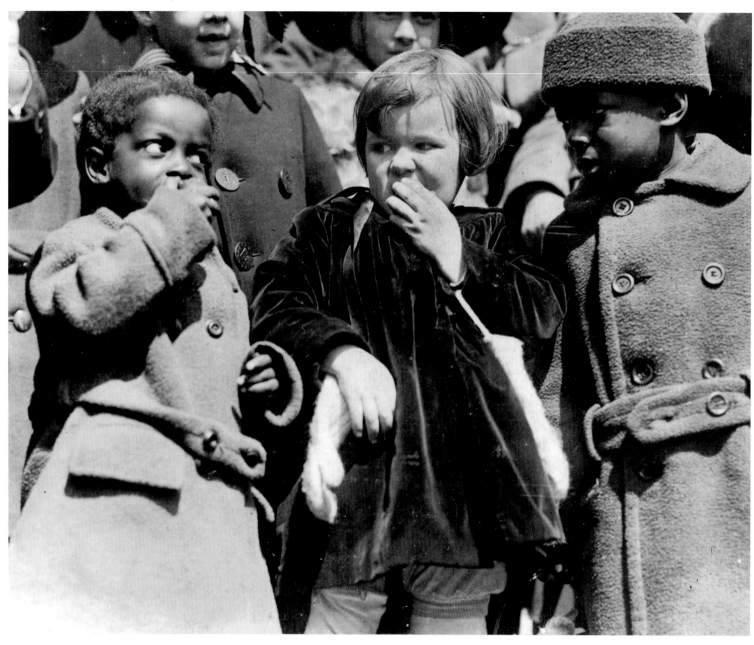

In April 1923, for the second year in a row, Florence Kling Harding opened the "backyard" of the White House to the children of Washington for the annual Easter Egg Roll. All were invited, from the poorest sections of Washington to the richest. President Harding had given a speech in 1921 in Birmingham, Alabama, advocating civil rights for every American, including African Americans. Even during a time of racial segregation, children black and white could join together at the White House to enjoy a day of "tossing painted eggs to each other or frolicking in the sunny spots at their games."

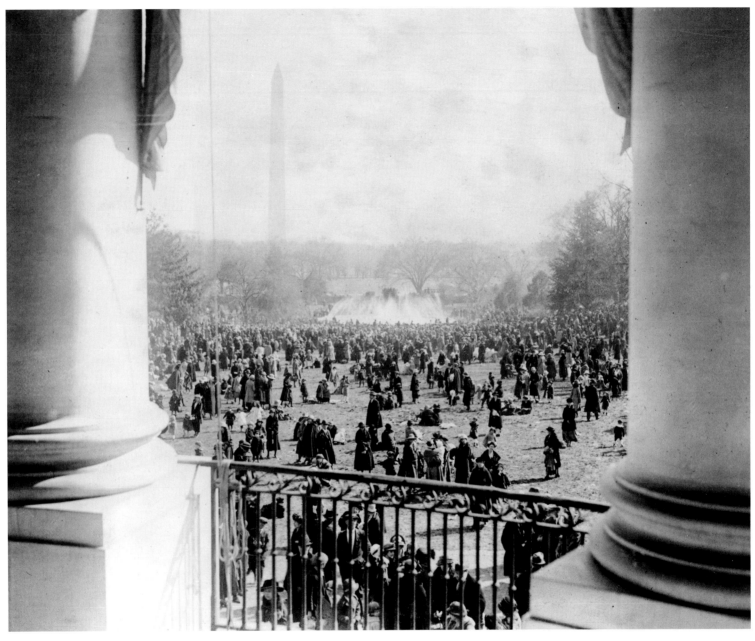

More than 5,000 children along with their parents, friends, or nurses crowded the South Lawn of the White House to participate in the annual Easter Egg Roll in 1923. Adults who tried to get in without having children younger than 10 years old in tow were turned away, though some made it through by pretending to accompany passing children who were not their own. In the afternoon the Marine Band entertained the throngs.

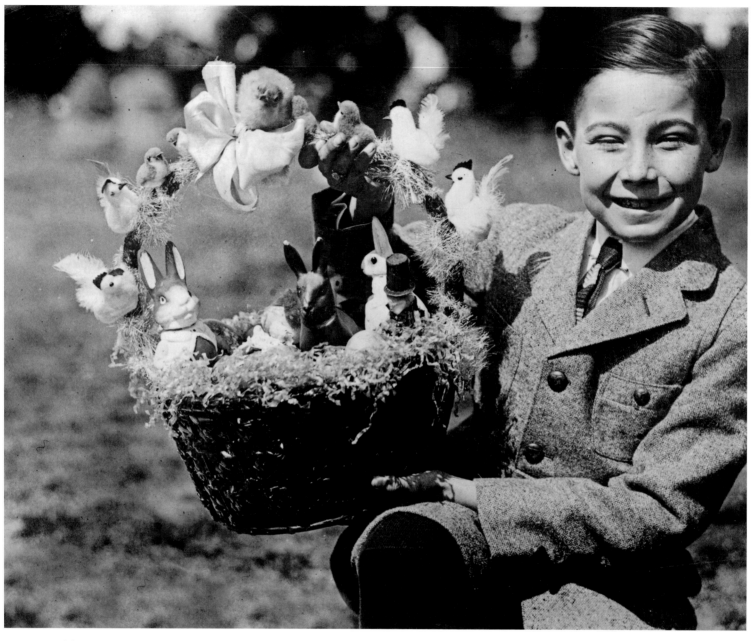

Nine-year-old Warren Sonnemann proudly displays the prize Easter basket that he had won at the annual White House Easter Egg Roll on April 2, 1923. He and his parents lived on North Carolina Avenue in Southeast Washington.

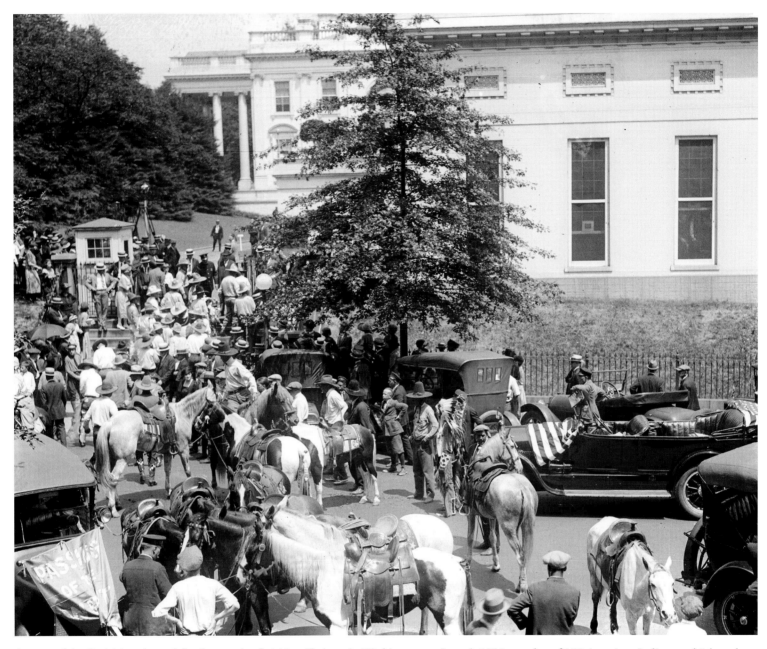

As part of the festivities planned for thousands of visiting Shriners in Washington on June 4, 1923, a rodeo of 150 American Indians and 24 cowboys and cowgirls paraded from Union Station up Massachusetts Avenue to L Street, and then out to Washington Circle and back down Pennsylvania Avenue, before returning to the show grounds for their performance. Two days earlier, some of the rodeo participants had made a stop at the White House gates, as seen here, and on June 6, they rode up to the east front of the Capitol for photographs.

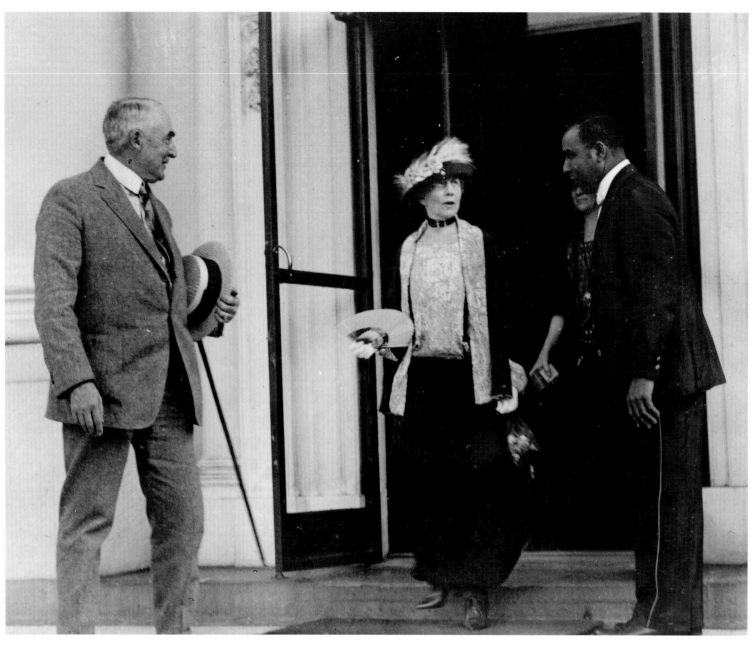

On June 20, 1923, President and Mrs. Harding left on a journey to Alaska, Panama, and Puerto Rico, by way of St. Louis, Denver, Seattle, San Francisco, and San Diego. The president intended to assess the state of the Union on his trip and expected to be gone until the end of August. Seen here leaving the White House, President Harding waits for Mrs. Harding to bid adieu to members of the staff.

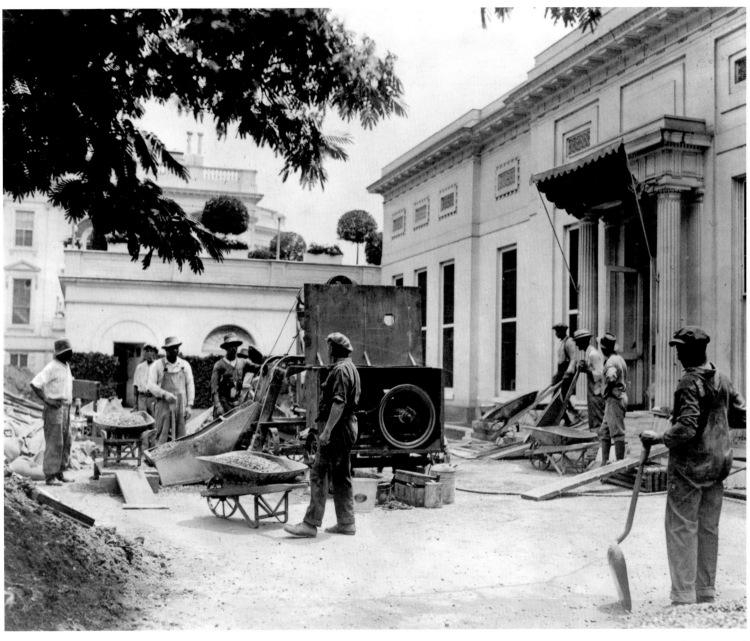

While the president and First Lady traveled in the West, repairs on the White House began on the day they left. Among the changes being carried out were redecoration of the first and second floors, a new heating plant, and new floors and draperies for the executive offices, where the repair work seen here is being done on July 16, 1923.

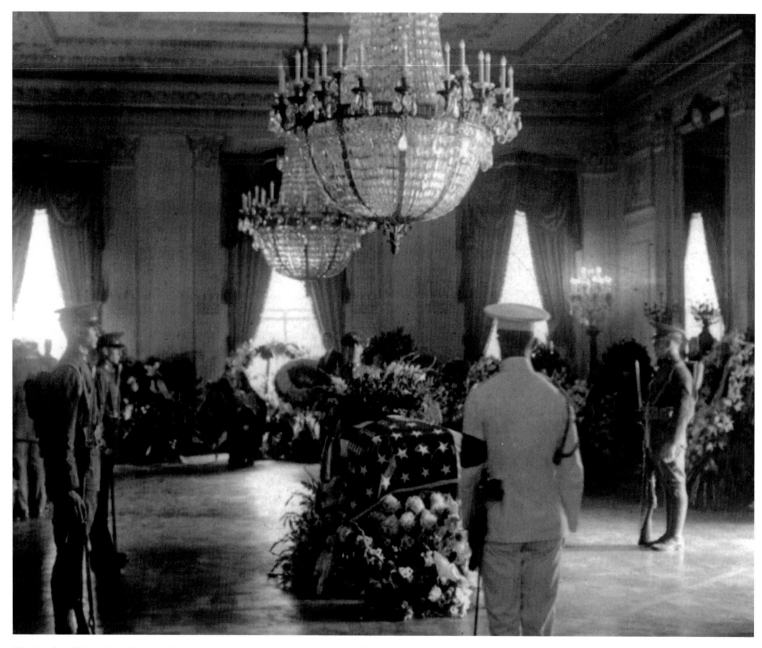

The body of President Harding lies in state in the East Room of the White House on August 7, 1923. The president and First Lady had reached Alaska on their journey and on July 28 had arrived in Seattle, where Harding planned to give a speech. Instead, he suffered what his personal doctor diagnosed as a gastric attack and the navy doctor called a heart seizure. The president's train traveled on to San Francisco, where Harding insisted on walking from the train to the car and from the car into the hotel. He suffered another bout of chest pains and died on August 2 of what was described as a cerebral hemorrhage. Five days later his body was returned to the White House.

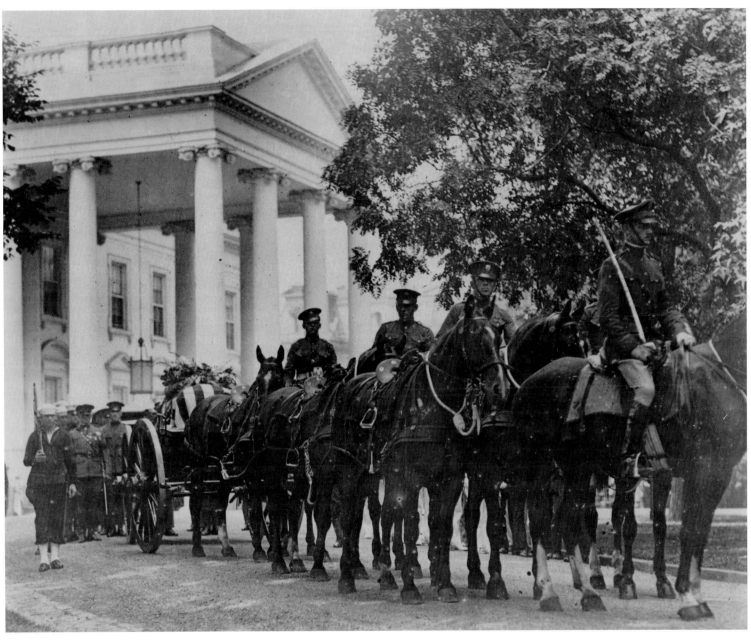

On August 8, 1923, Harding's funeral cortege left the White House for the train trip back to his hometown, Marion, Ohio, where he was laid to rest. The cortege is seen here at the North Portico entrance.

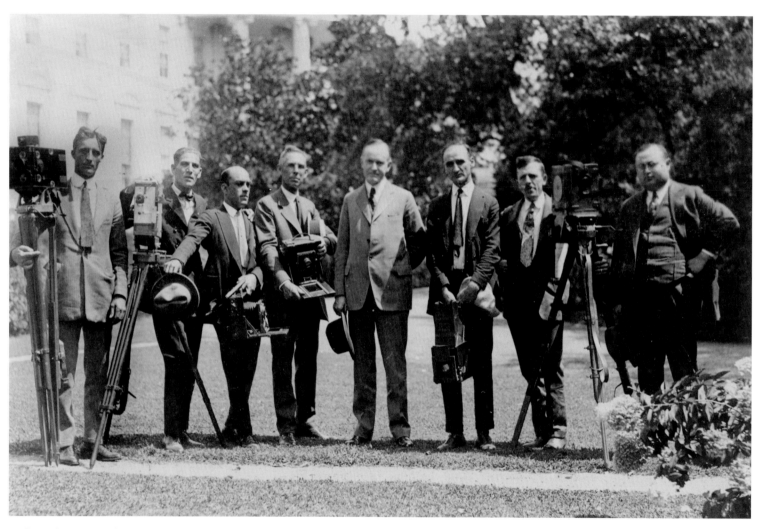

Early in the 1920s, when Washington newsmakers began to be photographed by motion-picture and still photographers, government activities were restricted, and photographers were even barred from the Capitol "without written permission of the building superintendent." Thus was born the White House News Photographers Association on June 13, 1921, when 17 photographers united to gain access for their coverage of the president's daily events. President Harding gave the association a pressroom in the White House, and the rest of official Washington soon followed his lead. After Harding's death in August 1923, Vice President Calvin Coolidge became president and was photographed here with a group of the White House News Photographers, probably later that month.

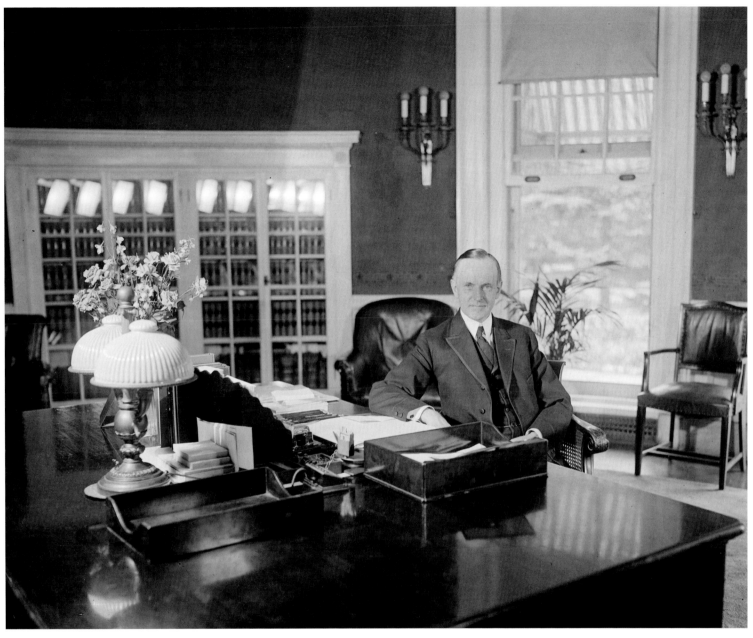

President Calvin Coolidge took the oath of office at his father's home in Plymouth Notch, Vermont, on August 3, 1923, soon after the death of President Harding. His father, John C. Coolidge, a notary public, also administered the oath of office while Calvin Coolidge held the family Bible. Appearing in the *Washington Post* on August 26, this photograph of the new president at his desk was taken on August 14. The next day, he sat for 10 minutes for 27 still- and motion-picture cameramen before raising his hand "good-naturedly" and telling them, "I think that is enough."

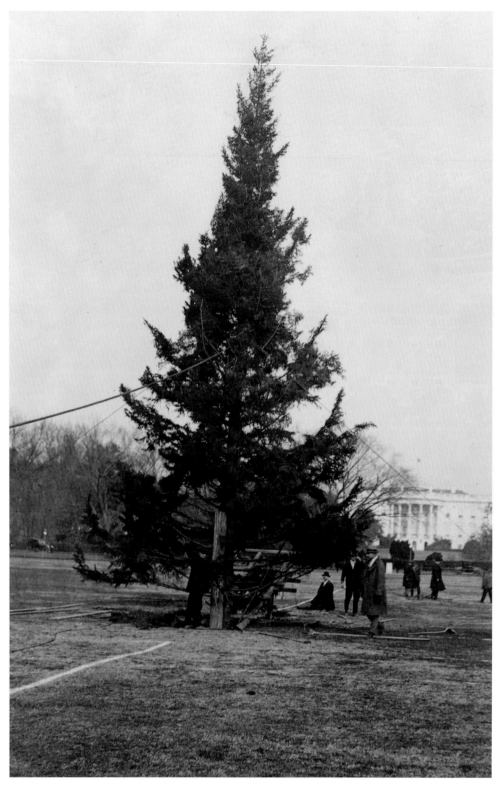

For the Coolidges' first Christmas at the White House, Middlebury College in Vermont sent their native son this 60-foot-high Christmas tree, which was set up behind the White House. At 5:00 P.M. on December 24, 1923, attended by thousands of citizens, young and old, President Coolidge touched an electric button at the foot of the tree and "turned it into a blaze of glory."

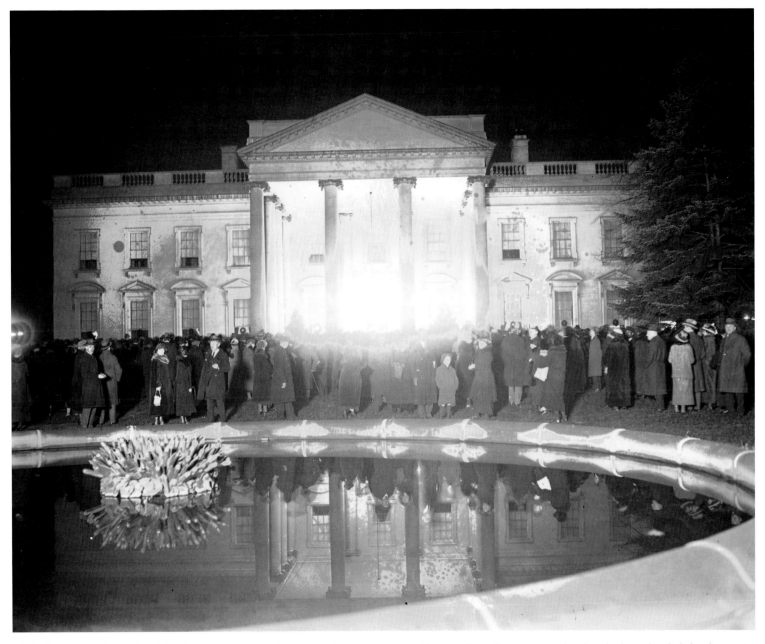

The lighting of the national Christmas tree on Christmas Eve 1923 was followed by a fanfare of trumpets and a church choir that led the throngs in singing carols. Seen here in the illumination from the north entrance to the White House are some of the participants in the singing.

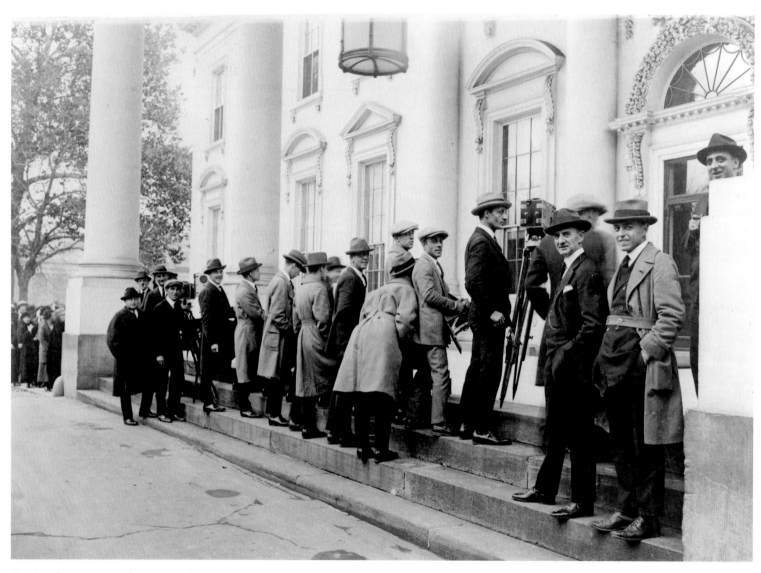

On October 25, 1923, former British prime minister David Lloyd George and his wife and daughter arrived in Washington for a whirlwind tour of the United States capital, where he visited the secretary of state Charles Evans Hughes and then attended a luncheon at the White House with President Coolidge. In the afternoon, Lloyd George had tea with former president Woodrow Wilson, with whom he had labored on the Treaty of Versailles that ended World War I. Seen here are a group of photographers waiting on the steps of the North Portico entrance to the White House for the Lloyd Georges to conclude luncheon with the Coolidges.

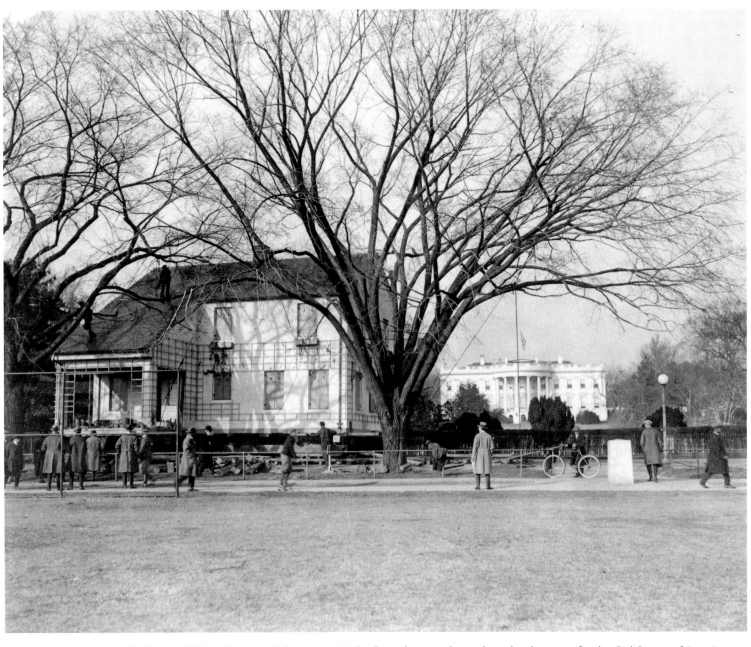

An unusual sight rolled by the White House on February 2, 1924, when a house to be used as a headquarters for the Girl Scouts of America was moved past the south grounds. Begun by Juliette Gordon Low in Savannah, Georgia, on March 12, 1912, and based on the Girl Guides that had been organized in England in 1910, the Girl Scouts was incorporated under the laws of the District of Columbia on June 10, 1915. The national headquarters was moved in 1916 to New York but Washington remained a scouting center as well.

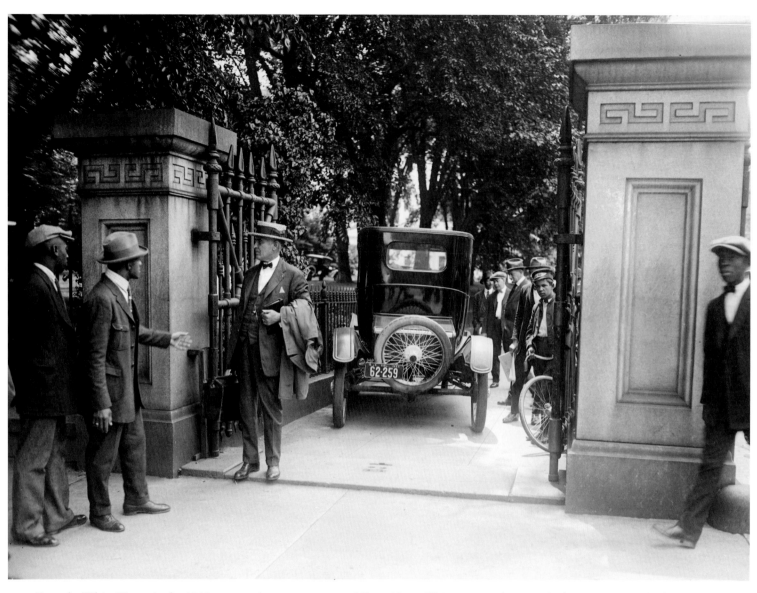

Even the White House in the 1920s was not immune to automobile accidents. This one was photographed on June 3, 1924. If that is the driver standing behind the auto at the gate's entrance, he seems curiously unaffected by the wreck and looks as though he is waiting for a taxicab to take him away.

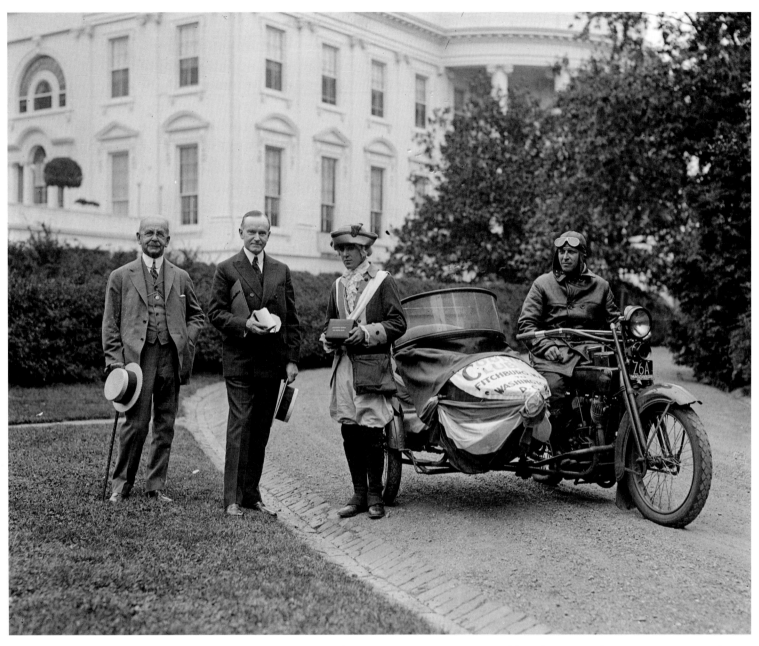

On June 6, 1924, Francis Mahoney, a Boy Scout dressed as a Revolutionary War Minuteman, arrived by sidecar in Washington, D.C. Starting his journey on June 5, Mahoney had ridden from Fitchburg, Massachusetts, to give President Calvin Coolidge a roster of the Fitchburg Coolidge Club's 5,000 members and their endorsement of the president. Many such clubs were formed across the country to support Coolidge in his 1924 election campaign.

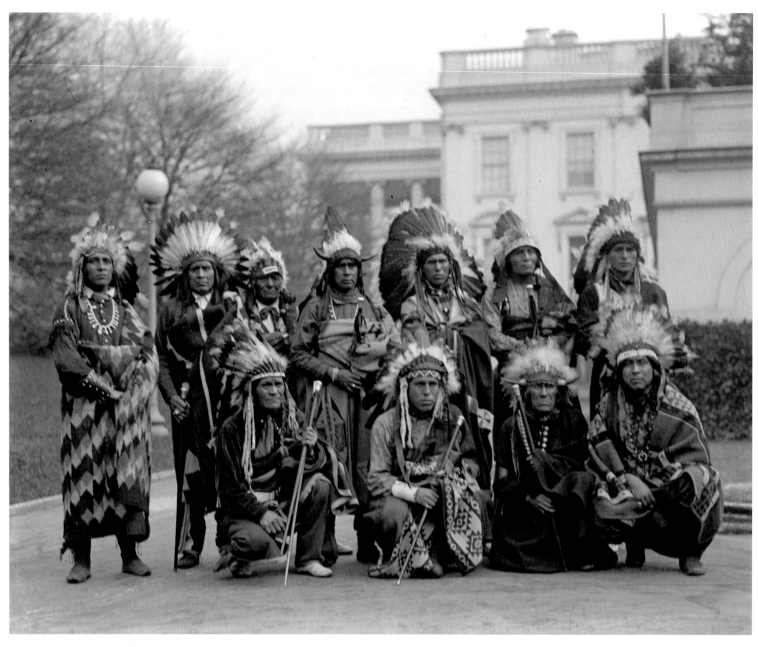

After American Indians fought in World War I, the United States Congress decided to make Native Americans citizens, a right they had not previously received, and thus passed the Indian Citizenship Act on June 2, 1924. This tribal group posed at the White House sometime during the year, perhaps traveling to Washington in response to the passage of the citizenship act.

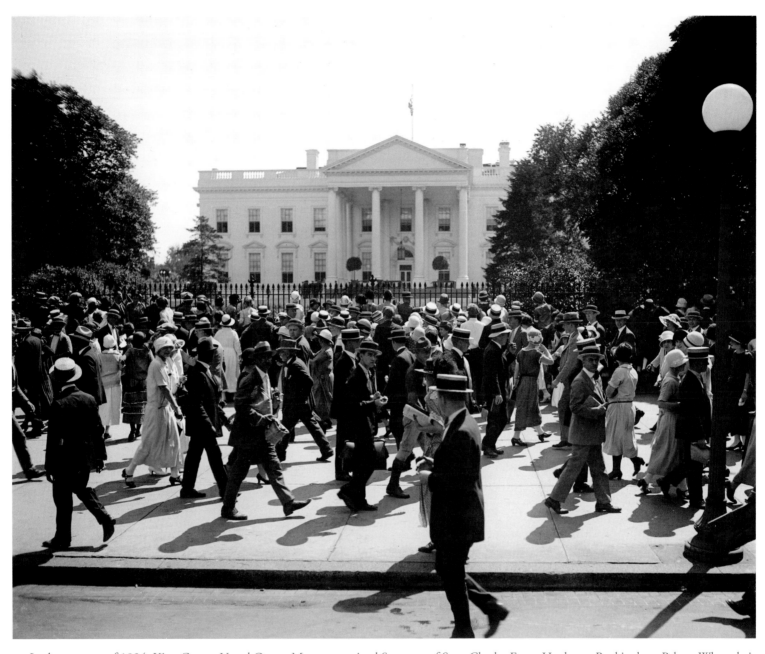

In the summer of 1924, King George V and Queen Mary entertained Secretary of State Charles Evans Hughes at Buckingham Palace. When their son the Prince of Wales visited the United States in August, President and Mrs. Coolidge returned the favor by entertaining the future Edward VIII for luncheon at the White House on the thirtieth. The prince drew crowds to the White House, as seen here, hoping for a glimpse of "the most popular man in the world," the *Washington Post* reported.

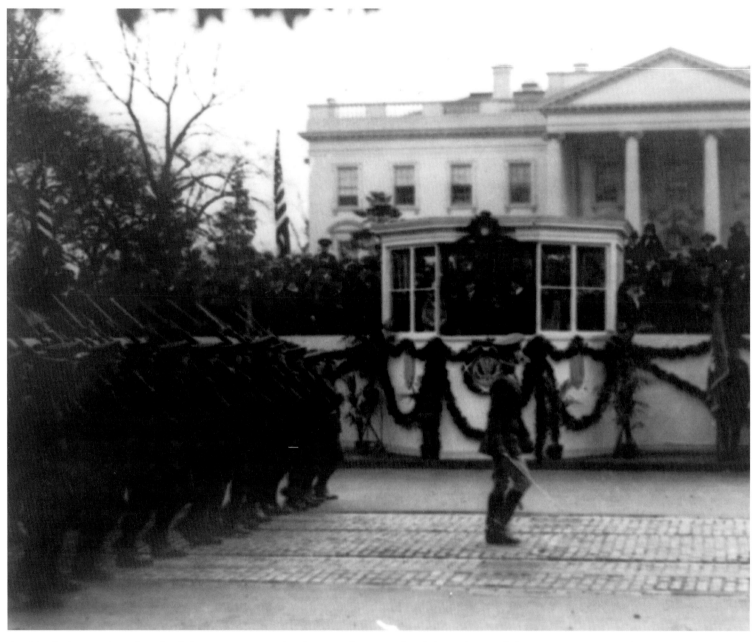

On March 4, 1925, President Coolidge was inaugurated to his second term, and with his wife, son, father, mother-in-law, and the vice president, Charles G. Dawes, he stood in the enclosed reviewing stand, seen here, to watch the inaugural parade. Coolidge maintained his inscrutable expression throughout most of the ceremonies, only once smiling broadly for the cameramen. Reportedly, the military portion of the parade interested Coolidge the most, particularly "the cavalry and the slow-moving tanks."

The date May 21, 1925, was "Tom Mix Day" in Washington, with the cowboy actor appearing first at the White House, as seen here, then as guest of honor at a Mayflower Hotel gala. According to the *Washington Post,* only one guest was absent from the Mayflower gathering: Mix's famous horse, Tony, despite having his own stall roped off in a separate ballroom. To explain the horse's absence, the reporter speculated, "Possibly it was the management of the Mayflower. Probably Tony was indisposed after a hard day's trouping with camera men and kids on his trail."

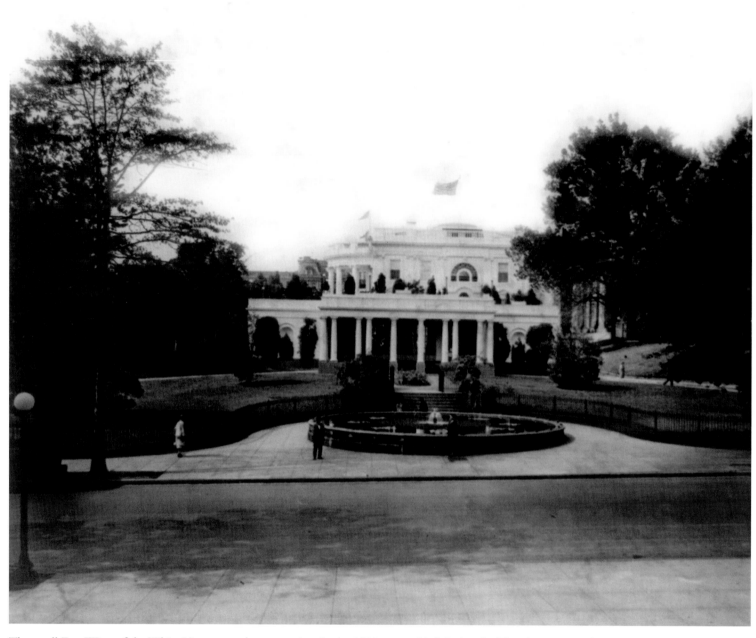

The small East Wing of the White House, seen here sometime in the 1920s, was added during the Theodore Roosevelt renovations in 1902 to provide public and formal access to the building. Prior to 1902 the east side of the White House contained a small colonnade overlooking flanking staircases that descended to the fountain in the middle ground.

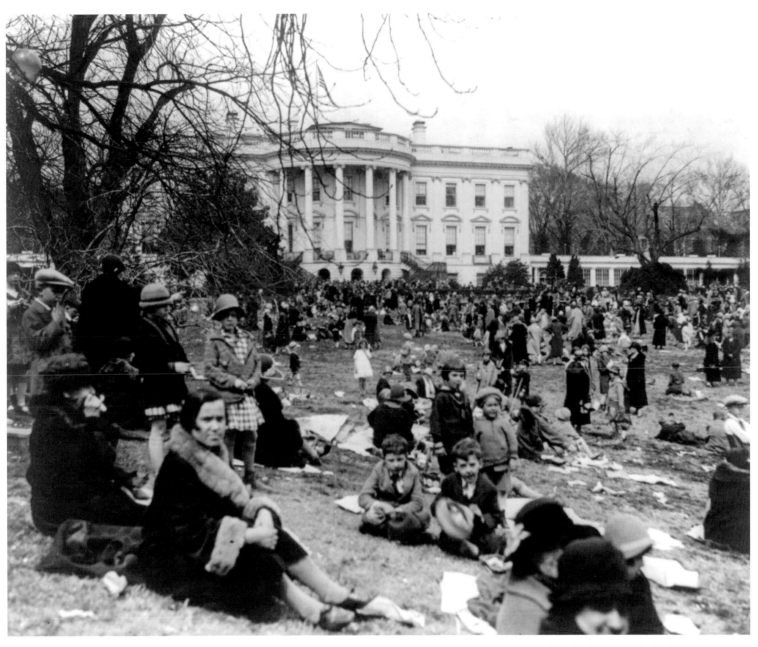

After a long day of egg rolling at the White House on April 5, 1926, many of the attendees seen here look as though they've begun to tire out. The woman in the left foreground seems to have abandoned the idea of keeping her overcoat clean while resting right on the grass. After the day ended, 30 truckloads of broken eggs, paper, and other trash that had accumulated on the grounds were hauled away. The White House florist led a group of 50 men to gather up all of the discards.

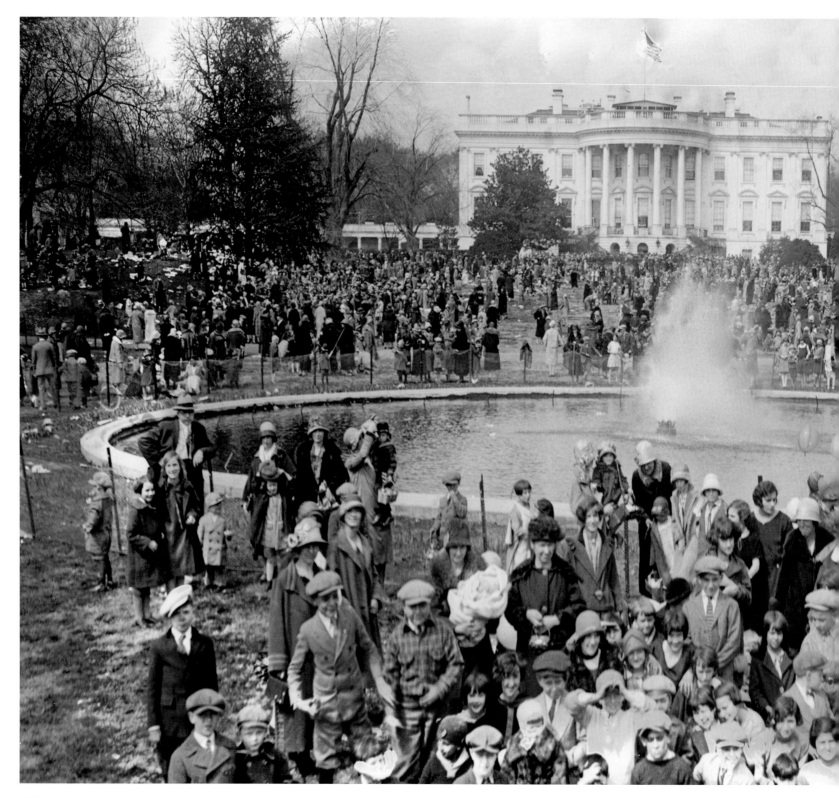

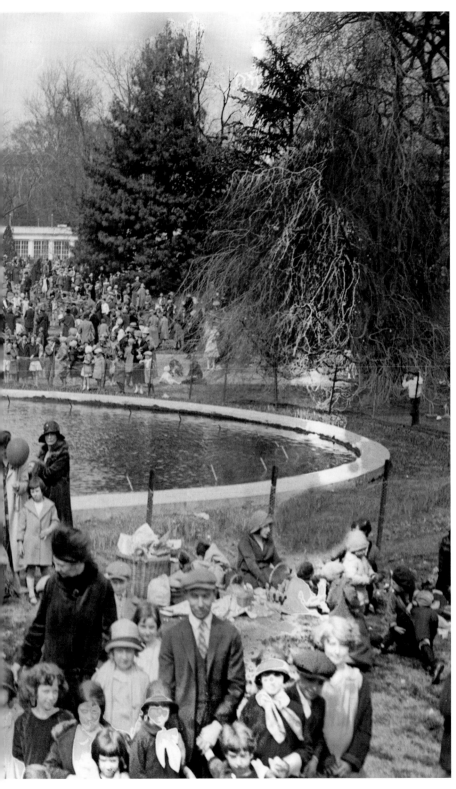

On April 5, 1926, a record-breaking crowd of 48,105 children and adults swarmed the White House grounds for the annual Easter Egg Roll. Many of them were photographed here on the South Lawn. Because adults not accompanied by children could not gain admittance before three o'clock, some enterprising boys would hire themselves out to be "adopted" by such grownups. One boy had earned almost $5 through repeat adoption before a policeman caught on to his scheme. An adult brought a balloon to the gate and claimed that he had stepped out to buy it for his children. He was allowed in, but others who tried the same trick failed.

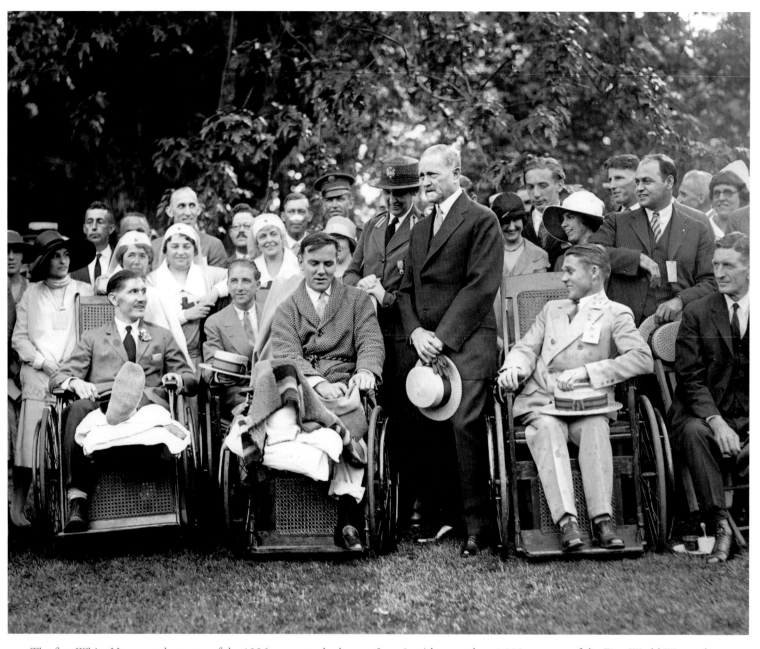

The first White House garden party of the 1926 season took place on June 3, with more than 1,000 veterans of the First World War as the guests of honor. General John J. "Black Jack" Pershing, commander of the American Expeditionary Forces who fought with the other Allies in Europe, is seen here standing amid the men and nurses gathered for the occasion. During the afternoon General Pershing held informal receptions with his doughboys and signed autographs for them.

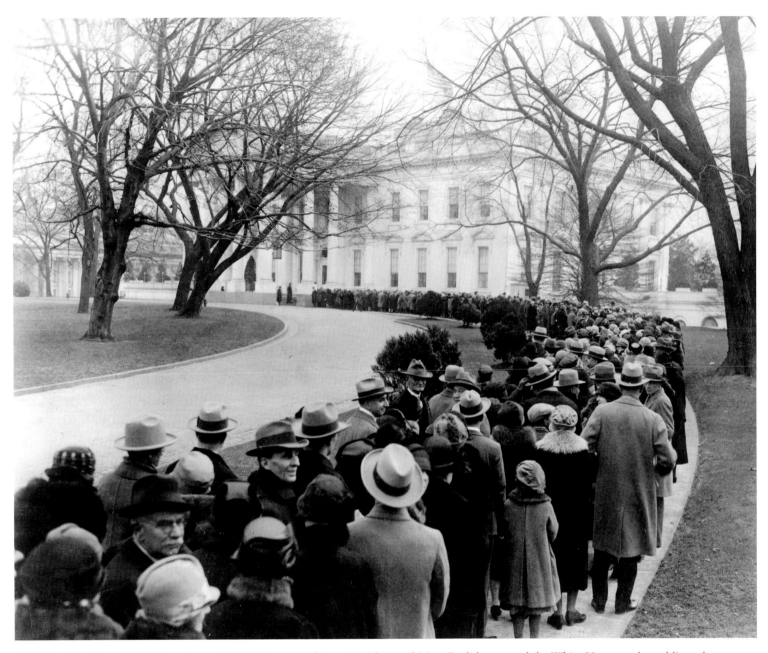

On New Year's Day 1927, in keeping with Washington tradition, President and Mrs. Coolidge opened the White House to the public and entertained 3,307 guests—233 more than in 1926, but 500 fewer than in 1925. The president and First Lady greeted various government figures and dignitaries, then at 1:00 P.M. members of the public seen lined up here began meeting the head of state and his wife. According to the *Washington Post,* the president singled out a two-year-old held by her mother, and welcoming her with "a broad smile," he told her, "I guess you are the smallest that ever came here."

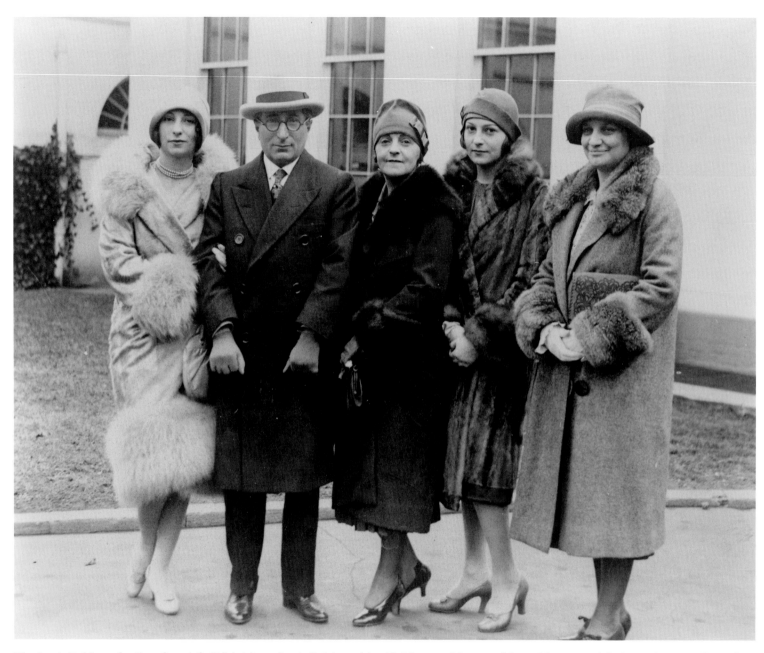

The Louis B. Mayer family—from left: Edith Mayer, Louis B. Mayer, his wife Margaret Mayer, and Irene Mayer—and Assistant Attorney General Mabel Walker Willebrandt were photographed at the White House in February 1927. Mrs. Willebrandt had entertained the Hollywood magnate and his family at the Carlton Hotel on February 1. On December 22, 1925, Mayer's World War I movie *The Big Parade* had been shown to President Coolidge and his wife and son in the East Room at the White House. Guests included cabinet members, congressmen, and MGM representatives, who were entertained by a 23-piece orchestra led by the composer of the incidental music for the movie.

By 1927, several rounds of renovations had taken place at the White House since Theodore Roosevelt's refurbishments in 1902 removed a 30-year accumulation of Victorian decorations and returned the interior to its Federal and Georgian roots. Woodrow Wilson supervised the addition of a painting room and guest rooms in part of the attic in 1917, but the changes proved inadequate. A rainstorm revealed to Calvin Coolidge that the roof was leaking, so in 1927 he had the roof and attic replaced with a third floor supported by steel girders. President Coolidge is seen here on March 15, 1927, watching workers who were removing the old roof.

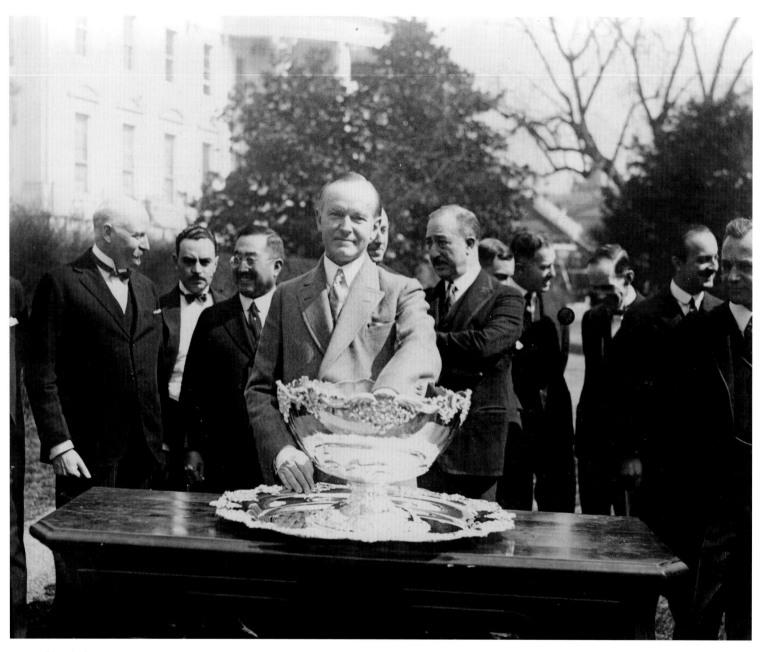

Assisted by diplomatic representatives of the other 24 countries competing, President Coolidge chose the pairings for the Davis Cup, "symbol of international tennis supremacy," on March 17, 1927. The president drew Czechoslovakia's name first, thus pairing it with Greece in the second round in the European zone. America's tennis champions Bill Tilden and William M. Johnston were expected to participate in the singles' matches, but a partner for R. Norris Williams in the doubles had not yet been chosen. His previous partner, Vincent Williams, had been disqualified for turning professional.

FROM HOOVER TO TRUMAN

(1930–1952)

President Herbert Hoover's inauguration on March 4, 1929, took place as clouds gathered literally and figuratively over the White House and the nation. A drizzle that began about noon turned into a downpour. The crowds that gathered to watch the ceremony at the Capitol and line the parade route on Pennsylvania Avenue stood and cheered nonetheless. When the Hoovers left the Capitol and walked to their car to begin the parade, the First Lady, Lou Henry Hoover, ordered the car's convertible top folded back, saying, "If these people can stand in the rain, so can we."

Hoover was a shy man, an engineer by education. When the stock market crash of October 1929 evolved into the Great Depression, the hardworking president was viewed unfairly as cold and uncaring. Faced with an economic collapse unprecedented in American history, Hoover formed commissions and met almost continuously with advisors as he attempted to find solutions. Nothing seemed to work, and Hoover was defeated in his campaign for reelection in 1932.

The new president, Franklin D. Roosevelt, took office on March 4, 1933, and immediately began pushing legislation through Congress that he believed would alleviate the Depression. Some of his New Deal creations, particularly the Civilian Conservation Corps, employed millions of Americans in public works projects. Although conditions improved by late in the 1930s, it was World War II that finally ended the Depression. Millions of men and women served in the armed forces or in factories producing bombers, tanks, and other military necessities.

Harry S. Truman, Roosevelt's vice president, assumed the presidency on April 12, 1945, after Roosevelt died of a cerebral hemorrhage. That day, Truman learned for the first time of the atomic bomb. When he and his wife, Bess Truman, and their daughter, Margaret, moved into the White House, they found it infested with rats and some of the floors about to collapse. Truman caused an uproar when he proposed enlarging the West Wing and an even bigger controversy when he installed a balcony—beloved by subsequent presidents—on the South Portico. In 1948, he had the interior of the White House gutted, key architectural elements numbered and stored, rotting wooden beams replaced with steel ones, and the components reassembled. The task was completed in 1952. Truman moved back in, but only for a few months before leaving office on January 20, 1953.

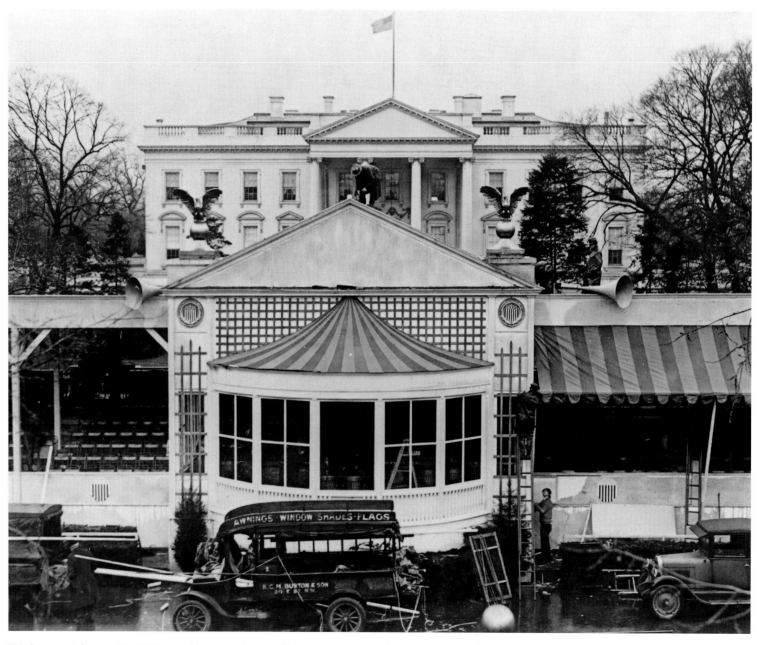

Workers on February 21, 1929, are shown putting the finishing touches on the reviewing stand in the Court of Honor for Herbert Hoover's inaugural parade. Approximately 200,000 people braved a pelting rain on March 4 to watch the parade with the new president. Umbrella vendors, appearing almost as soon as the rain began, did a land-office business with sales from $1 to $10 and "no questions asked."

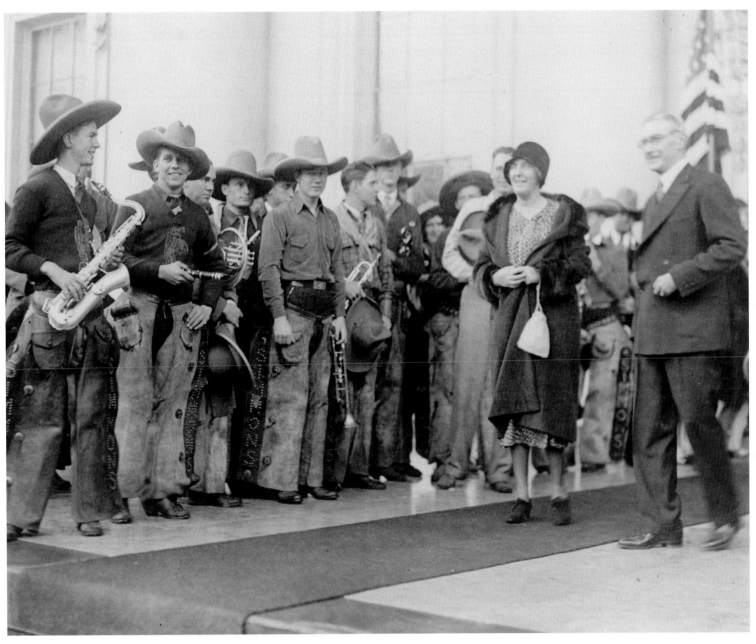

On March 5, 1929, the day after President Herbert Hoover was inaugurated, Lou Hoover greeted the Texas Cowboy Band from Simmons College (now Hardin-Simmons University) in Abilene at the White House. The band played first for Mrs. Hoover and later for the president.

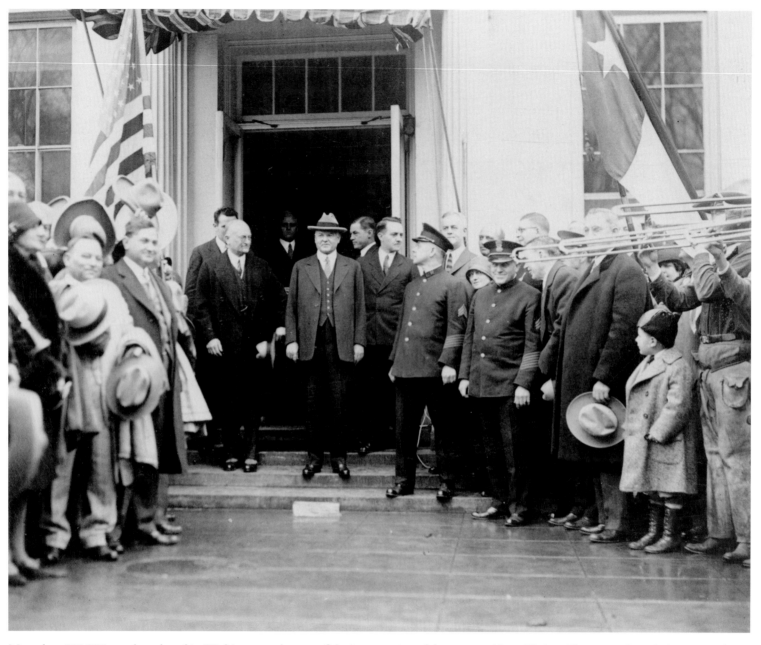

More than 200,000 people gathered in Washington to be part of the inauguration of the new president, Herbert Hoover, on March 4, 1929. A day later, Hoover, seen here in the doorway of the White House, made a number of appearances on the lawn to greet well-wishers from throughout the country.

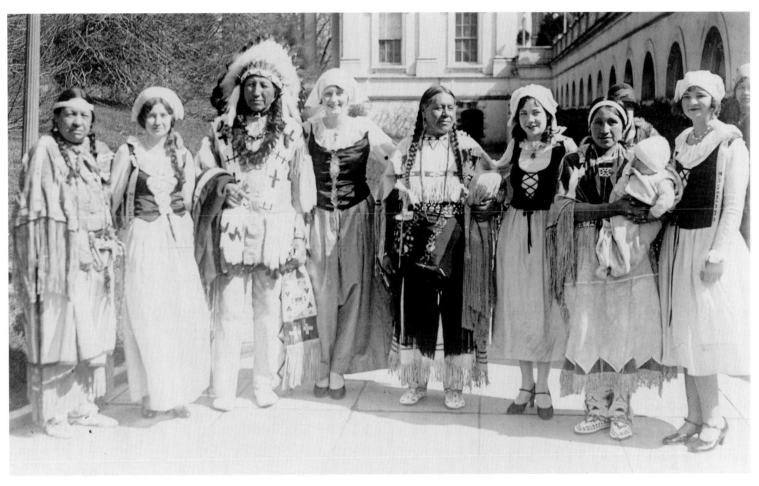

Among those who made the trip to Washington for Hoover's inauguration were descendants of the original Americans and of the early French settlers: members of the Sioux Nation from South Dakota and the Evangeline Girls from Louisiana. Chief Spotted Crow of the Sioux is third from the left in this photograph taken on March 5, 1929. The Evangeline Girls represented the Acadians, French settlers driven out of Nova Scotia by the British in 1755. Some made their way to Louisiana, where "Acadian" became "Cajun." In 1847 Henry Wadsworth Longfellow published his *Evangeline: A Tale of Acadie,* a narrative poem that told the fictional story of Evangeline, who wandered for years searching for her lost love after being driven out of Acadia.

The first flowers of spring at the White House appear in this image of the magnolias blooming on March 23, 1929, with the South Portico visible in the background. The White House magnolias were planted in the 1830s by Andrew Jackson. It is said that he planted them in memory of his wife, Rachel Donelson Jackson, who died on December 22, 1828, before Jackson could be inaugurated as president.

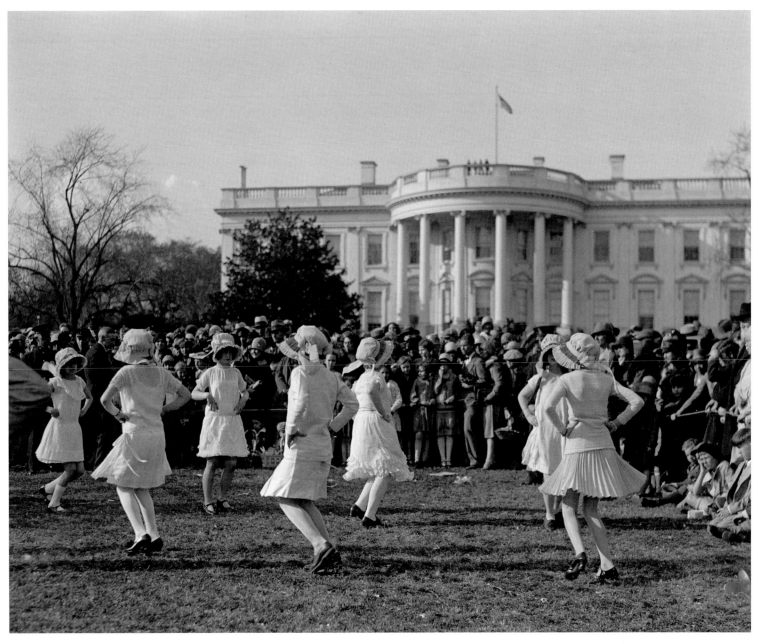

Lou Henry Hoover had been involved in the Girl Scout movement since 1917, when Juliette Gordon Low personally recruited her. She then served on the board or as an officer for the rest of her life. For the April 1929 Easter Egg Roll at the White House, Mrs. Hoover introduced a new innovation to the tradition by inviting a group of Girl Scouts to perform a May Pole dance, seen here, for the entertainment.

Wood for the 28 fireplaces at the White House is being unloaded here on April 8, 1929. Originally heated by fireplaces, the White House had seen a number of innovations to the heating system over the years. Thomas Jefferson affixed coal-burning fixtures to the fireplaces after he arrived in 1801. Martin Van Buren installed a huge new furnace in 1837 and hired a live-in fireman to manage the boilers to supplement the fireplaces in 1840. When Charles McKim renovated the White House in 1902, he removed a monstrous boiler that extended out into a hallway. By 1929 the wood was being neatly delivered thorough a grate into the basement storage room.

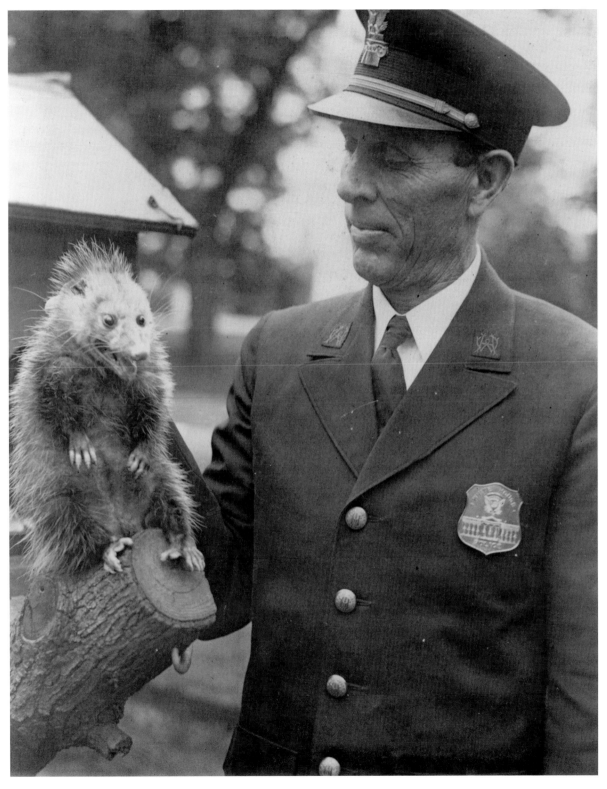

Officer Bertram E. Snodgrass of the White House police force is shown holding Billy Opossum on May 6, 1929. Billy had recently wandered onto the White House grounds and immediately became a family pet. Soon thereafter Billy became a mascot for Hyattsville High School in Prince George's County, Maryland, and led the school to victory in the soccer, basketball, track, and baseball championships. Writing a note to accompany Billy's return to the White House in June 1929, the managers of the school's athletic association told the president how much the school appreciated "the value of this little animal as a purveyor of good fortune."

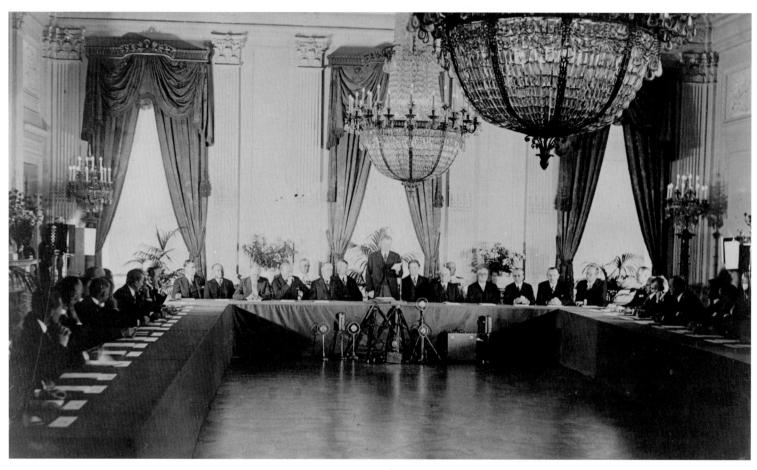

On August 27, 1928, the Kellogg-Briand Pact to outlaw war was signed by 15 nations, including Germany. On July 24, 1929, the day that Japan also agreed to the pact, the formal proclamation of the Treaty for the Renunciation of War took place in the East Room of the White House with President Hoover and almost all of the foreign chiefs of mission in Washington in attendance. Hoover is seen here delivering an address to the diplomats, announcing that "the High Contracting Parties solemnly declare in the names of their respective peoples that they condemn recourse to war for the solution of international controversies, and renounce it, as an instrument of national policy in their relations with one another."

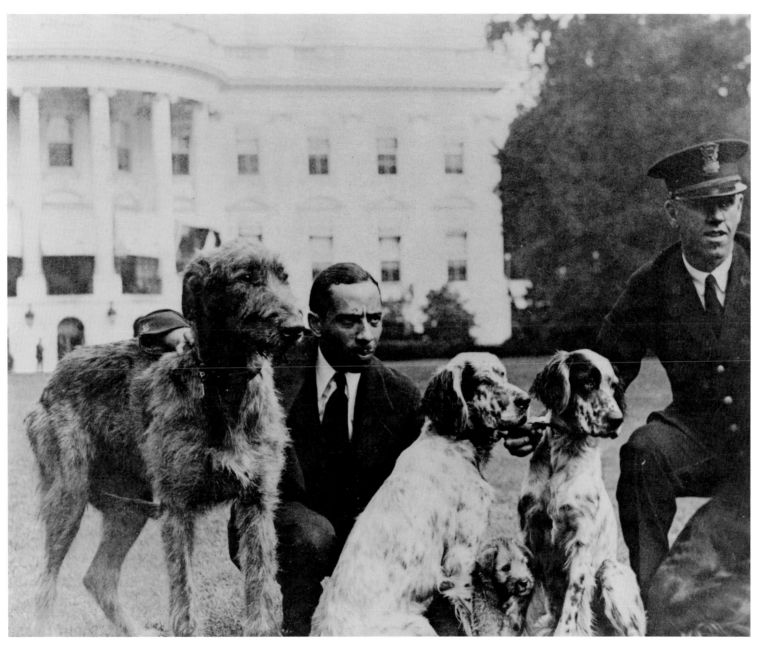

President Hoover and his family owned at least nine dogs while they lived at the White House: two police dogs (King Tut and Pat), two fox terriers (Big Ben and Sonnie), a Scotch collie (Glen), an Eskimo dog (Yukon), a wolfhound (Patrick), a Setter (Eaglehurst Gillette), and an elkhound (Weejie). Seen here on September 23, 1929, are Harry Waters with P. E. Allen of the White House police force and five members of the menagerie, including Patrick, the wolfhound, standing at left.

On Christmas Eve 1929, a fire broke out in the president's executive offices while the Hoovers were entertaining guests in the White House. While the president oversaw efforts to save the papers from his office, the Marine Band continued to play for the guests and Mrs. Hoover. The *Washington Post* reported that the "peculiar construction of the windows made it extremely difficult to reach the core of the fire. But for the extraordinary efforts of the firemen the White House itself might easily have become ignited." It took the firemen two hours to subdue the blaze. Their ladders can be seen here resting against the West Wing of the White House.

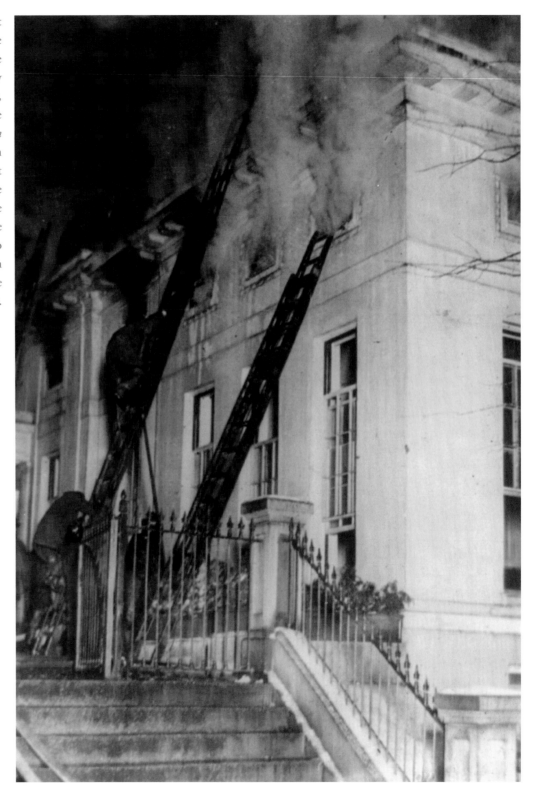

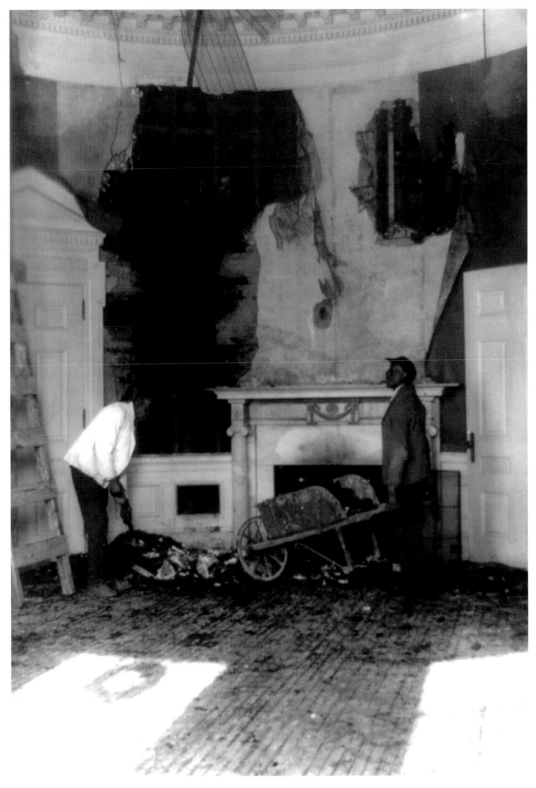

Here, the day after Christmas 1929, workmen in the Oval Office use a wheelbarrow to remove debris left from the Christmas Eve fire. At first it was thought that improper wiring caused the conflagration. But a March 1930 report from the National Fire Prevention Association, published in the *Washington Post,* said the fire originated in a partition on the first floor and was caused by a wood stud's having been set too close to the president's fireplace. The report noted that the fireplace construction was "decidedly faulty." A fire had burned in the fireplace all day, and after the stud ignited and smoldered for several hours, spreading in the partition, it burned through to the attic above and the blaze broke out.

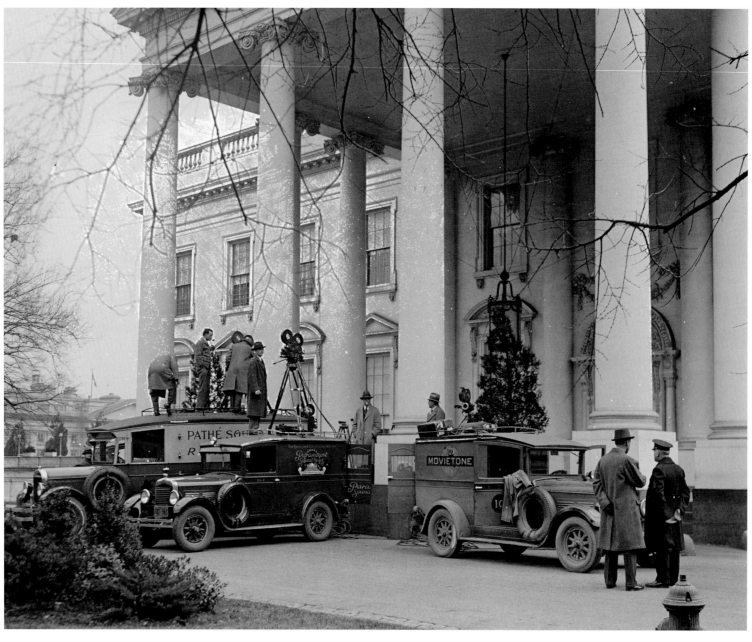

Sound movie trucks from Pathé, Paramount, and Fox Movietone News are seen here at the north entrance to the White House on December 26, 1929. The cameramen were undoubtedly covering the Christmas Eve fire's aftermath for their newsreel viewers. Pathé was begun in 1895, Paramount and Movietone News in 1927.

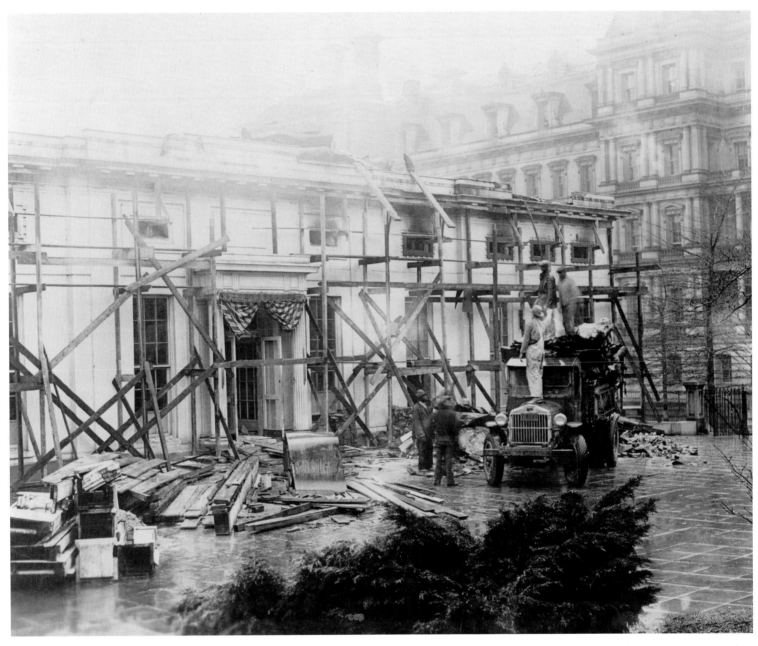

Repair on the president's and his staff's offices and the roof to the West Wing was well underway when this picture was taken on January 15, 1930. Although others wanted the president to have a completely new office building, Hoover overrode them and opted for repairs to the current spaces. By December 26, 1929, two bids for the repairs had already arrived at the White House. The contract for the repairs was given soon after January 3, 1930, to the C. H. Tompkins Company, of Washington, for its low bid of $74,880.

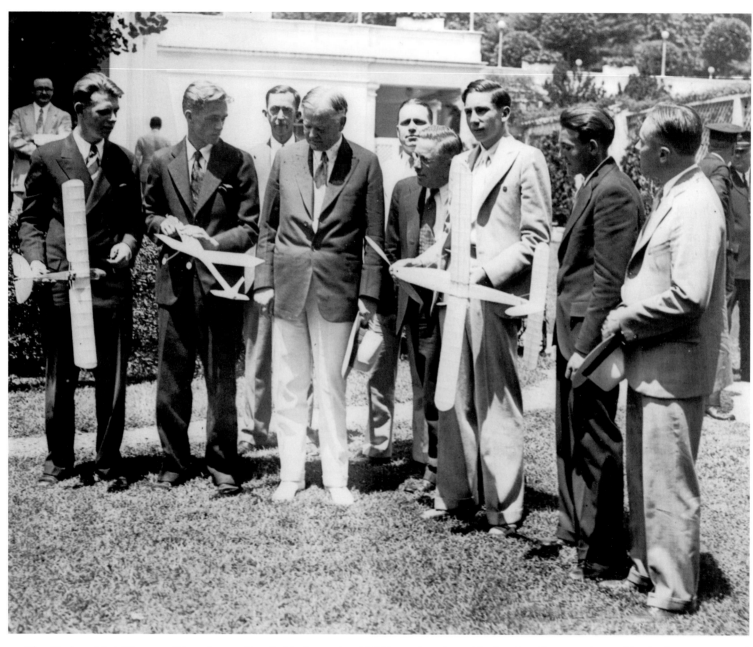

The Airplane Model League of America was founded in September 1927 in conjunction with *American Boy* magazine and in the first year attained a membership of almost 200,000 boys. On April 2, 1928, the first national winners of the National Model Airplane Championship met President Coolidge at the White House. On July 8, 1931, President Hoover met with the winners of that year's contest, which was held at Wright Field in Dayton, Ohio. Seen here at the White House with the president and their winning model airplanes are, left to right, Joseph Ehrhardt of St. Louis, George Lamb of Oakland, Emanuel Feinberg of Detroit, and Steve Klazura of Chicago.

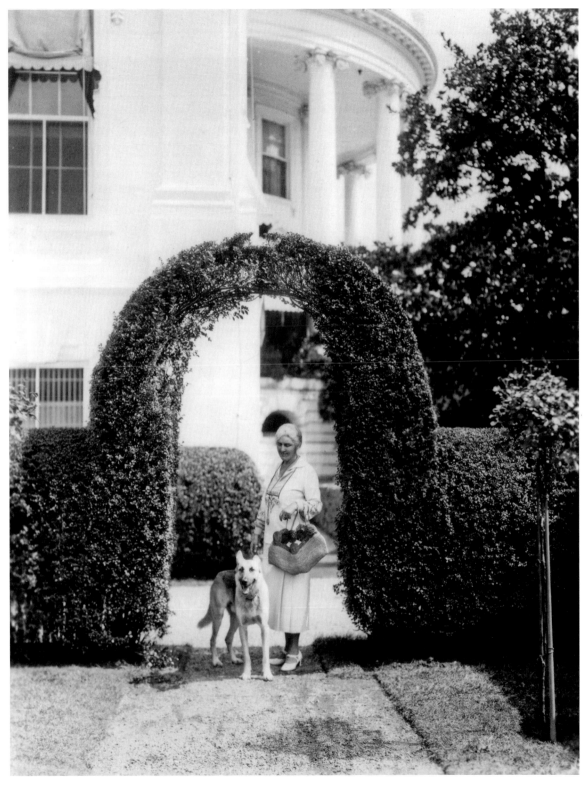

Lou Henry Hoover was photographed with her German shepherd, Buckeye, standing under an arch of a hedge next to the White House sometime during President Hoover's administration.

This photograph of the George Washington University archers with the White House in the background was made in 1931 by Underwood and Underwood of New York and other locales. Bert and Elmer Underwood had started the business in Ottawa, Canada, in 1880 as stereopticon photographers and moved the business to New York in 1891. After 1920, the firm left stereopticons and concentrated on news photographs, which the company had begun in 1904 and would virtually dominate for another thirty years.

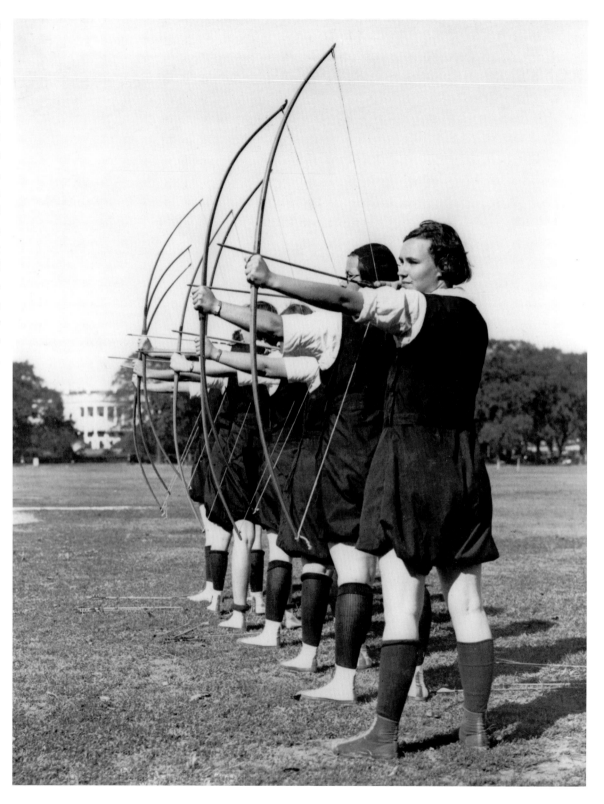

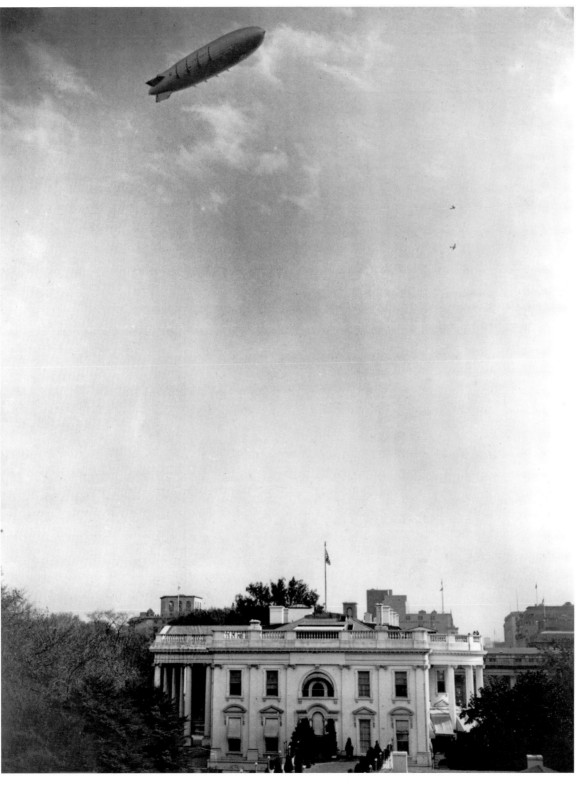

The White House and all of Washington received their first glimpse of the newest and largest naval airship, the *Akron,* when it floated over the city on November 2, 1931, seen here. Larger than New York's Woolworth Building, the *Akron* cost $5.3 million and made the voyage to Washington and back to its air dock at Lakehurst, New Jersey, in 10 hours. As the dirigible flew over Annapolis, Maryland, en route to Washington, it received a 13-gun salute from the United States Naval Academy. President and Mrs. Hoover stood on the White House lawn and watched the *Akron* and its sister ship the *Los Angeles* maneuver over the capital for 20 minutes.

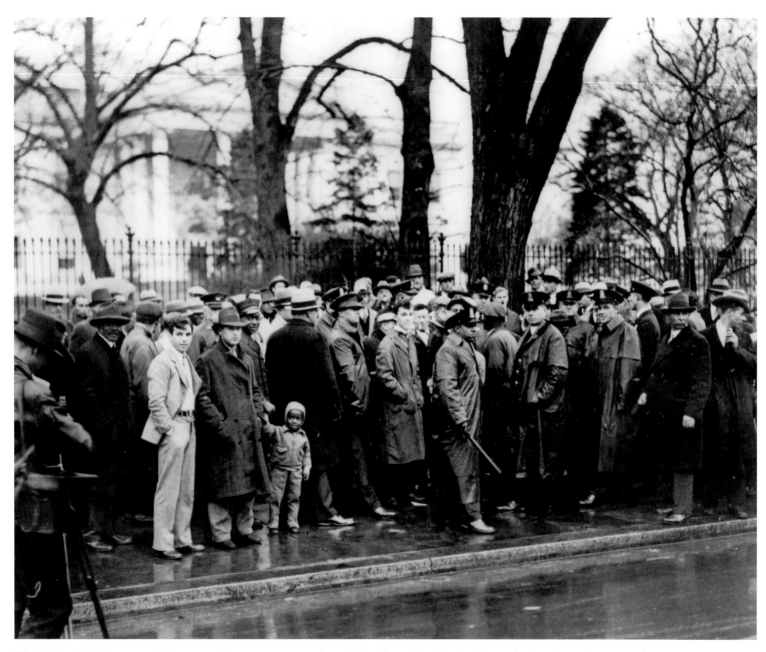

The Workers' Ex-Servicemen's League, a Communist veterans' association located in New York, marched on the White House beginning on October 30, 1931, asking for unemployment insurance and the full payment of the 1924 bonus that Congress had appropriated for returning World War I veterans that was to be redeemed in 1945. These Communist pickets were photographed on November 7, 1931, "kidding" the police in front of the White House. The full contingent of the largely noncommunist Bonus Army, as the petitioning veterans came to be known, did not arrive in Washington until May 1932. When Congress refused to pay the $1,000 bonus early, and the men in turn refused to disperse, Hoover sent General Douglas MacArthur and United States Army troops to disperse them by force.

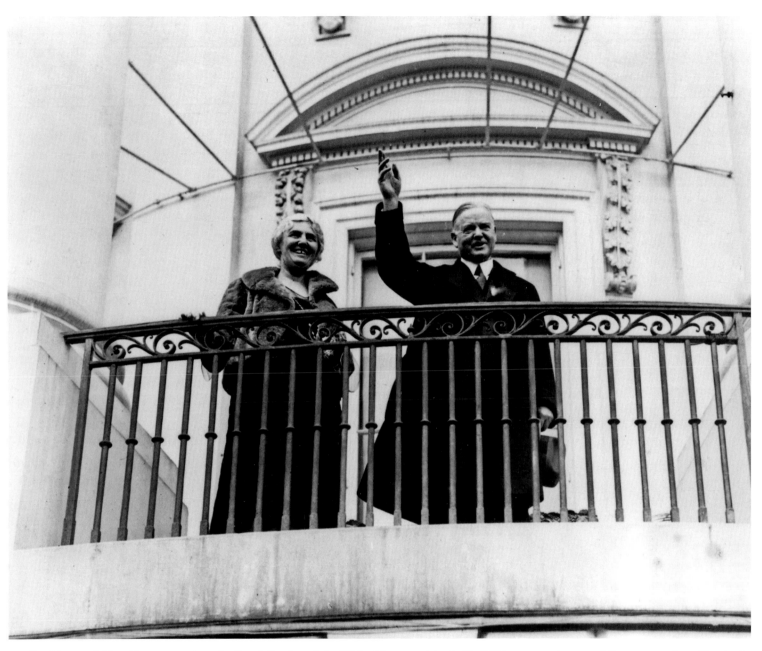

President and Mrs. Hoover stand on the South Portico of the White House on March 28, 1932, to greet the annual Easter egg rollers. Despite its being a soggy day with a stiff breeze, an estimated 11,000 hearty souls, mostly children, participated in the festivities. Mrs. Hoover roamed the crowd, handing out colored Easter eggs from a basket. The rubber Easter egg made its first appearance, and in the spirit of an unusual day, one little boy brought his live rabbit in a cardboard box. The rabbit, of course, escaped, but finding the elements so miserable rushed back to its "nest."

Governor and Mrs. Franklin D. Roosevelt, who had been attending a governors' conference in Richmond, Virginia, are seen here at the White House on April 28, 1932, to attend a dinner as the guests of President Hoover. Roosevelt, who had contracted polio in 1921, could not walk unassisted, but is shown here with his cane as though he could. As one of the Democratic candidates for the presidency, Roosevelt met with Hoover during his visit to Washington and discussed the world's dangerous economic situation in the face of the Great Depression.

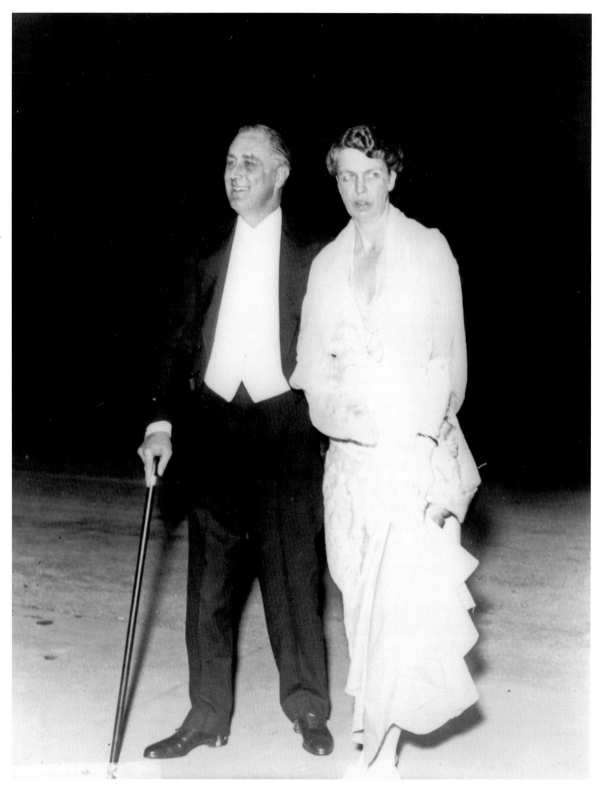

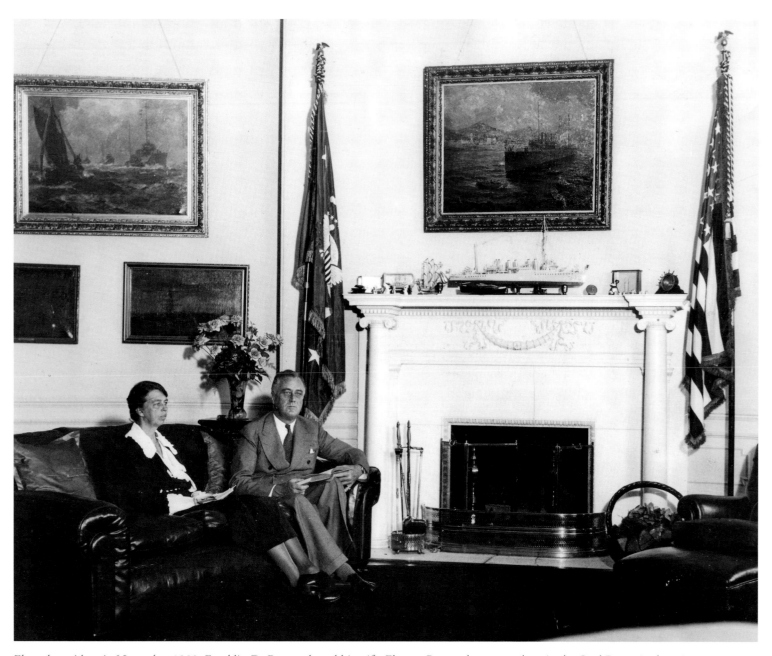

Elected president in November 1932, Franklin D. Roosevelt and his wife, Eleanor Roosevelt, are seen here in the Oval Room in the private second-floor quarters of the White House in 1933, relaxing with their reading. Naval paintings and ship models adorning the wall and mantelpiece attest to the new president's great interest in all things naval. He had served as assistant secretary of the navy under President Woodrow Wilson from 1913 to 1920. President Roosevelt used the room as his study during his administration.

The north front of the White House, the "president's front yard," is seen here about 1934, giving a very overgrown appearance. The fountain is just visible in the middle ground. President Roosevelt hired Frederick Law Olmsted, Jr., later in 1934 to assess the situation and design a landscape that would give the family privacy from the street while allowing the public a view of the house. Olmsted's design showed the landscape much as it is today. He retained as many of the original plantings and trees as possible while clearing a vista with trees along the sides to give ample sight lines of the house from the north and the south exposures.

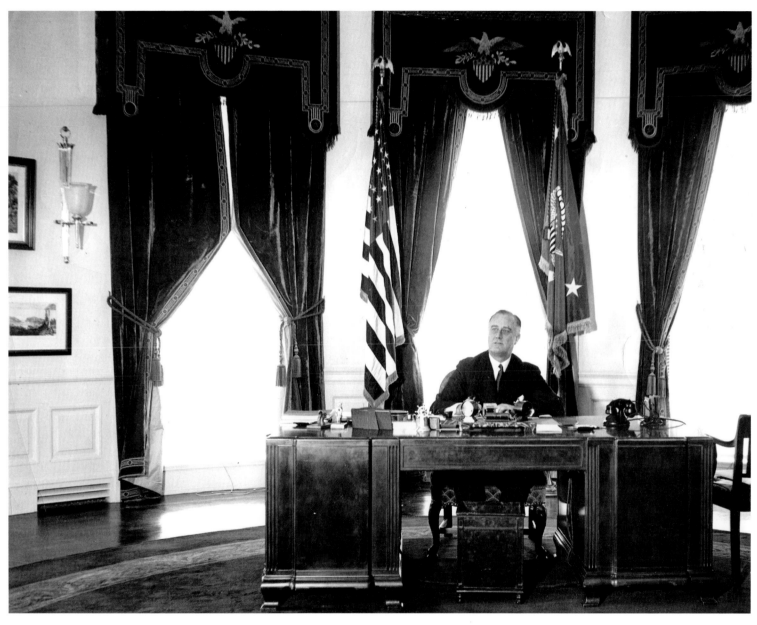

President Roosevelt was photographed in the new Oval Office in 1935. After the West Wing burned in 1929, the original Oval Office was gutted along with most of the rest of the building. Hoover rebuilt it to the same design, but in 1933 Franklin Roosevelt decided to renovate and expand the West Wing further to accommodate more staff members. He moved the Oval Office to the southeastern corner in place of the laundry-drying yard. The new location had better light and provided easier travel back and forth to the residence. Since its completion in 1934, the modern Oval Office has changed very little except in its furnishings. Most presidents have commissioned a new rug and drapes, but two presidents chose not to change the decor: Eisenhower and Carter. Kennedy's new decor was just being installed the day he was assassinated.

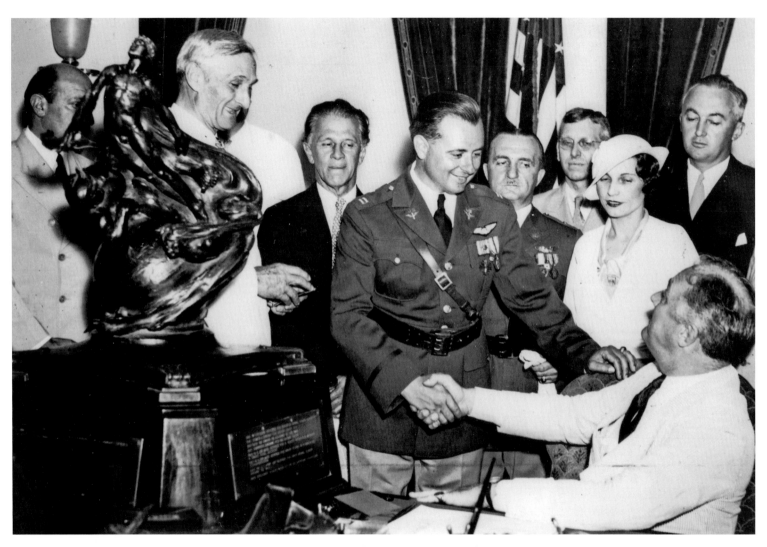

President Roosevelt, seated, is seen here shaking hands with Captain Albert F. Hegenberger of the United States Army Air Corps, to whom he was presenting the Collier Air Trophy at the White House on July 22, 1935. Senator William Gibbs McAdoo, president of the National Aeronautic Association, read the citation on the trophy to Captain Hegenberger, who received it for his "work in perfecting radio landing equipment." Hegenberger had used the equipment to make the first blind landing three years earlier. Others photographed with the award-winner and the president are Assistant Postmaster General Harllee Branch, who was in charge of airmail, and Brigadier General Oscar Westover, Major James Doolittle, and Colonel Edgar S. Gorrell, all members of the Bureau of Air Commerce.

Democratic senators Tom Connally and Key Pittman are seen here leaving the White House on September 22, 1939, after a conference with 18 other Democratic senators and President Roosevelt. They were discussing a proposed measure for lifting the Arms Embargo Act, thereby allowing the United States to send material to its allies overseas. On September 1, 1939, Adolf Hitler's Wehrmacht and Luftwaffe had invaded Poland, thus precipitating World War II. As an ally of Poland and Great Britain, Roosevelt believed it was of paramount importance for the United States to support its allies, especially Britain, despite a strong insistence on isolationism among much of the Congress and the public.

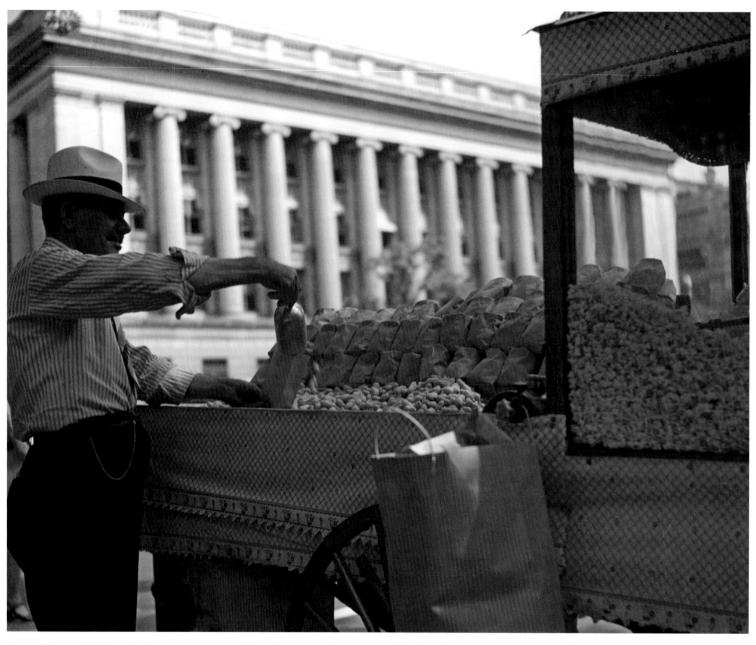

One of Roosevelt's New Deal programs was the Farm Security Administration (FSA), which sent photographers all across the United States to record scenes of daily life. Edwin Rosskam, who captured this image of a peanut and popcorn vendor outside the White House in 1940, was one of the photographers.

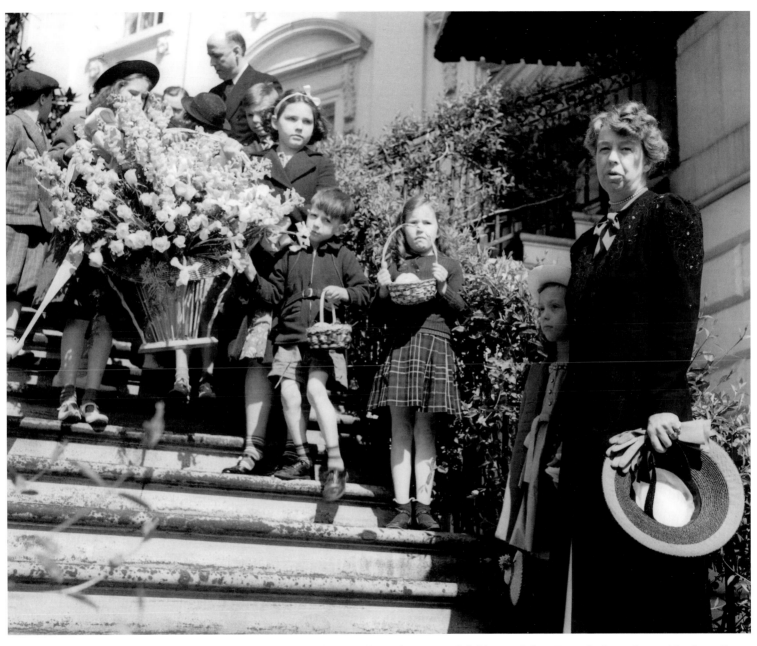

Eleanor Roosevelt is seen here on Easter Monday, March 25, 1940, with a group of children and their Easter baskets, along with a large flower arrangement. More than 30,000 egg rollers and escorts braved a freezing cold and left the White House gardeners plenty of egg whites and yolks to clean up. As in previous years, enterprising youth hired themselves out as escorts for adults otherwise not allowed in because they were not accompanying children. One youngster offered to get the president's press secretary, Stephen T. Early, through the gates for 10¢. The "hardest luck of the day," however, went to a young lady from Alexandria who was hit on the nose by a thrown Easter egg.

Stephen Early, the press secretary, is seen here briefing President Roosevelt on January 18, 1941. Late in December the president had given a fireside speech describing the United States as the "arsenal of democracy." The Lend-Lease bill for supplying Great Britain with ships and other "defense articles, defense services, and defense information" was being debated in Congress. At the time, England was fighting alone in Europe for survival against Nazi Germany, and suffering through both the Blitzkrieg and U-boat attacks on its merchant and naval fleets, and needed all the help it could get from the United States. Determining that aiding Britain was vital to America's interests, Congress passed the Lend-Lease Act on March 11, 1941.

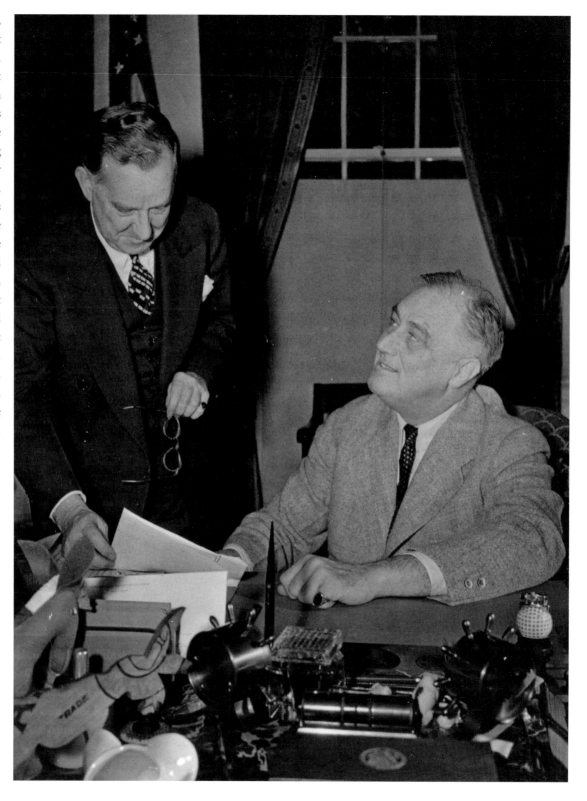

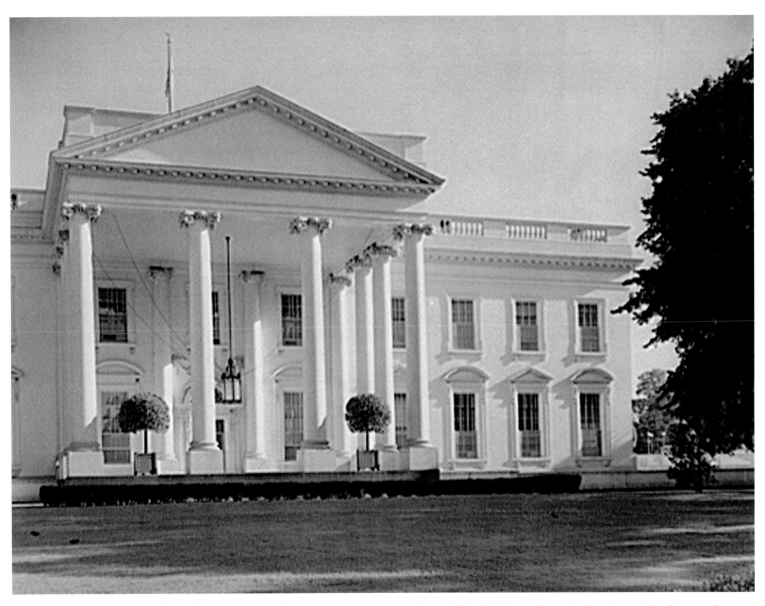

As war drew ever closer, the White House in June 1941 presented a brave face to the world. Jack Delano (born Ovcharov), an FSA photographer who was born near Kiev, Russia, in 1914 and had come to the United States in 1923, captured this image of the North Portico. Although the FSA had begun its work emphasizing rural life and the negative impact of the Great Depression, farm mechanization, and the Dust Bowl, by the time of World War II, the photographers had turned their attention to the mobilization effort for the war.

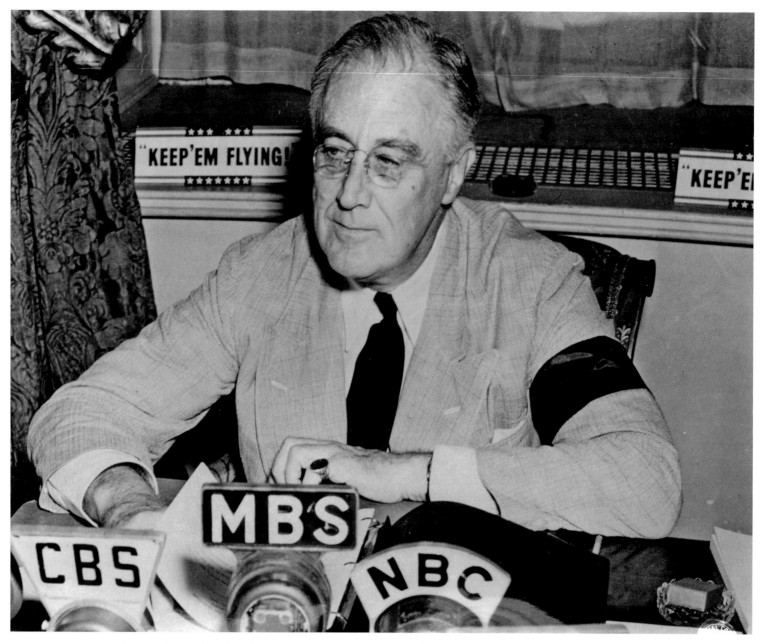

President Roosevelt is seen here addressing the nation over the radio on September 11, 1941. The United States had just suffered yet another loss of a naval vessel to German U-boats, which were trying to obtain supremacy over the Atlantic Ocean. In reviewing the continuous loss of merchant and naval shipping to the Nazis, Roosevelt told his listeners, "It is time for all Americans, Americans of all the Americas to stop being deluded by the romantic notion that the Americas can go on living happily and peacefully in a Nazi-dominated world." Roosevelt assured his listeners and the world that the United States would not sit idly by and let its naval and merchant ships be destroyed, stating, "From now on, if German or Italian vessels of war enter the waters, the protection of which is necessary for American defense, they do so at their own peril."

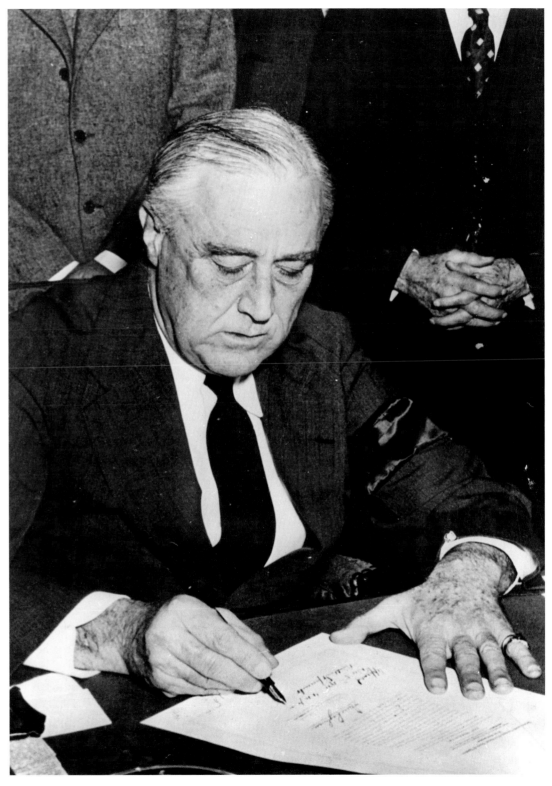

On December 7, 1941, "a date which will live in infamy," the Imperial Japanese Navy attacked the United States naval base at Pearl Harbor, Hawaii, nearly destroying the United States fleet there. On December 8, after his address to Congress asking for a declaration of war against the Imperial Government of Japan, President Roosevelt is seen here signing the Senate and House of Representatives' joint resolution declaring war.

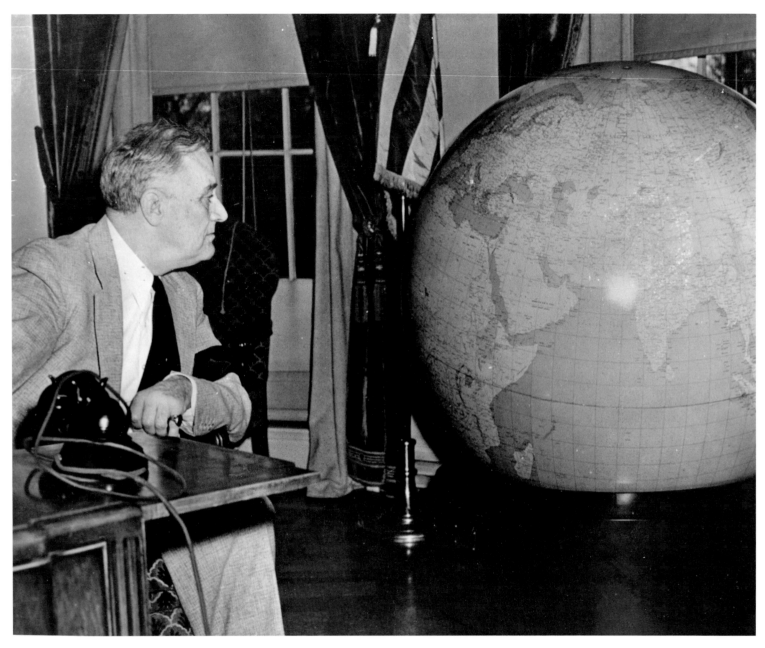

President Roosevelt is shown here in 1942 in the Oval Office looking at a globe of the world and contemplating North Africa, where the first strike against Germany was to be made. The invasion of North Africa was planned to relieve pressure on the Russians, to gain French Morocco, Algeria, and Tunisia as a base for enlisting the French colonial empire in the war, to assist the British in destroying Axis forces threatening Egypt and Suez, to open the Mediterranean to Allied shipping, to shorten the route to the Far East, and to prepare the way for further operations against the European Axis. Called Operation Torch, the action began on October 23, 1942, when the British attacked General Erwin Rommel's Afrika Korps at El Alamein. Rommel's forces retreated on November 6, 1942, and the American forces invaded North Africa on November 8.

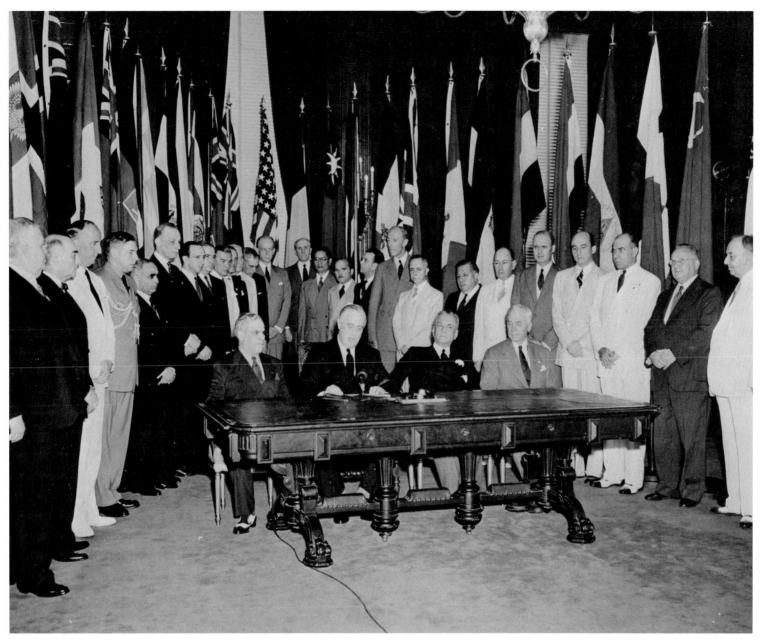

On Flag Day, June 14, 1942, President Roosevelt met with representatives of 26 of the 28 nations that had joined together as a United Nations. Roosevelt had coined the term on January 1, 1942, in a "Declaration of United Nations." Seated, from left to right, are Dr. Francisco Castillo Najera, ambassador of Mexico; President Roosevelt; Manuel Quezon, president of the Philippine Islands; and Secretary of State Cordell Hull. In his Flag Day address, Roosevelt stated, "Today on Flag Day we celebrate the declaration of the United Nations—that great alliance dedicated to the defeat of our foes and to the establishment of a true peace based on the freedom of man. Today the Republic of Mexico and the Commonwealth of the Philippine Islands join us. We welcome these valiant peoples to the company of those who fight for freedom."

Seen here in the summer of 1942 is an amateur baseball game on the South Lawn at the White House. The man with his back to the camera is playing in the outfield. The picture was taken by Marjory Collins, another of the FSA's photographers.

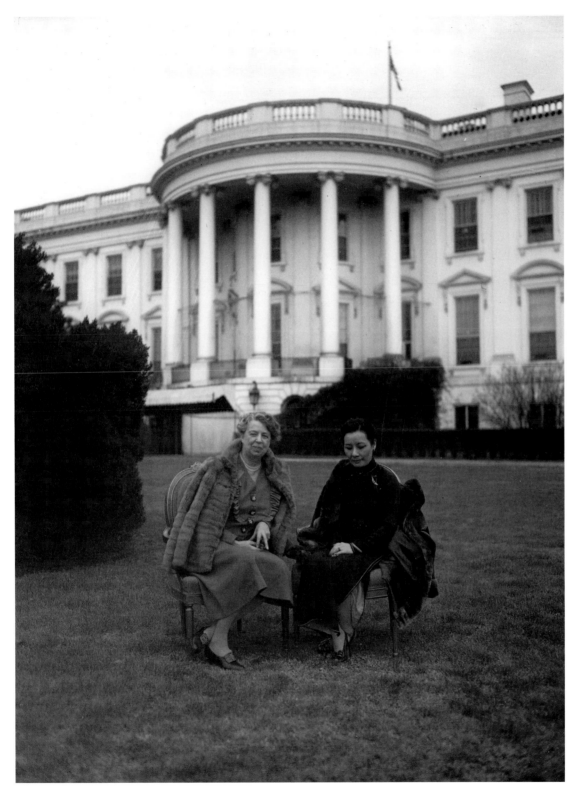

Seated on the lawn at the White House on February 24, 1943, are Madame Chiang Kai-shek and Mrs. Roosevelt. Madame Chiang was visiting Washington as "an honor guest" at Mrs. Roosevelt's weekly press conference. During her remarks, Madame Chiang noted that the United States could most aid China by providing matériel, especially ammunition, since President Roosevelt had declared the United States "the arsenal of democracy." During World War II, Chiang Kai-shek's Nationalist government and Mao Zedong's rebel Communists fought separate battles against the occupying Japanese. Until 1941 the Nationalists received some equipment from the Soviet Union. The Americans sent some troops, pilots, and supplies to the Nationalists from India over the rugged Burma Road until it was cut by the advancing Japanese army in 1942. Thereafter until 1945, Allied military aid to China had to be flown over the Himalaya Mountains from India.

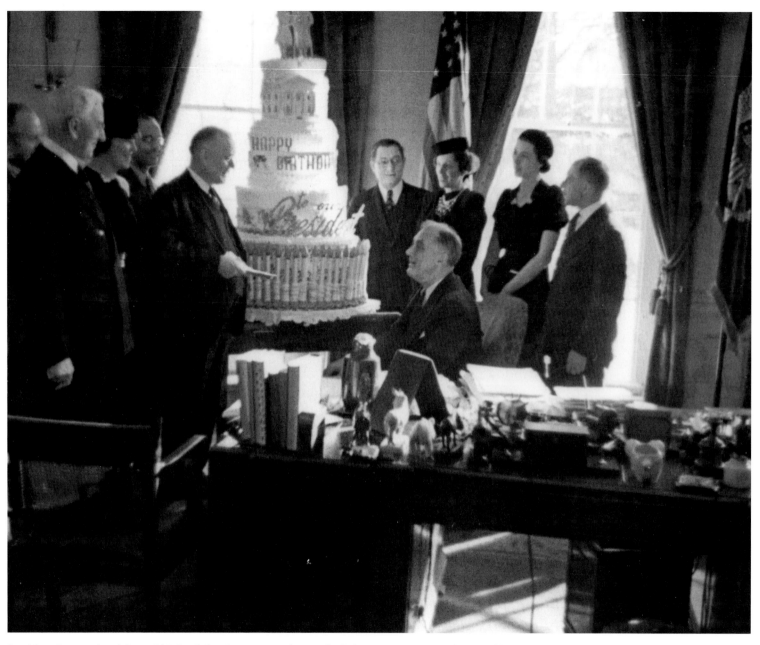

President Roosevelt celebrated his birthday, January 30, during the White House years with several large parties each year that included Hollywood stars to raise money for infantile paralysis (polio) research. This photograph may have been taken for his fifty-ninth birthday on January 30, 1941. The president is seen here at his desk with his birthday cake and surrounded by his staff. The *Washington Post* reported that for 1941's celebration, "Washington gave Franklin D. Roosevelt a gay and glamorous birthday festival last night, and before a glittering delegation from Hollywood, 41,000 of its citizens poured a golden stream of hope into lives darkened by disease."

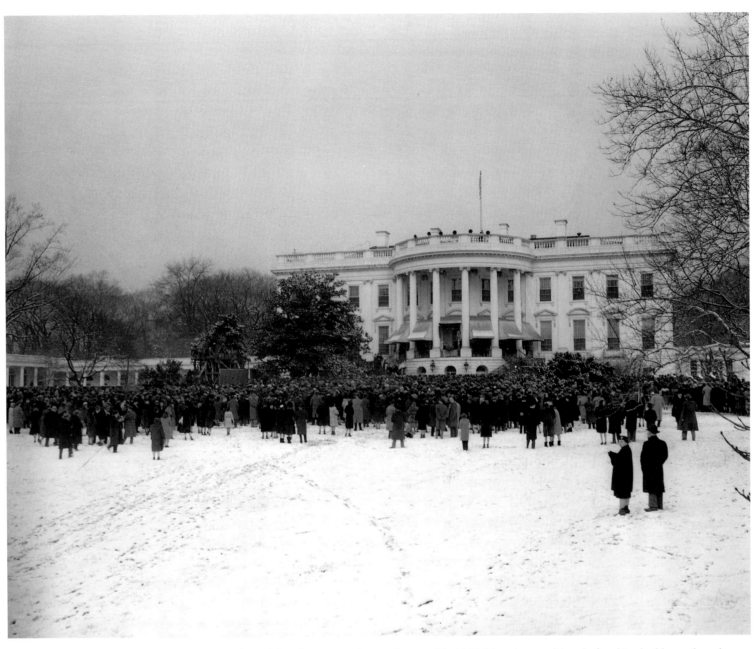

Franklin D. Roosevelt celebrated an unprecedented fourth inauguration on January 20, 1945. No other president before him had been elected more than twice to the office. Since that time the Twenty-second Amendment to the Constitution, ratified on February 26, 1951, has limited a president to two terms in office. By January 1945, it had become clear that the war in Europe was being won, and the United States was island-hopping toward Japan as well. Roosevelt, however, was in extremely bad health with high blood pressure and atherosclerosis and had only four months to live.

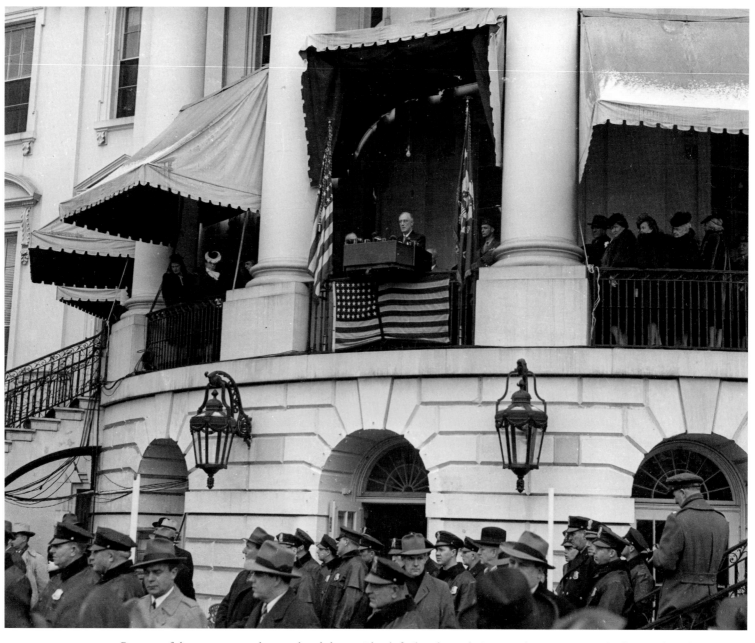

Because of the snow-covered ground and the president's frailty, the 1945 inaugural ceremonies took place at the White House. President Roosevelt delivered a short address on the South Portico and went back into the house, where he almost collapsed into his wheelchair, suffering with chest pains.

Word spread rapidly across the country that President Franklin D. Roosevelt had died suddenly at his retreat in Warm Springs, Georgia, on April 12, 1945. In Washington, crowds gathered in front of the White House, and stunned citizens wondered what would happen next. Many of them had known no other president and could not imagine anyone else's hand steering the ship of state. Victory in World War II grew closer every day; it seemed grossly unfair that Roosevelt had not lived to see the end.

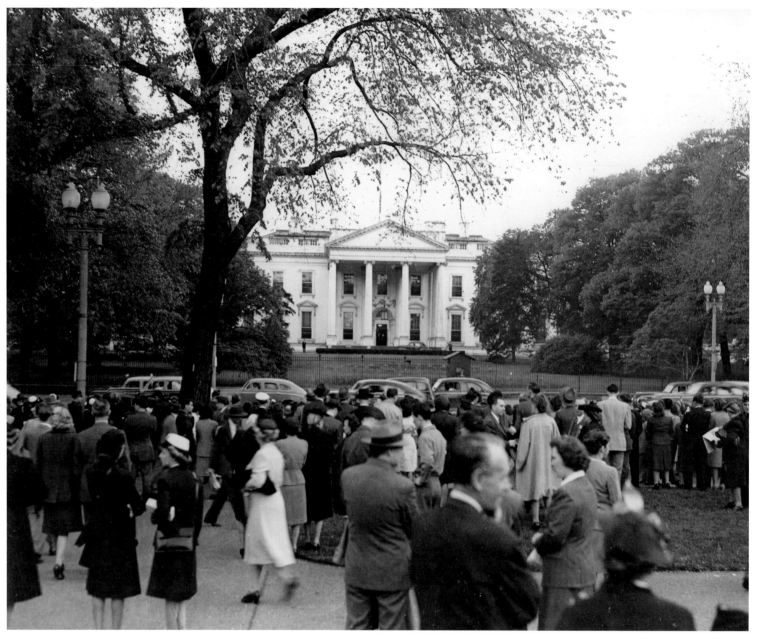

At about the time Harry S. Truman took the oath of office as president at 7:09 P.M. on April 12, 1945, people in the crowd in Lafayette Park expressed their shock and disbelief over Roosevelt's death to each other. To many of them, Truman was a little-known Missouri senator, a virtual nonentity, and they could not imagine him filling Roosevelt's shoes.

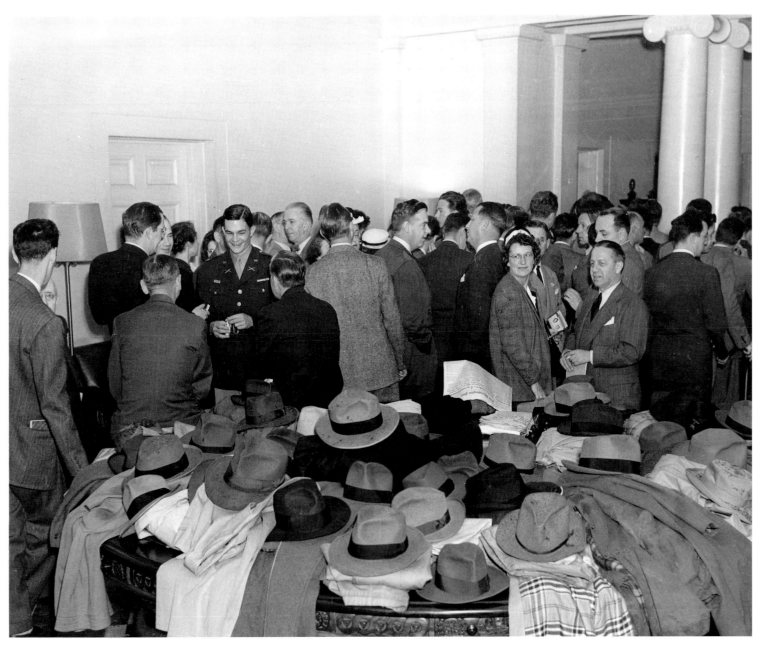

On May 8, 1945, less than a month after the death of President Franklin D. Roosevelt, World War II came to an end in Europe with Germany's unconditional surrender. Celebrations broke out all over the United States, perhaps most famously in New York's Times Square. Here, at the White House, newsmen and other visitors piled their coats and hats on a table as they gathered for the official announcement by President Harry S. Truman.

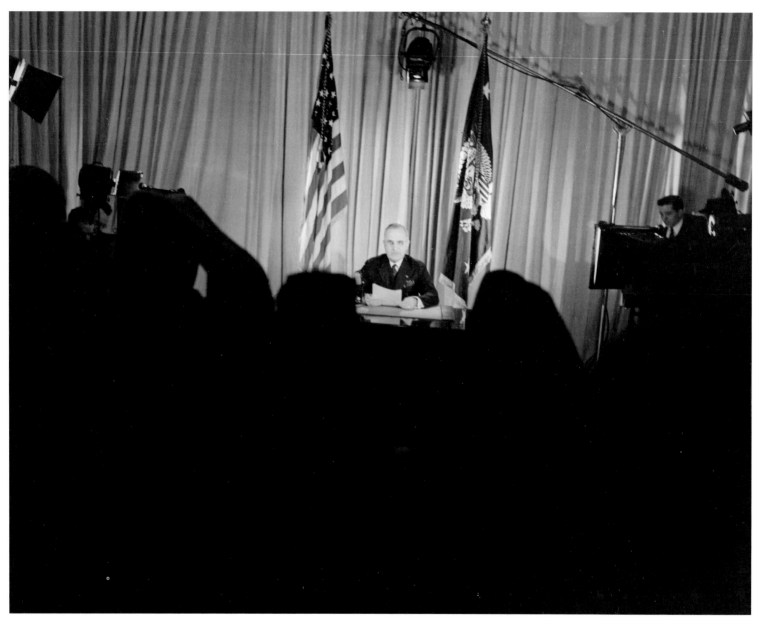

This photograph, taken May 8, 1945, inside the Radio Room of the White House, shows President Harry S. Truman announcing the victory over Germany. Truman began by saying, "This is a solemn but a glorious hour. I only wish that Franklin D. Roosevelt had lived to witness this day. General Eisenhower informs me that the forces of Germany have surrendered to the United Nations. The flags of freedom fly over all Europe. For this victory, we join in offering our thanks to the Providence which has guided and sustained us through the dark days of adversity." He went on to remind Americans that the war in the Pacific had yet to be won, and he proclaimed Sunday, May 13, to be a national day of prayer and thanksgiving.

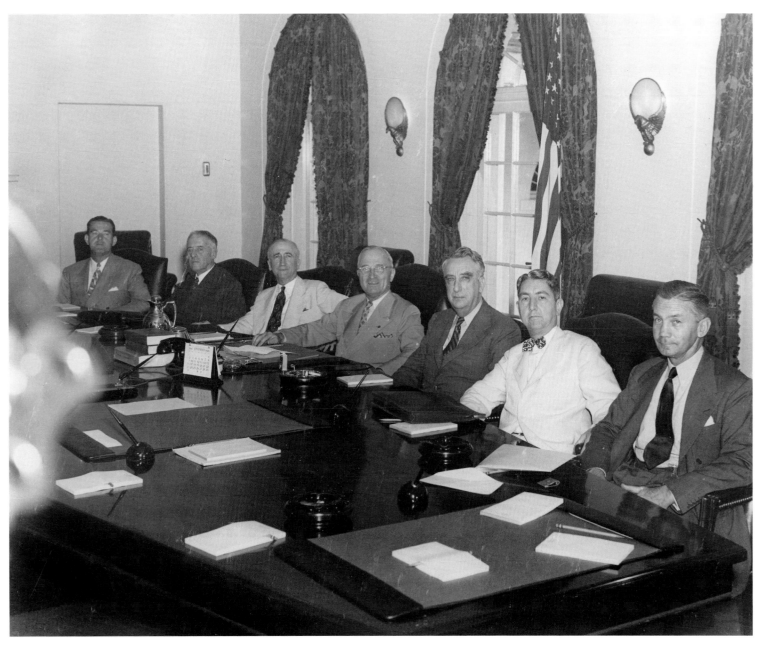

The most controversial decision that President Harry S. Truman made was to drop the newly developed atomic bomb on Japan. Truman was convinced that it would end the war in the Pacific and save American lives. At the time, some military analysts predicted up to a million American casualties if the planned invasion of the main Japanese islands was carried out. The first bomb was dropped on August 6, obliterating the city of Hiroshima. When the Allies' demand for surrender went unanswered, the second bomb was dropped on Nagasaki on August 9. This image shows Truman and his cabinet meeting in the West Wing the next day, August 10, as they awaited word on whether Japan would at last surrender.

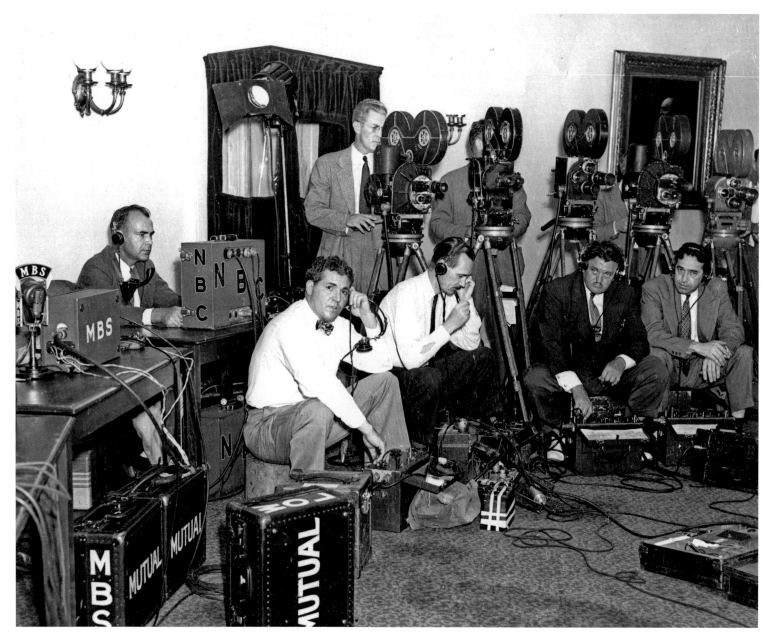

President Harry S. Truman announced the surrender of Japan and the end of World War II from the Oval Office on August 14, 1945. Newsreel cameramen and sound technicians set up their equipment in the room beforehand, as this image shows.

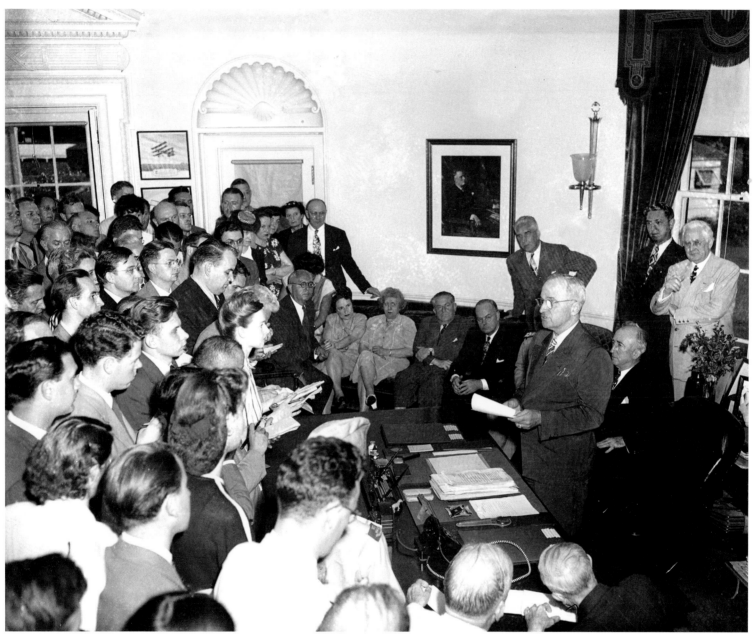

The news that America had been waiting to hear through almost four years of bloody war came at last on August 14, 1945. President Truman read a statement to the press assembled in the Oval Office. He began, "I have received this afternoon a message from the Japanese Government in reply to the message forwarded to that Government by the Secretary of State on August 11. I deem this reply a full acceptance of the Potsdam Declaration which specifies the unconditional surrender of Japan. In the reply there is no qualification. Arrangements are now being made for the signing of the surrender terms at the earliest possible moment." World War II was over.

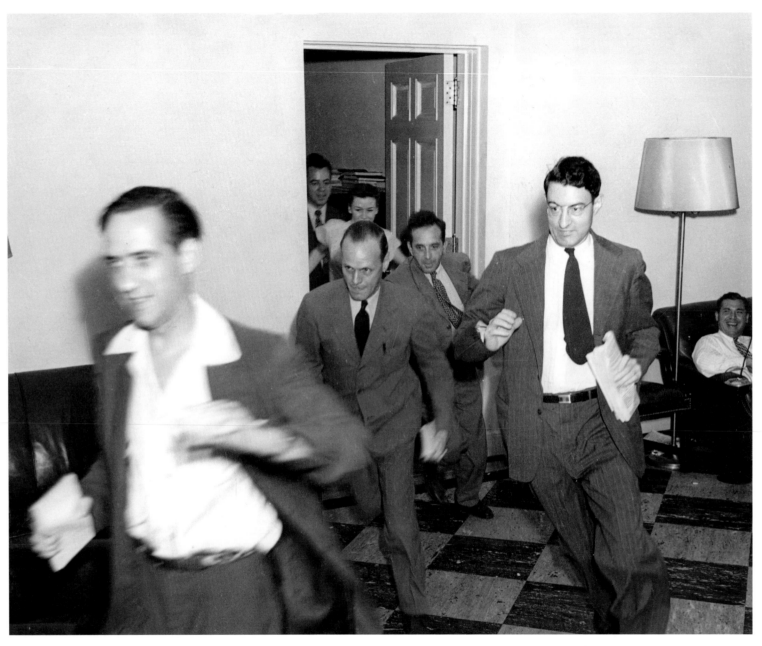

Members of the White House press corps rushed through the West Wing after President Truman's announcement of the Japanese surrender and the end of World War II on August 14, 1945. They were scrambling to pick up copies of the official White House news release and get to their telephones to call their editors.

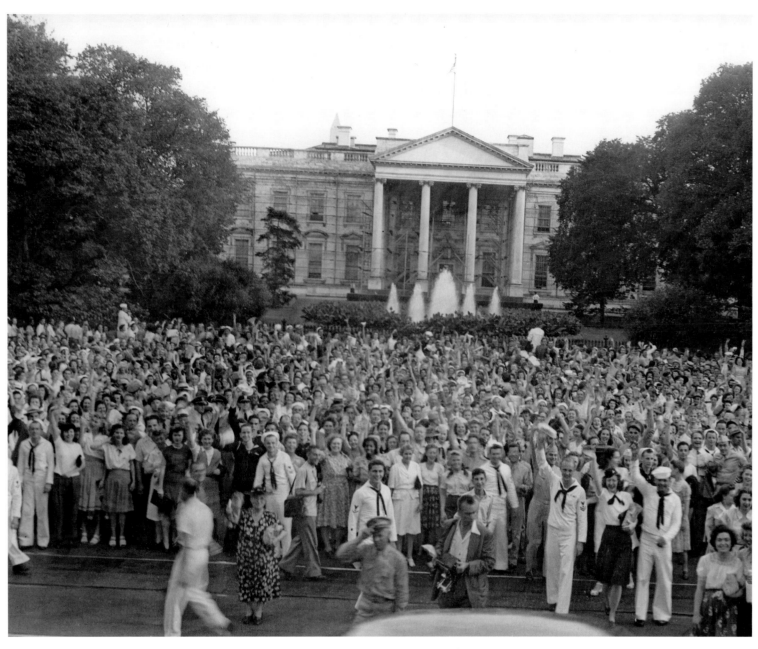

After news of the end of World War II reached the public, huge crowds filled the streets of Washington, especially on Pennsylvania Avenue in front of the White House. Soldiers, sailors, and civilians jubilantly celebrated into the night.

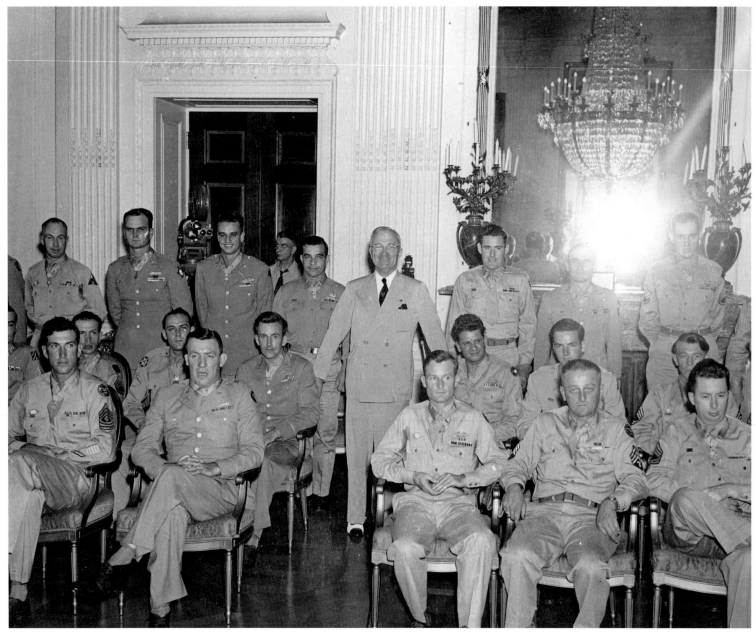

On August 23, 1945, President Harry S. Truman decorated 28 recipients of the Medal of Honor in a ceremony held in the East Room of the White House. Truman, who had fought in France in World War I, greatly admired servicemen and relished such ceremonies. He said it was his favorite presidential duty. Frequently, he would tell recipients of the Medal of Honor, "I would rather have this medal myself than be president."

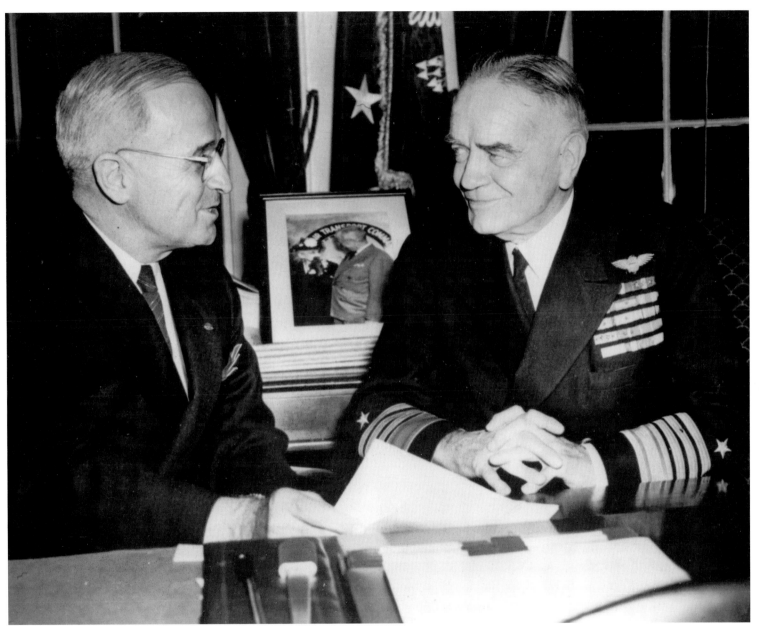

President Harry S. Truman met with Admiral William F. Halsey when the naval commander returned to the East Coast from the Pacific. The meeting took place in the Oval Office about 4:00 P.M. on Friday, October 19, 1945. Halsey's flag was flying on USS *Missouri* on September 2 in Tokyo Bay when the formal Japanese surrender was signed on board.

During World War II, austerity programs and military necessity required that electricity be conserved. The traditional lighting of the National Community Christmas Tree on the White House grounds was suspended in 1941 for the duration of the war. On December 24, 1945, however, the tree was lit once more. This image shows part of the crowd that assembled for the concert that preceded the lighting ceremony.

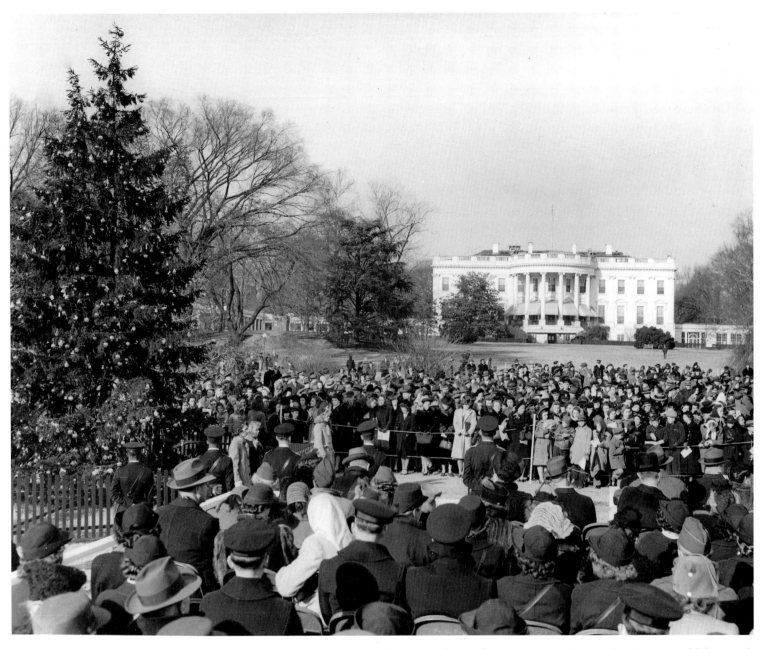

On December 24, 1945, the National Community Christmas Tree was illuminated for the first time since 1941. President Truman told the crowd, "This is the Christmas that a war-weary world has prayed for through long and awful years. With peace come joy and gladness. The gloom of the war years fades as once more we light the National Community Christmas Tree. We meet in the spirit of the first Christmas, when the midnight choir sang the hymn of joy: 'Glory to God in the highest, and on earth peace, good will toward men.'"

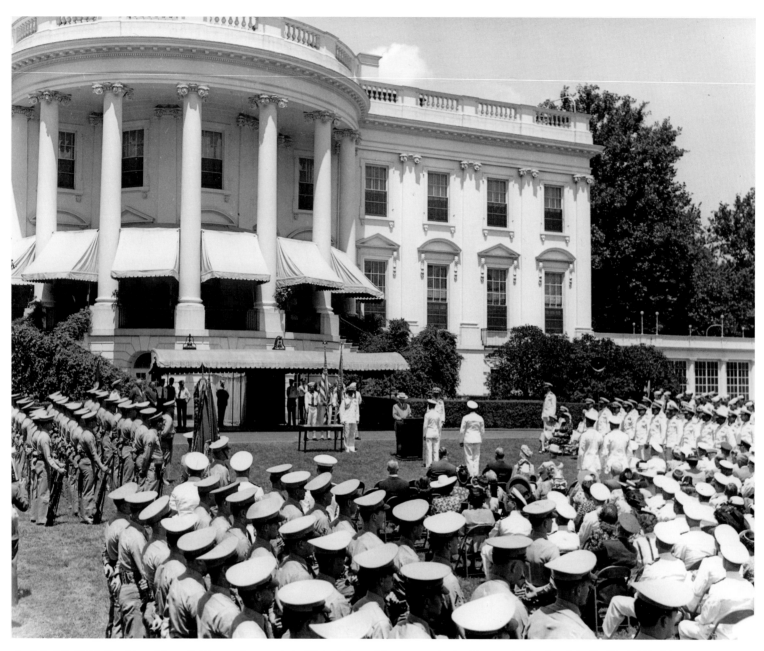

On July 16, 1946, President Harry S. Truman honored the United States Navy men who had borne the battle of the Pacific in World War II. He awarded Presidential Unit Citations to the crewmen of eight aircraft carriers: *Belleau Wood, Bunker Hill, Cabot, Essex, Hornet, Lexington, San Jacinto,* and *Yorktown.* In his address, Truman said, "It is a very great pleasure to me to have had the privilege of presenting citations to these aircraft carriers. They made remarkable records. When you read those records, you read the history of the war in the Pacific. . . . It is a great pleasure to me to have this privilege today of showing just what the country thinks about the contributions which these men have made to the victory we have just won."

Visiting Washington on October 3, 1949, to open a Library of Congress exhibition on the subject of comics, a group of America's leading comic-strip artists called on President Truman at the White House and presented him with sketches they drew of him on the spot. Among the artists were Milton Caniff (*Steve Canyon*), George Wunder (*Terry and the Pirates,* which he had taken over from Caniff), Ham Fisher (*Joe Palooka*), Ken Ernst (*Mary Worth*), Bill Holman (*Smokey Stover*), Lank Leonard (*Mickey Finn*), Ed Reed (*Off the Record*), and Allen Saunders (*Steve Roper*). Cartoonists had been accused of corrupting youth, and anti-cartoon groups wanted cartoon strips and comic books banned. One congressman, however, instead had a patriotically themed excerpt from *Terry and the Pirates* read into the *Congressional Record.*

President Truman is shown here speaking to a group of foreign journalists in the White House Rose Garden on May 3, 1951. At the time, Truman was embroiled in the controversy surrounding his firing of General Douglas MacArthur, a hero of World War II and Supreme Commander, Allied Powers, in Korea. MacArthur had disobeyed orders repeatedly and defied directions from Truman, the commander in chief. Truman had relieved MacArthur of command on April 11, and the general had returned to the United States, addressed a joint session of Congress, and was being discussed as a possible presidential candidate. Truman professed to be unconcerned by MacArthur's popularity and urged reporters to await the outcome of a congressional investigation, which Truman asserted would prove that the firing was justified.

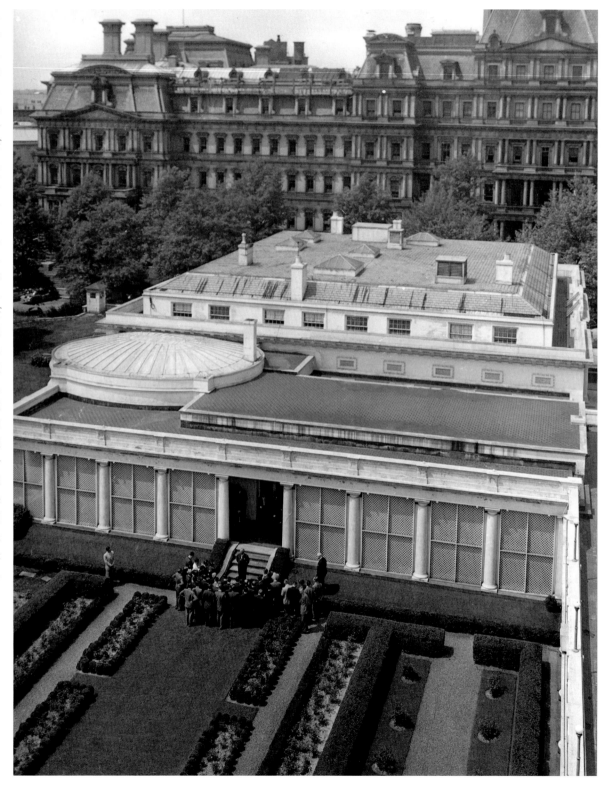

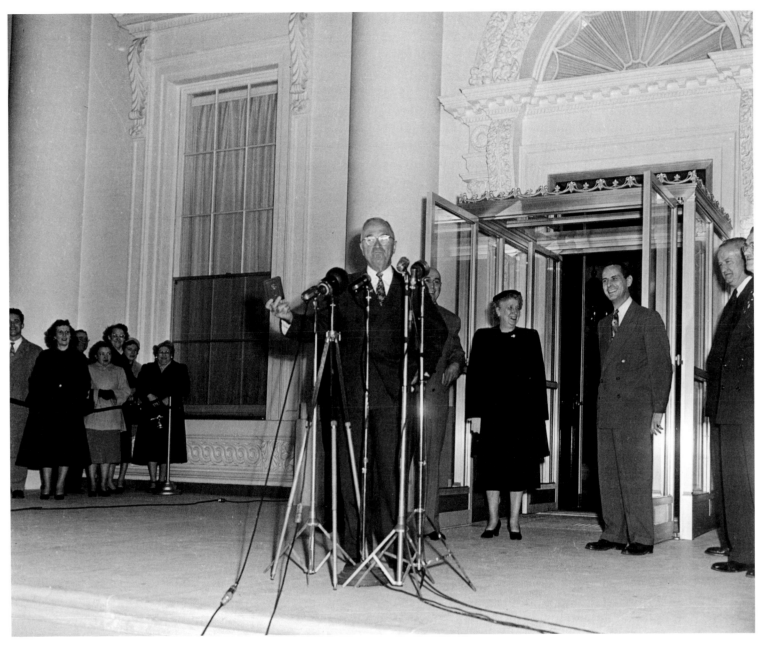

After about three years of work, the renovated White House was available for President Harry S. Truman to move back into on March 27, 1952. In a brief ceremony, the president received a gold key to the residence, as his wife, Bess Truman, looked on from the doorway. The Trumans had lived at Blair House, on the north side of Lafayette Square, while the work was underway. While there, they had survived an assassination attempt on November 1, 1950, as two Puerto Rican separatists had attempted to shoot their way past guards. Both were killed, and one guard died while another was wounded. Whether at Blair House or the White House, President Truman was frequently alone, as his wife much preferred to remain at their home in Independence, Missouri.

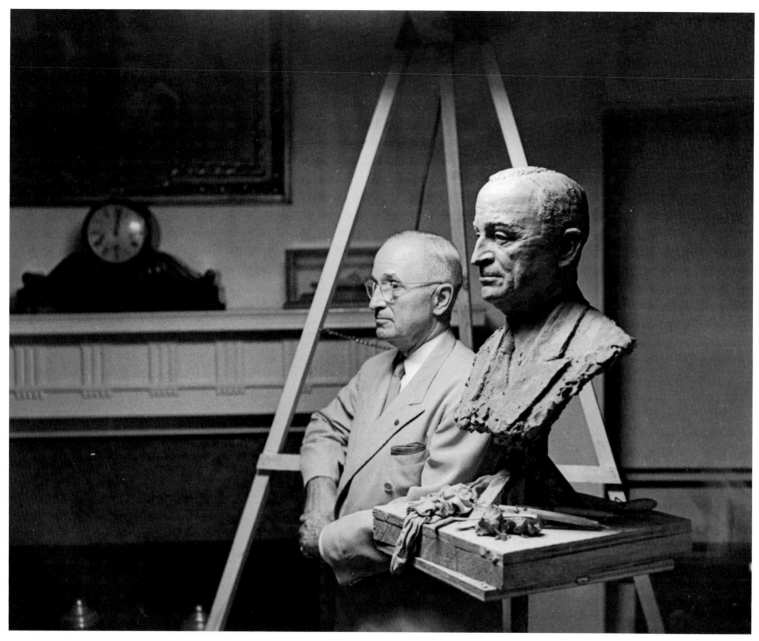

Several busts of President Truman were created during his lifetime, including this one by Nison Tregor, a naturalized American citizen from Russia. Truman posed with the bust in July 1952 in the Cabinet Room.

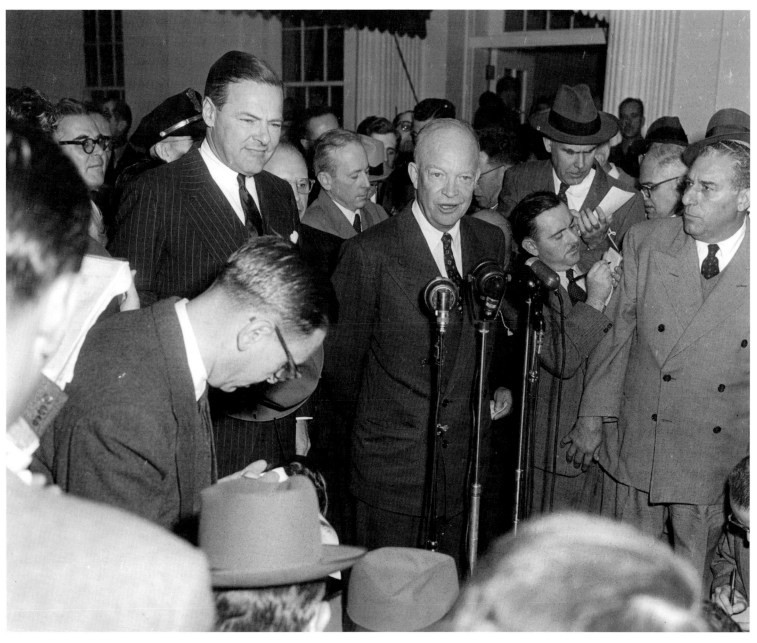

On November 18, 1952, president-elect Dwight D. Eisenhower paid President Harry S. Truman a visit at the White House and spoke to reporters there. Although Truman respected Eisenhower for his long military career and especially his role in achieving victory during World War II, he had hoped the general would campaign for the presidency as a Democrat and was disappointed when Eisenhower joined the Republican Party. Truman campaigned for the Democratic nominee, Adlai Stevenson, and the relationship between Truman and Eisenhower grew increasingly strained. On Inauguration Day, neither one spoke to the other, and the silence was only broken after a lapse of more than 10 years, at the funeral of President John F. Kennedy. On leaving the burial ceremony at Arlington National Cemetery on November 25, 1963, the two former presidents were compelled to share a limousine, began talking, and reconciled at last.

As President Truman prepared to leave the White House for his home in Independence, Missouri, in January 1953, he began making his farewells to the White House staff and to others who had served him there. Most of the men and women under Truman liked and respected him, in part because he was unpretentious and treated them with kindness and common courtesy. In this photograph taken on January 16, Truman is being presented honorary badges from Robert Murray, chief of the Washington Metropolitan Police Department, Mark Raspberry, chief of the United States Park Service, and Hobart Francis, inspector, White House Police.

FROM EISENHOWER TO CARTER

(1953–1977)

The inauguration of President Dwight D. Eisenhower on January 20, 1953, seemed to usher in an era of prosperity and growth. Rising postwar employment, increasing incomes, easier credit, a manufacturing boom, and sprouting suburbs enabled Americans to afford cars, houses, and other amenities as they never had before.

Another war was waged during the Eisenhower years, however: the cold war. The president had to deal with a constant string of international crises as the Soviet Union and its surrogates confronted the United States and its allies. Eisenhower used the new medium of television effectively to rally support for his policies, explain his programs, and outline his strategies. Although he did not appear entirely at ease, his grandfatherly demeanor and his reputation as a leader in World War II comforted Americans during dangerous times.

His successor, President John F. Kennedy, inherited the cold war and addressed its challenges with a vastly different style. Kennedy's youth and good looks, his obvious comfort in front of the cameras, and his quick wit made him well-suited to the age of television. In addition, his elegant and sophisticated wife, Jacqueline Bouvier Kennedy, brought her talents to bear on everything from restoring the White House to state dinners and entertainment.

Kennedy's assassination in Dallas on November 22, 1963, ushered in a darker period that is reflected in photographs taken at the White House during the next decade. The war in Vietnam, pickets in the streets, President Lyndon B. Johnson's decision not to seek reelection in 1968, and the Watergate scandal of President Richard M. Nixon's administration unfolded next. After Nixon's resignation in 1974, President Gerald R. Ford, Jr., oversaw a period of relative calm, much to the nation's relief. President Jimmy Carter's administration, however, eventually foundered on inflation concerns and the Iranian hostage crisis, although he also had successes such as the Camp David Accords between Israel and Egypt.

Through it all, the White House has remained as solid as the Aquia sandstone of which it is constructed. It, too, has suffered travails but has survived them all, like the Republic. It remains a symbol not only of American power and leadership but also of American endurance, optimism, and confidence. It has stood through two eventful centuries and will, we hope, stand for many more.

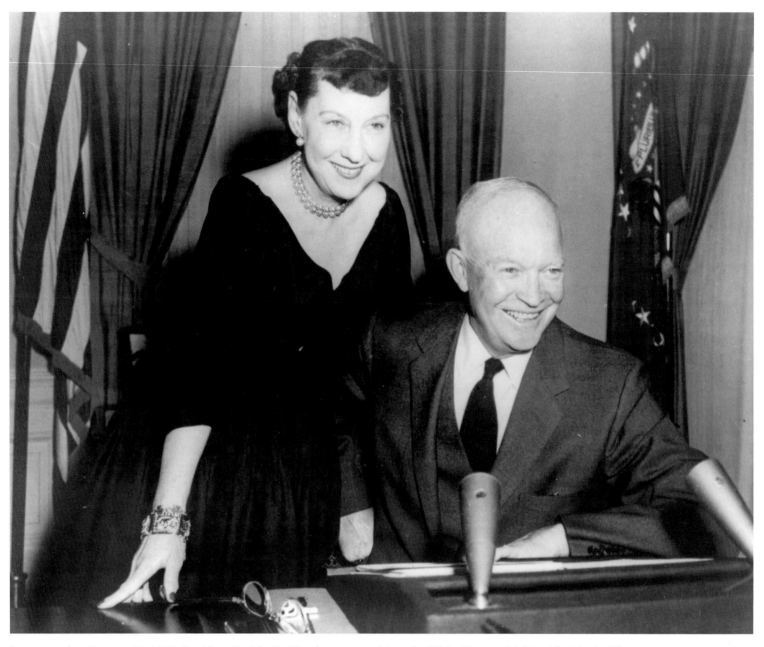

Inaugurated on January 20, 1953, President Dwight D. Eisenhower moved into the White House with his wife, Mamie. The newspapers reported that they settled in quickly, and after the first 48 hours, the president couldn't believe that he'd been in office only two days. Mamie Eisenhower, as a general's spouse, was accustomed to entertaining, although it was reported that she preferred small groups. She also received praise for her fashion sense, particularly her penchant for colorful ready-made outfits, which were inexpensive and available to middle-class women.

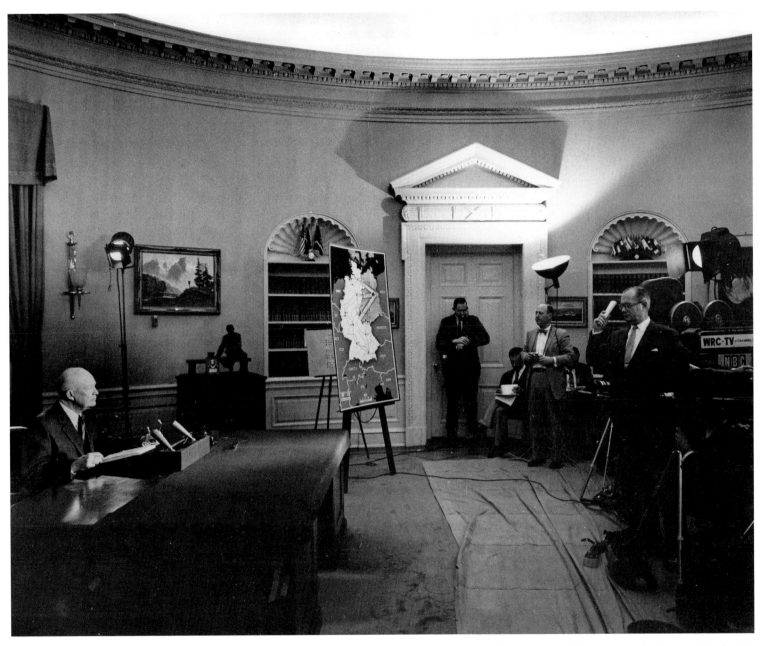

President Eisenhower gave numerous television and radio addresses from the Oval Office during his tenure. In this photograph, he is waiting for the sign that he is on the air to be given by the man standing next to the television camera. The topic of his speech probably was Eastern Europe; the map shows East and West Germany.

Homer Gruenther, assistant to the deputy assistant to President Eisenhower, accepts a Yuletide turkey named Mr. St. Mary's County from Mrs. Lucille Norman of Charlotte Hall, Maryland. She told reporters that she and her husband, Hobart Norman, raised about 12,000 turkeys a year. In the background are two gallons of southern Maryland oysters to accompany the bird. Mr. Gruenther, who was wearing gloves as a precaution, escorted the turkey to White House maitre d' Charles Ficklin. Whether the bird received a holiday reprieve, as has long been the custom with Thanksgiving turkeys presented to the president, is not known.

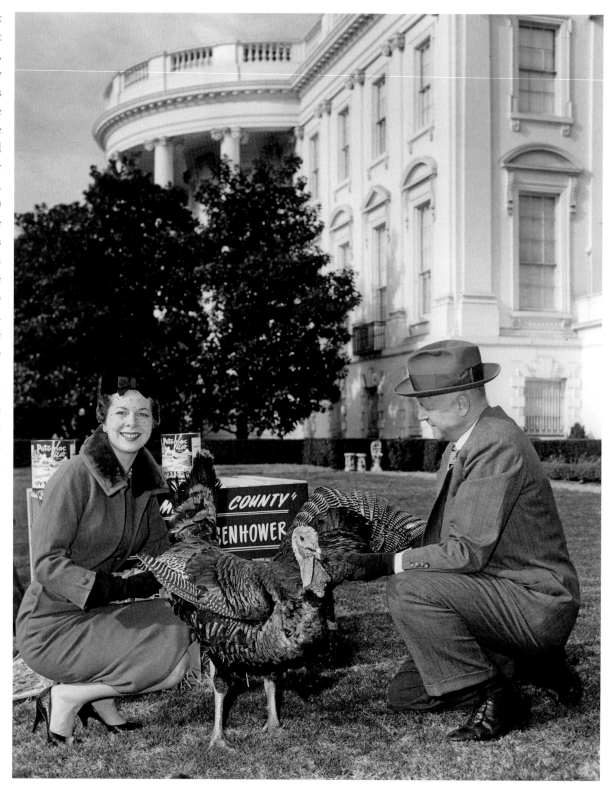

A noted writer of plays and screenplays, Clare Boothe Luce was also the wife of Henry R. Luce, publisher of *Time* and other magazines. She was an ardent Republican who served two terms in the House of Representatives beginning in 1942. During the 1952 election, she campaigned for Dwight D. Eisenhower, who rewarded her the next year with an appointment as ambassador to Italy. Here on January 6, 1954, during one of her periodic visits to the United States for consultations, she met in the Oval Office with the president, who hosted a luncheon in her honor later that day. Luce resigned two years later because of ill health.

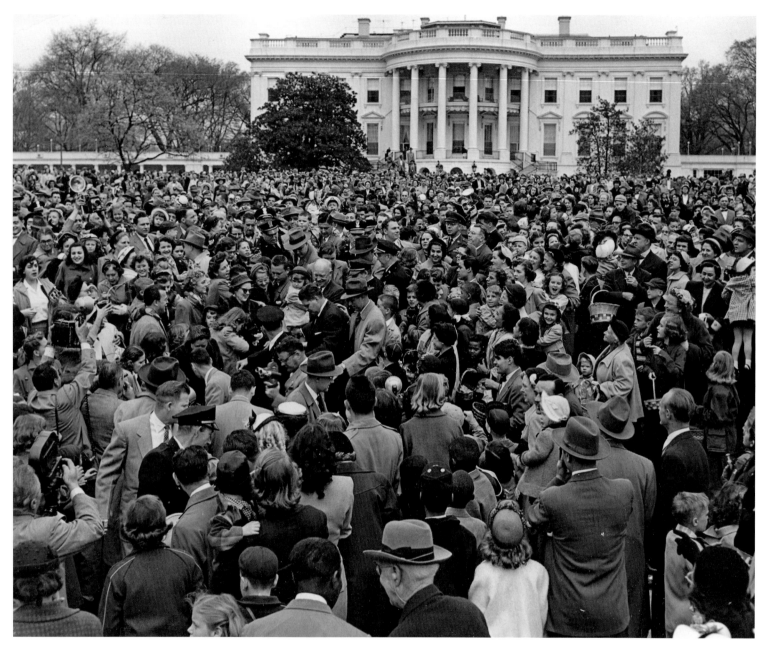

With America at war in 1942, the annual Easter Egg Roll at the White House was cancelled and was not resumed until 1953, under President Eisenhower (who had grandchildren, unlike President Truman). This photograph—with Eisenhower at center, holding a child—illustrates the enthusiasm of children and parents alike at the resumption of the Washington tradition. As a newspaper account reported, "An estimated 12,000 persons were milling about on the lawn, shouting and stamping each other's eggs when Mr. Eisenhower appeared with his two grandchildren. Shouting parents tried to propel their children into the President's arms, nearly overpowering a protective escort of secret service men and police."

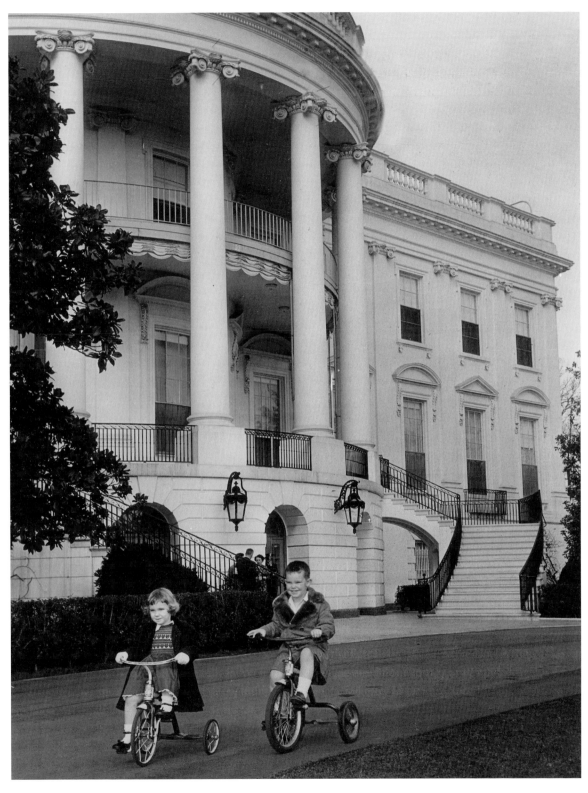

David and Barbara Anne Eisenhower, the grandchildren of President Dwight D. Eisenhower and his wife, Mamie, were photographed in 1953 riding their tricycles on the drive by the south front of the White House. David was about five years old and Barbara was about four. The president's son, John S. D. Eisenhower, often brought the children for visits. They also enjoyed watching movies with their grandmother in the East Wing theater.

During the cold war, periodic "summit conferences" were held at which leaders of the free world and the Soviet Union discussed issues of importance to both sides, such as nuclear disarmament. Typically, a summit conference occurred only after countless lower-level meetings resolved issues concerning the agenda and other matters. Mikhael A. Menshikov, Soviet ambassador, was photographed on March 3, 1958, as he walked to the White House to meet with President Dwight D. Eisenhower and present the latest Soviet agenda proposals. Secretary of State John Foster Dulles objected to the Soviet agenda as essentially ignoring the points the Western leaders wished to discuss. In the end, no summit conference was held in 1958, but the president hosted Soviet leader Nikita Krushchev at Camp David, Maryland, the next year. A welcome if temporary easing of tensions was the result.

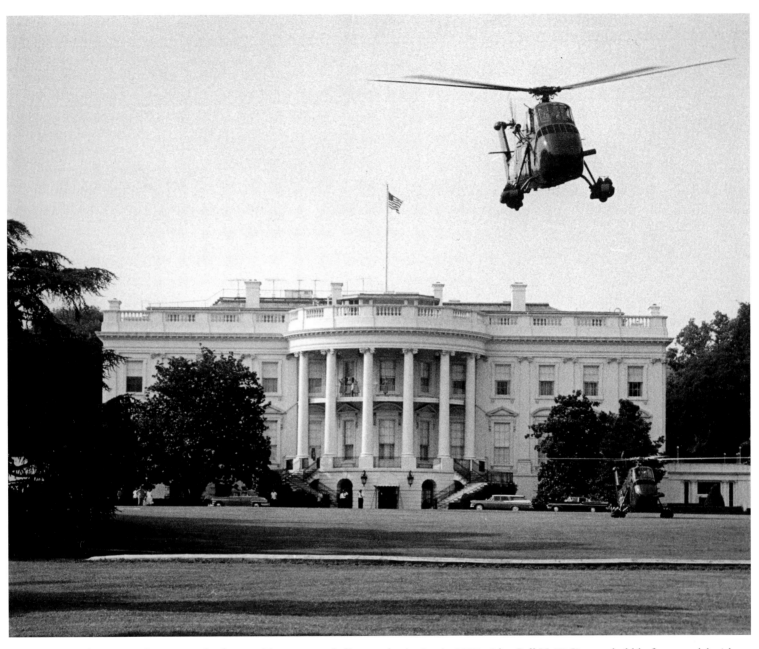

Dwight D. Eisenhower was the first president to use a helicopter, beginning in 1957 with a Bell H-13 Sioux, a bubble-front model with no amenities. In 1958, he was provided the much larger and more comfortable Sikorsky H-34 Choctaw, shown here lifting off from the South Lawn. Other models have replaced the H-34. The helicopter is referred to as Marine One because it belongs to the United States Marines, but the call sign Marine One is used to designate any Marine aircraft carrying the president. Generally, the helicopter is used to transport the president for relatively short distances.

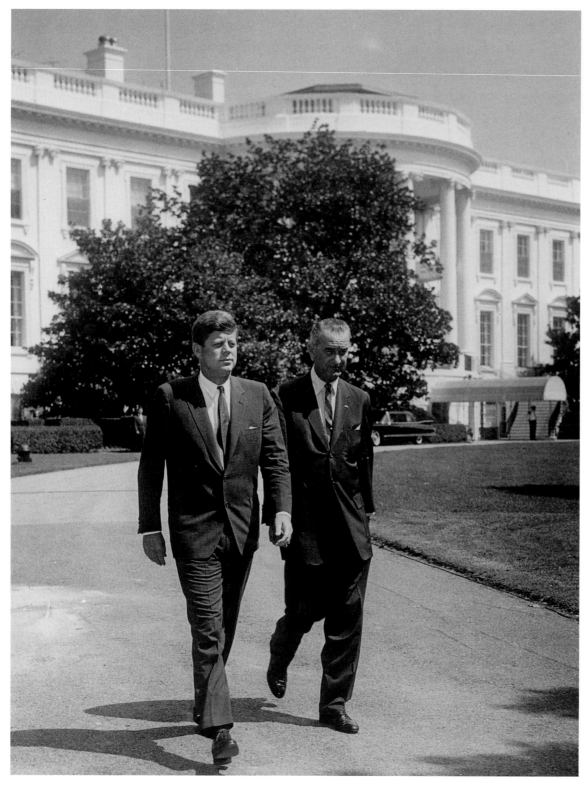

President John F. Kennedy and Vice President Lyndon B. Johnson, photographed with the south front of the White House behind them, were elected on November 8, 1960, and sworn into office in the brilliant sunshine of January 20, 1961. Kennedy's youthful appearance—he was four months shy of his 44th birthday when he was inaugurated—contrasted sharply with the grandfatherly President Dwight D. Eisenhower. Kennedy and his 31-year-old wife, Jacqueline, their daughter, Caroline, and their son, John, brought an air of glamour and vigor to the White House.

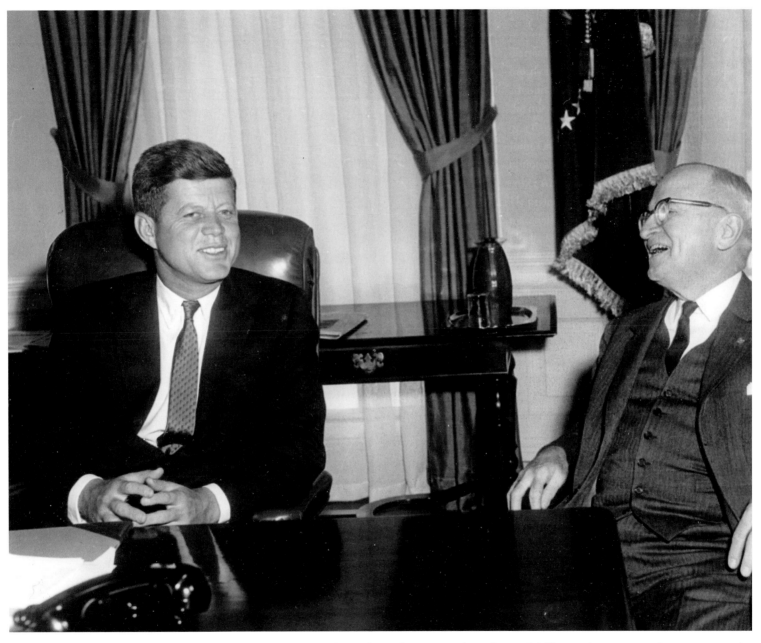

Former president Harry S. Truman, on the right, visited President John F. Kennedy in the Oval Office on the morning of January 21, 1961. Truman had attended the president's inauguration the day before. Kennedy looked remarkably fresh, considering that he had not returned to the White House from the inaugural balls and parties until almost 4:00 A.M. and had come to the Oval Office before 9:00 A.M. that morning. Truman arrived an hour later.

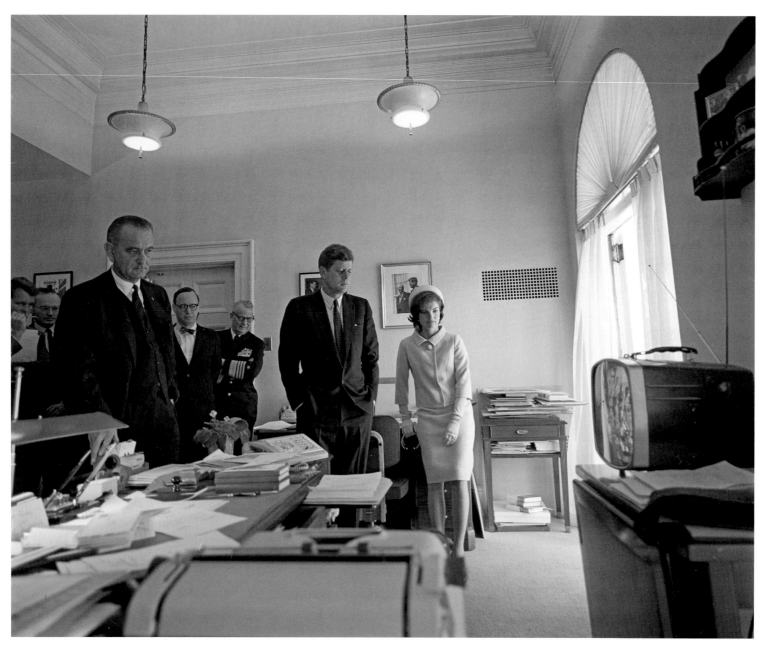

On May 5, 1961, President John F. Kennedy, Jacqueline Kennedy, and Vice President Lyndon B. Johnson gathered in the office of the president's secretary with Attorney General Robert F. Kennedy, presidential advisor McGeorge Bundy, historian Arthur M. Schlesinger, Jr., and Admiral Arleight Burke to watch television coverage of the space flight of Alan B. Shepard, Jr., the first American in space. Shepard attained an altitude of 116 miles in the Freedom 7 capsule and landed safely 302 miles downrange. Afterward, in a May 25 speech to Congress, President Kennedy said, "I believe that this nation should commit itself to achieving the goal, before this decade is out, of landing a man on the Moon and returning him back safely to the earth." As commander of Apollo 14, Shepard would be the fifth man to set foot on the Moon and the first to play golf there.

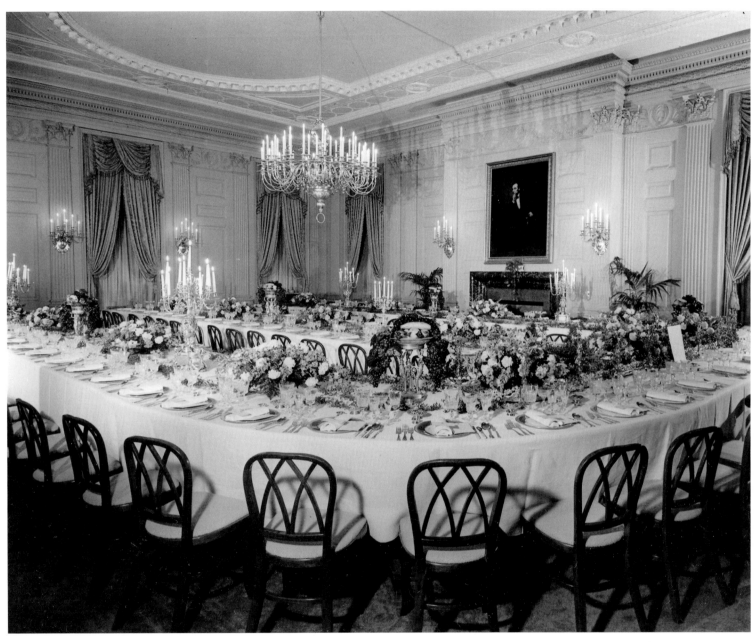

Jacqueline Kennedy, appalled at the poor quality of many of the White House furnishings, decided to replace them with historically appropriate and significant pieces befitting the residence of the head of state. She accomplished her goals with private funding, the advice of experts in the fields of antiques and interior design, and the power of her considerable charm to persuade owners of priceless antiques to donate them to the White House. On February 14, 1962, the project was advanced far enough that CBS televised a tour of the White House hosted by Mrs. Kennedy. Approximately a third of America watched the program. As a result of Mrs. Kennedy's efforts, today a number of organizations and foundations, including the White House Historical Association, continue to contribute to the restoration and preservation of the White House. This photograph shows the restored State Dining Room set for a dinner.

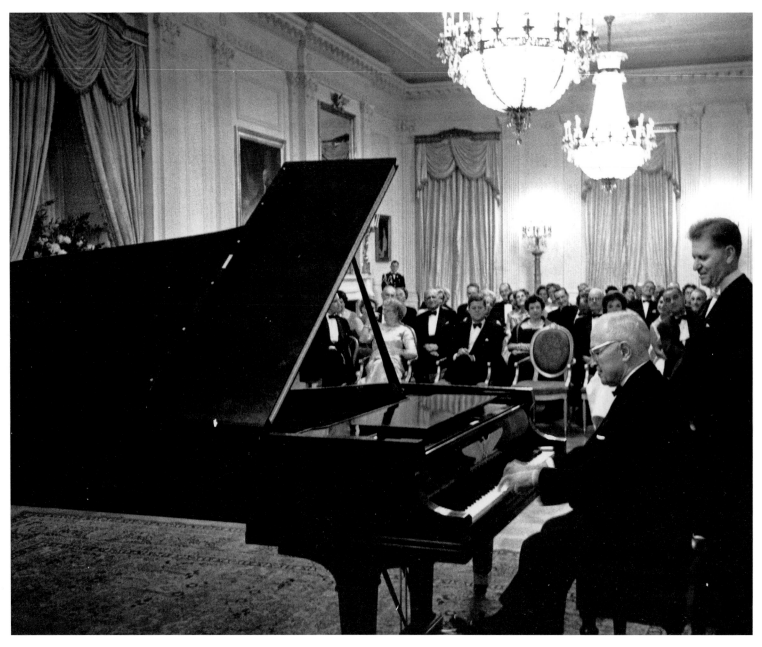

On November 1, 1961, President and Mrs. Kennedy gave a dinner for former president Harry S. Truman and his wife, Bess Truman. Afterward, the pianist Eugene List gave a recital in the East Room, and Truman took a turn at the piano to play "The Missouri Waltz," his theme song. President Kennedy is seated next to Bess Truman. List, standing at the right, was an army staff sergeant in Potsdam in 1945 and played for Truman when the president was there to make final peace plans with Churchill and Stalin.

Captain Cecil Stoughton, United States Army Signal Corps, was detailed to the White House at the beginning of the Kennedy administration to serve as the official photographer. He was given unparalleled access not only to the president's daily routine but also to many of the family's private moments. Some of Stoughton's photographs, such as this one from a series taken one evening in August 1962, have become iconic. Jacqueline Kennedy was preparing son John F. Kennedy, Jr., for bed and cuddling him when he began playing with her pearl necklace. Although the boy was called John-John in the press, Mrs. Kennedy later said that she and the president never used that nickname but always called him John.

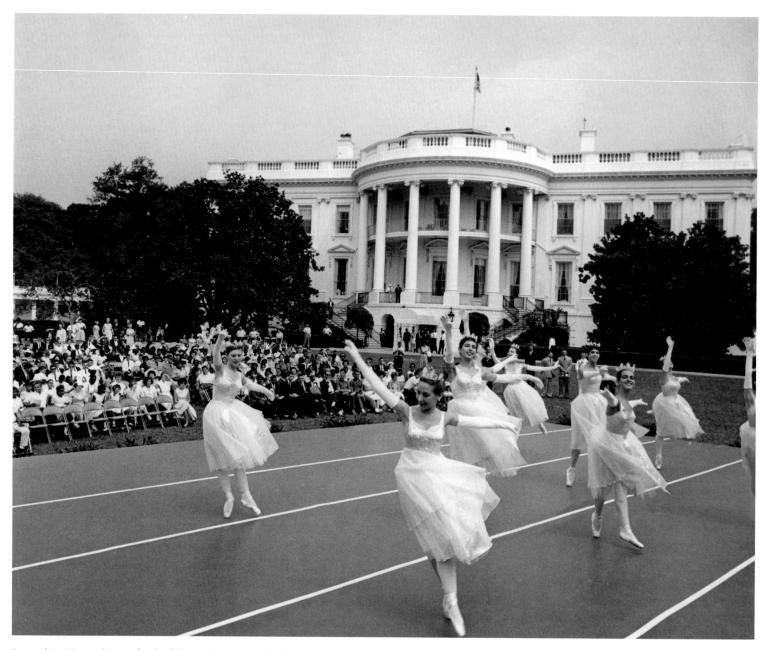

Jacqueline Kennedy was fond of classical music and ballet; President Kennedy was less interested, but he generally supported his wife's programs. On August 6, 1962, on the South Lawn of the White House, the president welcomed the National High School Symphony Orchestra of the National Music Camp of Interlochen, Michigan. Mrs. Kennedy sponsored and planned the concert and ballet performance that followed.

Special assistant Kenneth O'Donnell, Democratic National Committee chairman John M. Bailey, and President John F. Kennedy were photographed in 1962 walking onto the Ellipse, with the south front of the White House in the background. O'Donnell, a long-time friend and political associate of Kennedy, was part of the team of Boston politicos nicknamed the Irish Mafia. Bailey, who first met Kennedy in 1952, served as party chairman from 1961 to 1968 and had long backed Kennedy behind the scenes.

While campaigning for the presidency in October 1960, John F. Kennedy addressed students at the University of Michigan and challenged them to dedicate themselves to promoting peace and to helping the people of developing countries around the world. Thus was born the idea of the Peace Corps, which President Kennedy established by executive order on March 1, 1961. He named his brother-in-law, Sargent Shriver, as the first director. More than 180,000 Americans have served in approximately 140 countries since 1961. Kennedy was delighted with the response of young people and made it a point to meet with the volunteers whenever he could, as he is doing here on August 9, 1962, on the South Lawn of the White House.

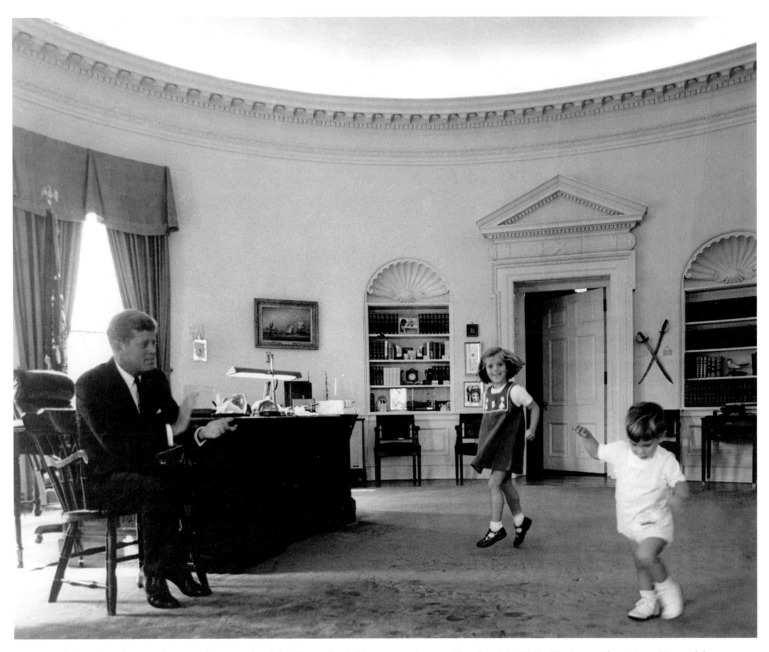

Cecil Stoughton's most famous photograph of the Kennedy children was taken on October 10, 1962. Having paid a visit to Kennedy's secretary, Evelyn Lincoln, and raided the candy jar on her desk, Caroline and John Kennedy next invaded the Oval Office and started to dance around the room while the president clapped. Stoughton followed them and took 12 pictures, then had them printed right away. Kennedy chose this one as his favorite and had it released to the press; it was soon published worldwide. He later autographed a copy "For Captain Stoughton, who captured beautifully a happy moment at the White House."

Presidents have used the Treaty Room, located on the second floor of the White House, for private meetings and for ceremonies associated with the signing of important treaties. President John F. Kennedy signed the Partial Nuclear Test Ban Treaty there on October 7, 1963. Jacqueline Kennedy had the room decorated in the Victorian manner to resemble the Cabinet Room of President Ulysses S. Grant's administration. The cabinet table is in the foreground. Mrs. Kennedy's decoration survived until the administration of President George H. W. Bush, who had the room painted a light green. Here on June 28, 1962, when the newly decorated room was opened, Senate Minority Leader Everett M. Dirksen stands at left of Mrs. Kennedy, followed by Vice President Lyndon B. Johnson, Senate Majority Leader Mike Mansfield and his wife, Maureen Mansfield, and Archivist of the United States Wayne C. Grover.

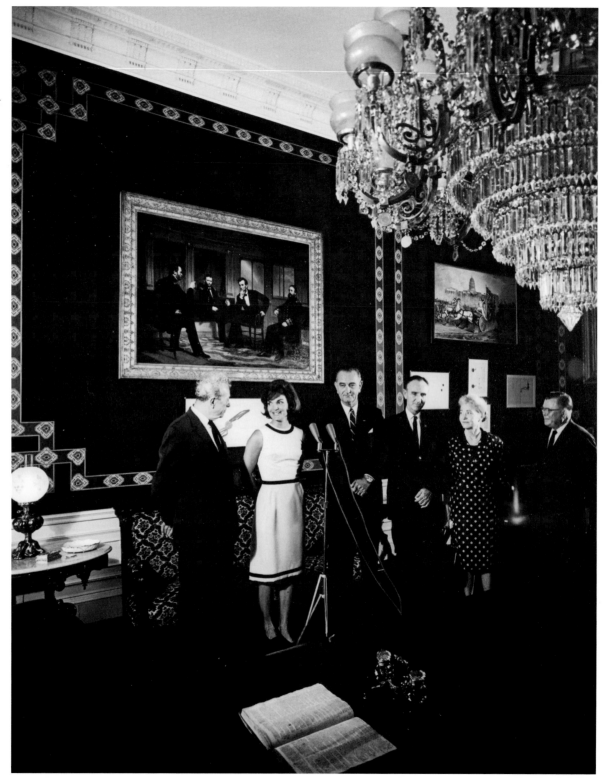

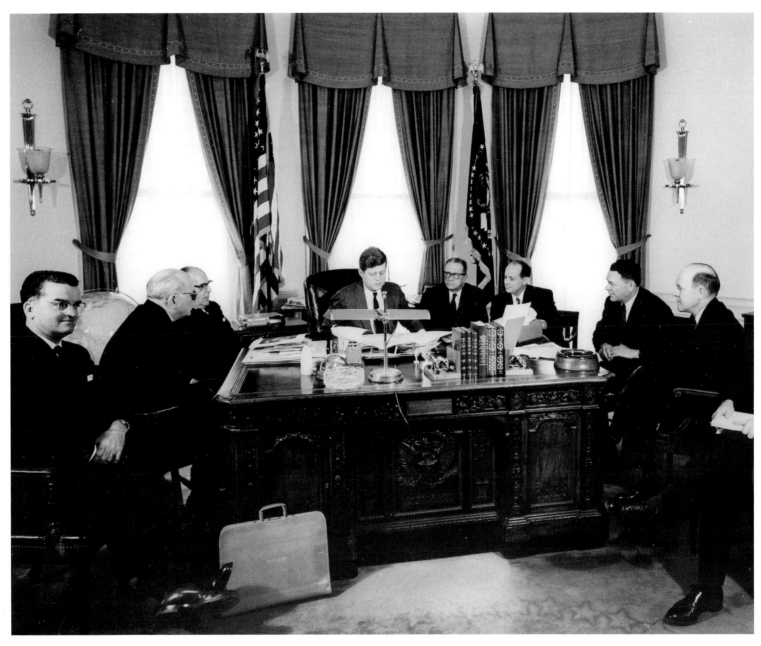

Here, President Kennedy is seated at the *Resolute* desk in the Oval Office. HMS *Resolute* was a Royal Navy vessel sent with three others to the Arctic in the 1850s to search for Sir John Franklin's expedition, which had disappeared while attempting to find a Northwest Passage to the Pacific Ocean (and whose members were later discovered to have all perished). *Resolute* became stuck in the ice, was abandoned, and then later broke free and was recovered by an American whaler. Congress had the ship refitted and presented to Queen Victoria in 1856. When *Resolute* was decommissioned in 1879, this desk was made from some of its timbers and presented to President Rutherford B. Hayes in 1880 on behalf of Queen Victoria. Kennedy had the desk brought to the Oval Office from its long-time location on the second floor of the White House because he enjoyed the naval connection.

The lights are burning late in the West Wing in this photograph taken during the Cuban missile crisis of October 1962. Soviet premier Nikita Krushchev and the Politburo had authorized the insertion of offensive ballistic missiles in Cuba, in part because of concerns that a United States–led invasion of the island was likely, and in part to balance the large number of American ballistic missiles in Turkey and elsewhere near the Soviet border. After a U-2 spy plane photographed the Cuban missile sites under construction on October 15, Kennedy demanded that the missiles be removed. Krushchev refused, and the crisis escalated for two weeks. Throughout, Kennedy met extensively with key advisors, the Joint Chiefs of Staff, and the cabinet. His secret tape-recordings of those meetings, released by the John F. Kennedy Library in 1997, show how close the world came to nuclear annihilation.

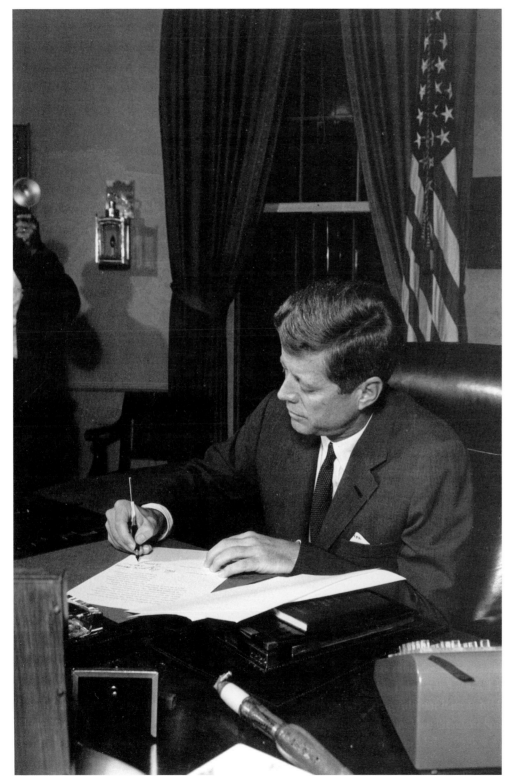

President John F. Kennedy's demands to Soviet premier Nikita Krushchev that offensive missiles discovered in Cuba be removed produced mostly belligerent responses. Kennedy and his advisors studied three options: an air attack on the missile sites, a full-scale military invasion, or a naval blockade or quarantine of Cuba. The Joint Chiefs of Staff advocated for the first two options, but Kennedy supposed (correctly) that either would invite Soviet nuclear retaliation. He preferred a naval quarantine against offensive materials only, one step removed from a general blockade, which in international law is an act of war. On October 23, 1962, as shown in this photograph, Kennedy signed the Proclamation for Interdiction of the Delivery of Offensive Weapons in Cuba. On October 28, Krushchev agreed to remove the missiles from Cuba in exchange for a pledge from the United States not to invade and, secretly, a pledge to remove the American missiles from Turkey. The crisis was over.

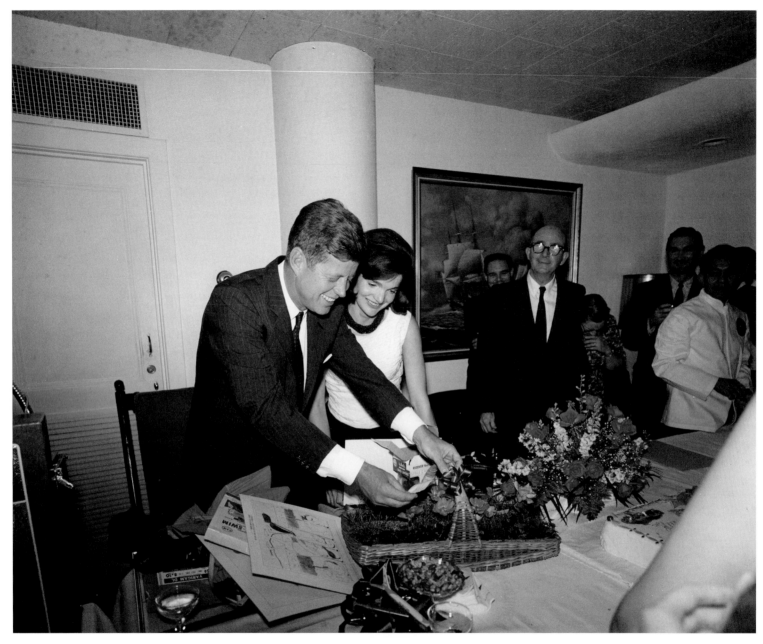

When President Kennedy walked into the Oval Office on the morning of May 29, 1963, his 46th birthday, he found a bouquet of 46 red roses waiting for him. Later that day, the staff gave him a surprise party in the White House mess. It was lighthearted and affectionate, the way Kennedy liked such occasions. Here, he and Jacqueline Kennedy read the gift card attached to a decorated basket of crabgrass from the Rose Garden. Presidential aide Dave Powers, with the light reflecting off his glasses, stands in the background, while special assistant Kenneth O'Donnell is beaming to the right of Powers.

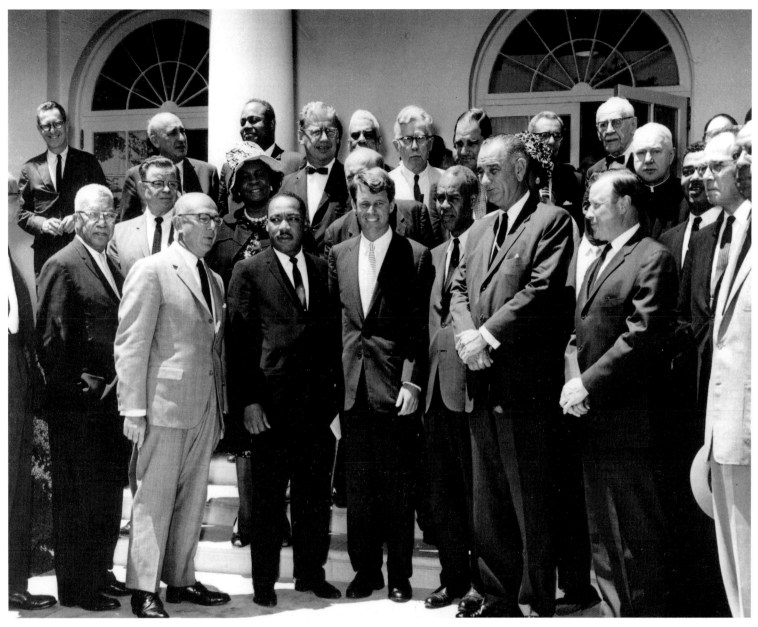

On June 22, 1963, President John F. Kennedy met at the White House with 30 civil rights leaders. They included Dr. Martin Luther King, Jr., NAACP executive secretary Roy Wilkins, Congress on Racial Equality leader James Farmer, and United Automobile Workers president Walter Reuther. In this photograph of the delegation outside the White House, King and Wilkins stand at left and right, respectively, of Attorney General Robert F. Kennedy. President Kennedy also met privately with King and Wilkins to ask whether it might be counterproductive to continue holding civil rights demonstrations while Congress was debating his civil rights program. The president was concerned that the demonstrations might further inflame opposition from Southern legislators, but he did not ask that they be cancelled. On the same day, he issued Executive Order 11114, which expanded the authority of the President's Committee on Equal Employment Opportunity to include the "withdrawal of Federal funds from construction projects where racial discrimination is practiced."

President Kennedy occasionally invited groups to hold meetings on subjects of national concern in the White House; then he would make an appearance and offer some remarks, as he is shown doing here in the East Room. For example, on May 9, 1963, he addressed a meeting of the Citizens Committee for Tax Reduction and Revision, and on June 11, he spoke to a conference of businessmen about the need to desegregate. Both addresses were given in the East Room.

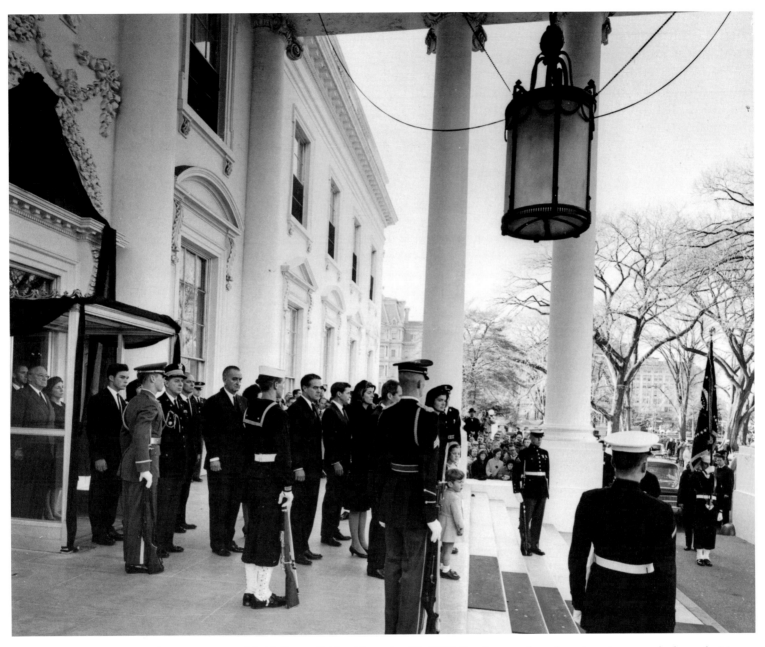

President John F. Kennedy was assassinated in Dallas on Friday, November 22, 1963. For the next three days, Americans watched on television as one unforgettable scene after another unfolded: the return of Kennedy's body to Washington and Mrs. Kennedy climbing down from Air Force One in her bloodstained suit; the flag-draped casket reposing first in the East Room of the White House and then in the Capitol Rotunda; the murder of the assassin, Lee Harvey Oswald; Kennedy's funeral Mass; the procession, the riderless horse, and the unceasing thump of muffled drums; the burial at Arlington National Cemetery and the bugler breaking a note as he played Taps. Here, on Sunday, November 24, Jacqueline Kennedy and the children are waiting to leave the White House for the Capitol.

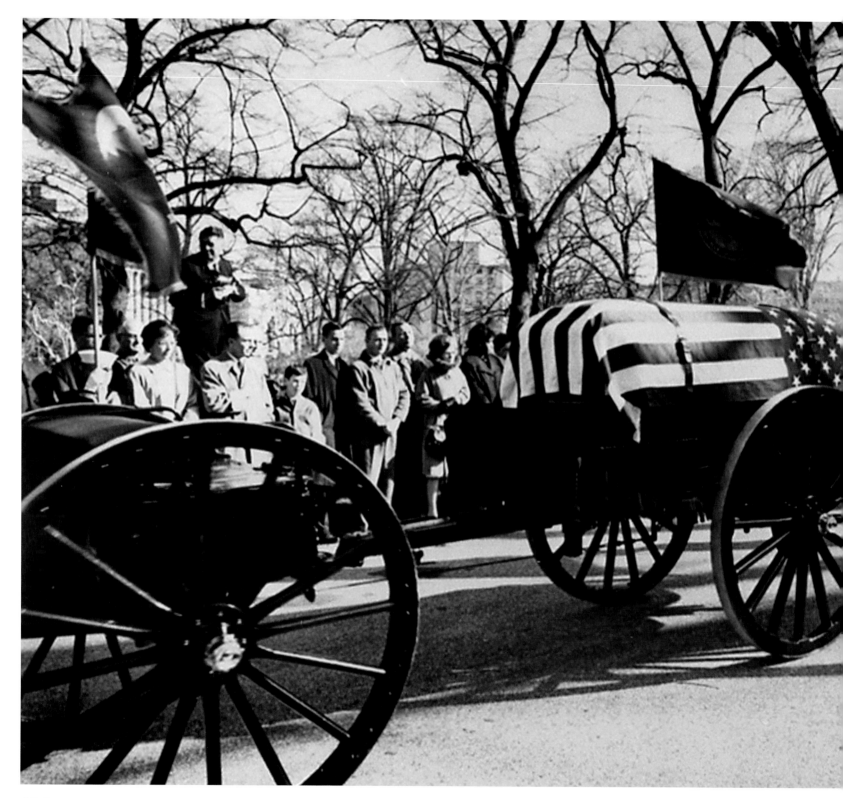

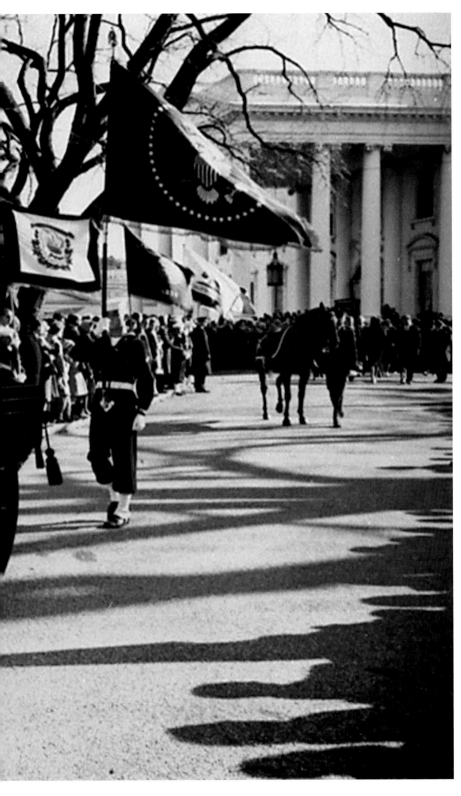

After lying in state overnight at the Capitol, the body of President John F. Kennedy was borne on an artillery caisson—the same caisson used to carry the body of President Franklin D. Roosevelt after his death in 1945—to St. Matthew's Cathedral for the Requiem Mass on Monday, November 25, 1963. En route, the procession paused briefly on the White House grounds, and then continued to the cathedral; this photograph was taken upon the departure from the White House grounds. Approximately a quarter-million people had passed through the Capitol Rotunda to pay their respects, and an estimated million lined the route of the procession. Countless millions more in the United States and around the world watched on television as the procession ended at Arlington National Cemetery, where Kennedy was laid to rest.

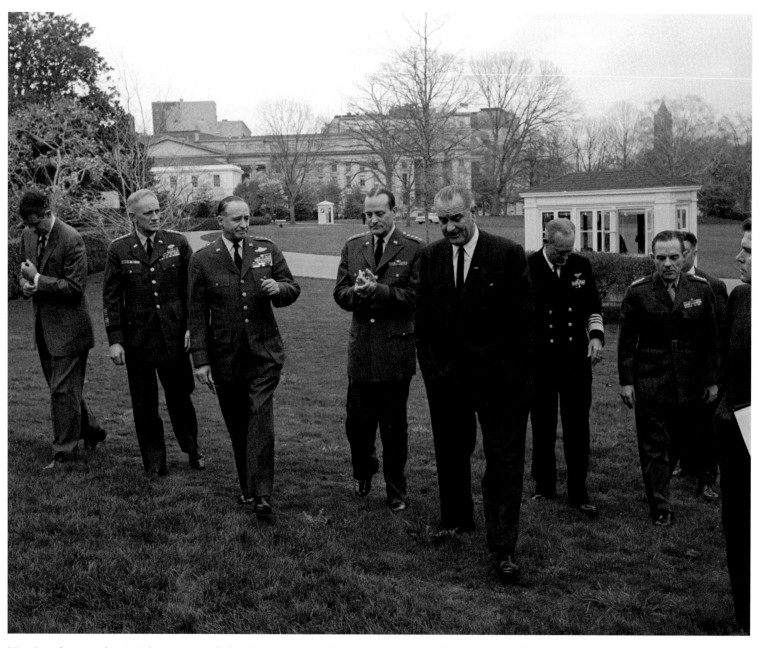

Vice President Lyndon B. Johnson succeeded to the presidency after the assassination of President John F. Kennedy on November 22, 1963. A former senator from Texas, Johnson steered some important pieces of legislation through the Congress, most significantly the Civil Rights Act of 1964. He also mired the United States deeper in an increasingly unpopular war in Vietnam. Several of Kennedy's former aides have asserted that Kennedy would have removed the small number of American advisory troops there if he had been reelected in 1964. That is speculation, but it is a fact that President Johnson "escalated" America's role in the conflict, adding huge numbers of combat troops. Here, Johnson is walking on the White House lawn with the Joint Chiefs of Staff on April 8, 1965.

On July 28, 1965, President Johnson held a press conference in the East Room of the White House, shown here the next day. Johnson announced that he had ordered the number of American troops in Vietnam increased from 75,000 to 125,000. The involvement of the United States in the conflict there was thus deepened dramatically. In this photograph, Secretary of Defense Robert McNamara sits alone in the East Room pondering the situation.

McGeorge "Mac" Bundy and President Johnson were photographed on August 23, 1967, during a meeting in the Oval Office. Bundy had come to Washington with President Kennedy in 1961, and had served as National Security Advisor to Kennedy and then to Johnson until Bundy left government in 1966. He served as president of the Ford Foundation from then until 1979. At the time of this meeting, he was also serving as chairman of the Special Presidential Committee on the Middle East. He reported to the president on the Middle East crisis, also known as the Six-Day War, in which Israel fought and defeated Egypt, Syria, and Jordan in June 1967.

General William C. Westmoreland studied the floor in this photograph taken on November 16, 1967, while President Lyndon B. Johnson examined a document. Westmoreland was reporting to the president on conditions in Vietnam, where Westmoreland had been commander of American troops since 1964. Under his command, the number of United States soldiers engaged in Vietnam had increased from 16,000 to about 535,000. The conflict dragged on regardless, in part because Westmoreland's opposite number in North Vietnam, General Vo Nguyen Giap, continued to wage a small-unit war despite heavy losses, and to avoid large-scale engagements. In 1968, Westmoreland was made Chief of Staff of the United States Army and relinquished command in Vietnam to General Creighton W. Abrams.

In 1968, General Creighton W. "Abe" Abrams assumed command of all American forces in Vietnam. During his tenure, the number of troops declined from 535,000 in 1968 to 30,000 at the end of 1972. Like his predecessor, General William C. Westmoreland, Abrams was a veteran of World War II, having served under General George S. Patton. A tanker, Abrams was regarded by Patton as the best in the business and was well-known for his concern for his men and his personal integrity. In this photograph taken on October 29, 1968, Abrams, at right, is shown discussing the situation in Vietnam with President Johnson, at center, and Secretary of State Dean Rusk, at left, as well as other presidential advisors. President Johnson had declined to run for office again, and it would be under his successor, Richard M. Nixon, that the United States would at last disengage from the Vietnam conflict.

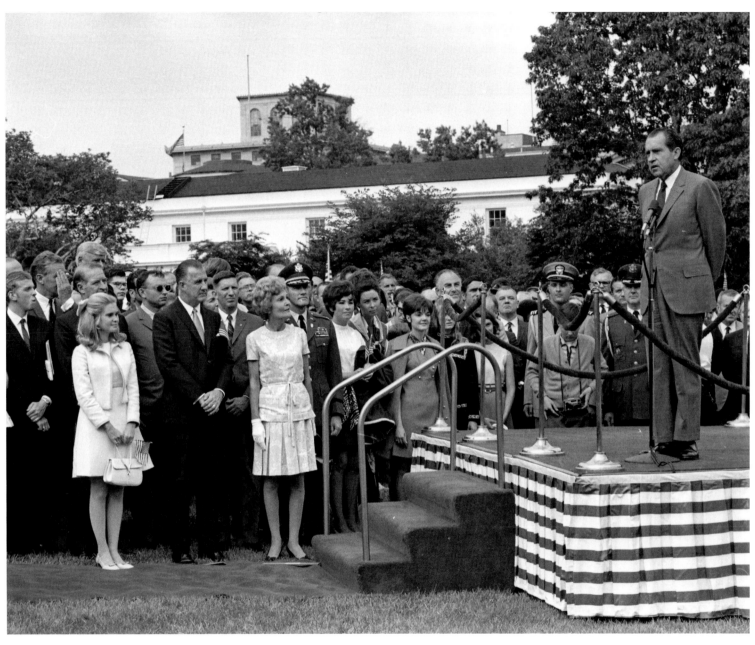

Richard M. Nixon, who had lost to John F. Kennedy in the 1960 presidential election, defeated Hubert H. Humphrey in the 1968 election. Nixon alleged that he had a "secret plan" to end the war in Vietnam; after he took office he began searching for a way out of the quagmire. In June 1969, he flew to Midway Island to meet with South Vietnam President Nguyen Van Thieu. On his way back to Washington, he stopped in Honolulu and was briefed on other issues in the Pacific from several commanders including Admiral John S. McCain. When Nixon returned to the White House on June 10, he was met by a group of well-wishers including his daughter Tricia, Vice President Spiro T. Agnew, and Pat Nixon, the president's wife, all shown here. Nixon gave a short report on his trip, and later announced that 25,000 American troops would be withdrawn from Vietnam.

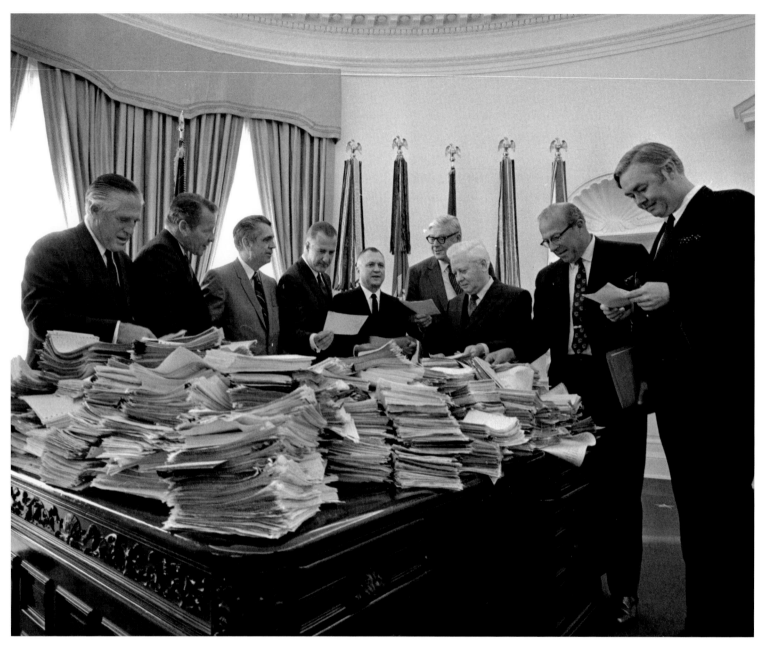

On November 3, 1969, amid growing public outcry over the war in Vietnam, President Nixon addressed the nation from the Oval Office. He described the progress that had been made toward the withdrawal of all American forces from Vietnam, the obstinacy of the North Vietnamese Communists, and his determination to follow a careful plan for withdrawal. Near the end of his speech, he characterized those who demanded a faster pace as a "vocal minority," and called on "the great silent majority of my fellow Americans" to support his approach instead. The speech resulted in a flood of telephone calls to the White House and telegrams of support. In this photograph, taken on November 5, members of the Nixon cabinet pore over telegrams piled on the president's *Resolute* desk in the Oval Office.

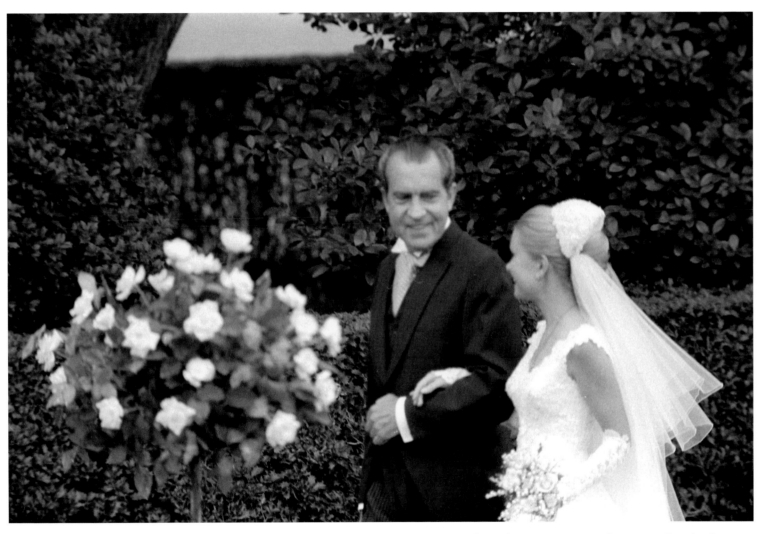

Amid the demonstrations and controversy surrounding the slow withdrawal of American forces from Vietnam, President Nixon found at least one moment of joy—the wedding of his daughter Tricia to Edward F. Cox in the White House Rose Garden on June 12, 1971. When it began to rain before the ceremony, which had long been planned for the garden, the president tried to convince Tricia to move it indoors, but she refused. Once the recessional was over, the guests bolted for cover. The reception followed inside the White House.

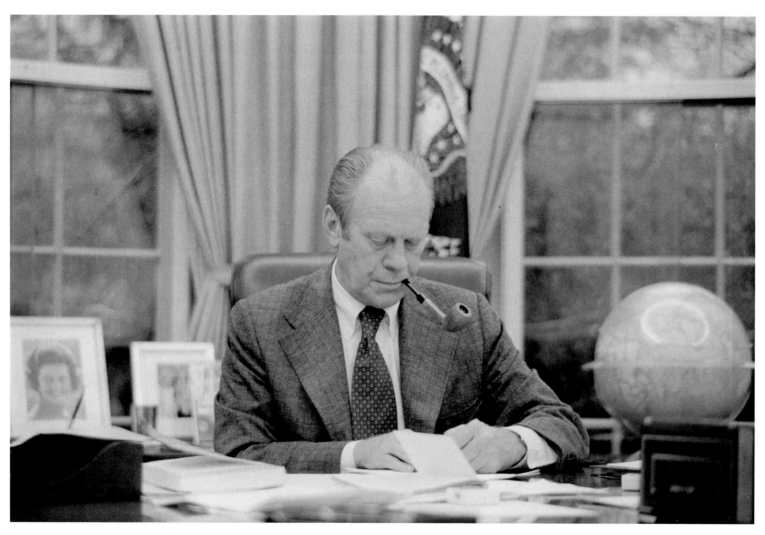

Seen here in the Oval Office in February 1975, Gerald R. Ford, Jr., became president when Richard M. Nixon resigned the office on August 9, 1974. Ford had served for 25 years as a congressman from Michigan when President Nixon nominated him to replace Vice President Spiro T. Agnew after the latter resigned on October 10, 1973, over corruption and bribery charges. The president himself was embroiled in the Watergate scandal—a web of secret tapes, coverups, and lies that eventually became his undoing. With Ford's assumption of the presidency, the nation breathed a sigh of relief, finding that his aura of calmness and decency was just what it needed. He did create a firestorm of controversy when he issued a full and unconditional pardon of Nixon, but eventually many Americans agreed that Ford's action had allowed the country to put Watergate and Nixon behind it.

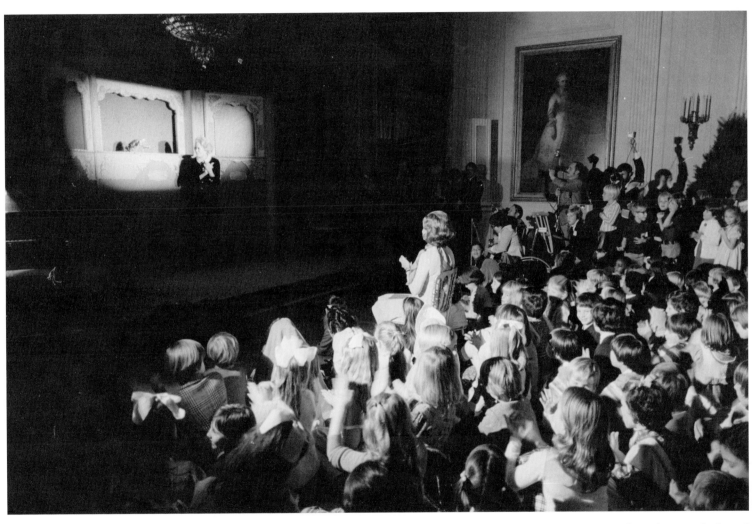

Betty Ford, the wife of President Ford, sponsored many entertainers at the White House during her tenure there. On December 16, 1975, she hosted *Kukla, Fran, and Ollie,* a puppet show that had premiered in 1953 and remained popular for many years thereafter. The occasion was a Christmas party for children of members of the diplomatic corps.

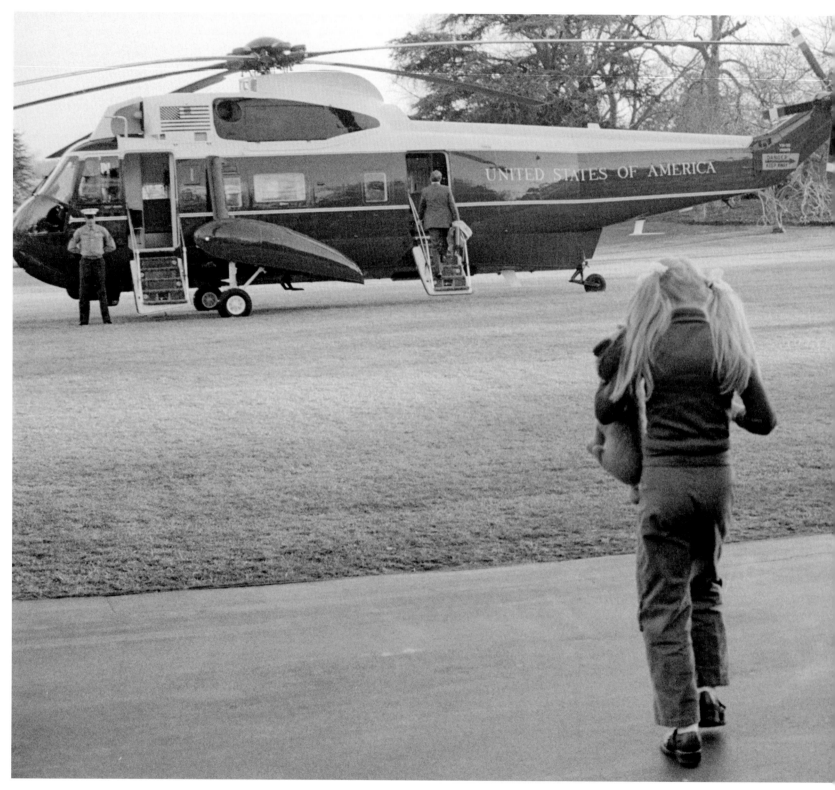

On February 25, 1977, Rosalynn Carter, the wife of President Jimmy Carter, and their nine-year-old daughter Amy prepared to board Marine One, the Sikorsky SH-3 Sea King helicopter that would take them to the presidential retreat at Camp David, Maryland, for the weekend. The getaway was cut short, however, when Caron Carter, wife of the president's son Chip Carter, gave birth to a son. President Carter, Rosalynn Carter, and Amy Carter boarded the helicopter and flew from Camp David to Bethesda Naval Hospital to be with the couple and the new baby.

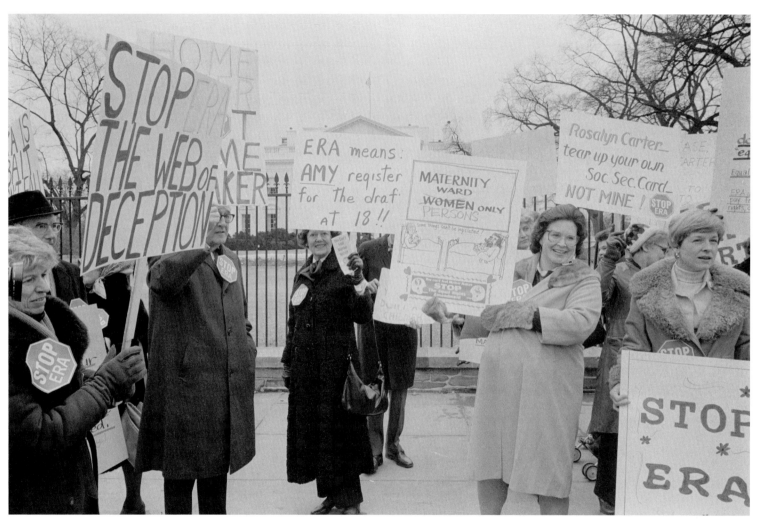

Governor Jimmy Carter of Georgia won the 1976 presidential election, defeating Gerald Ford, the incumbent. Carter's wife, Rosalynn, like her predecessor Betty Ford, was outspoken on social issues, and in particular voiced her support for the Equal Rights Amendment to the Constitution. The proposed amendment read: "Equality of rights under the law shall not be denied or abridged by the United States or by any State on account of sex." The House of Representatives approved the language in 1971 and the Senate followed in 1972, and the amendment was presented to the states for ratification, which ultimately failed. During the ratification process, some opponents picketed the White House on February 4, 1977, angered that Mrs. Carter had been contacting state legislators to encourage support.

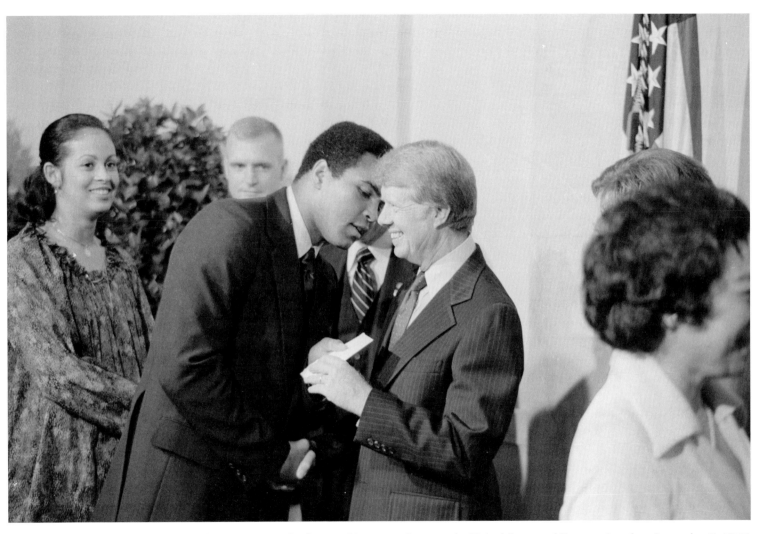

Years of negotiations concerning the Panama Canal culminated in a treaty between the United States and Panama signed on September 7, 1977. President Jimmy Carter and General Omar Torrijos of Panama signed the agreement to turn over control of the canal to the Panamanians by the year 2000. After the treaty had been signed, Carter gave a dinner at the White House to celebrate. Former presidents Lyndon B. Johnson and Gerald R. Ford, Jr., attended, as did celebrities such as Muhammad Ali and his wife, Veronica. Here, Muhammad Ali is giving President Carter tickets to his upcoming heavyweight championship fight against Earnie Shavers at Madison Square Garden on September 29. Carter did not attend; Ali won the 15-round bout by unanimous decision.

NOTES ON THE PHOTOGRAPHS

These notes, listed by page number, attempt to include all aspects known of the photographs. Each of the photographs is identified by the page number, photograph's title or description, photographer and collection, archive, and call or box number when applicable. Although every attempt was made to collect all available data, in some cases complete data was unavailable due to the age and condition of some of the photographs and records.

II SOUTH FRONT OF THE WHITE HOUSE
Library of Congress
LC-USZ62-65441

VI THE NORTH FACADE OF THE WHITE HOUSE
Library of Congress
LC-DIG-npcc-19925

X LAFAYETTE PARK
Library of Congress
LC-USZ62-117991

2 EARLIEST-KNOWN PHOTO OF THE WHITE HOUSE
Library of Congress
LC-USZ62-112293
Photo by John Plumbe

3 THE WHITE HOUSE DURING THE CIVIL WAR
National Archives and Records Administration
111-B1-4047

4 CASSIUS M. CLAY BATTALION ON THE SOUTH LAWN
National Archives and Records Administration
064-M-184

5 THE PORTICO DESIGNED BY JAMES HOBAN
Library of Congress
LC-DIG-ppmsca-09381

6 AMERICAN INDIANS AT THE WHITE HOUSE
Library of Congress
LC-DIG-npcc-28301

7 HIGH BICYCLE
National Archives and Records Administration
77-RP-73474

8 GATHERING FOR THE 1889 EASTER EGG ROLL
Library of Congress
LC-USZ62-119295
Photo by Frances Benjamin Johnston

9 LITTLE GIRLS GATHERING EASTER EGGS
Library of Congress
LC-USZ62-94495

10 RUSSELL HARRISON, SON OF PRESIDENT HARRISON
Library of Congress
LC-USZ62-118058
Photo by Frances Benjamin Johnston

11 WHITE HOUSE EMPLOYEES AT THEIR DESKS
Library of Congress
LC-USZ62-90804
Photo by Frances Benjamin Johnston

12 THE WHITE HOUSE'S EVERYDAY KITCHEN
Library of Congress
LC-USZ62-83161
Photo by Frances Benjamin Johnston

13 THE OVAL ROOM
Library of Congress
LC-USZ62-127424
Photo by Frances Benjamin Johnston

14 THE STATE DINING ROOM
Library of Congress
LC-USZ62-66967
Photo by Frances Benjamin Johnston

15 EAST CORRIDOR ON GROUND FLOOR
Library of Congress
LC-USZ62-127421
Photo by Frances Benjamin Johnston

16 THE WHITE HOUSE CONSERVATORY
Library of Congress
LC-USZ62-116020
Photo by T. W. Ingersoll

17 STREET VENDORS NEAR
THE WHITE HOUSE
Library of Congress
LC-USZ62-94133
Photo by Frances Benjamin
Johnston

18 VOLUNTEERS FOR THE
WAR AGAINST SPAIN
Library of Congress
LC-USZ62-116044

19 PRESIDENT MCKINLEY'S
WAR ROOM
Library of Congress
LC-USZ62-90805
Photo by Frances Benjamin
Johnston

20 LONG CORRIDOR
TRANSFORMED FOR A
FORMAL DINNER
Library of Congress
LC-USZ62-90815
Photo by Frances Benjamin
Johnston

21 CHILDREN PLAYING
ON THE WHITE HOUSE
LAWN
Library of Congress
LC-USZ62-68048
Photo by Frances Benjamin
Johnston

22 TWO CHILDREN AT THE
1898 EASTER EGG
ROLL
Library of Congress
LC-USZ62-46453
Photo by Frances Benjamin
Johnston

23 THE WHITE HOUSE
CONSERVATORIES
Library of Congress
LC-USZC2-6169

24 PRESIDENTIAL SECURITY
Library of Congress
LC-USZ62-90809
Photo by Frances Benjamin
Johnston

25 THE PUBLIC VISITING
THE WHITE HOUSE
Library of Congress
LC-USZ62-94542

26 THE ORCHID HOUSE
Library of Congress
LC-USZ62-118498

27 THE FORERUNNER OF
TODAY'S WEST WING
Library of Congress
LC-USZ62-77661

28 WHITE HOUSE GARDEN
PARTY
Library of Congress
LC-USZ62-126408

29 MARRIAGE OF ALICE
ROOSEVELT
Library of Congress
LC-USZ62-94240

30 EMPLOYEES OF THE
BUSINESS OFFICE
Library of Congress
LC-USZ62-131523
Photo by Waldon Fawcett

31 UNITED STATES SECRET
SERVICE CHIEF JOHN E.
WILKIE
Library of Congress
LC-USZ62-132385
Photo by Waldon Fawcett

32 SNOWY NIGHT AT THE
WHITE HOUSE
Library of Congress
LC-USZ62-91031

33 PAGEANT ON THE SOUTH
LAWN
Library of Congress
LC-USZ6-649

34 SNOWY INAUGURAL DAY
AT THE WHITE HOUSE
Library of Congress
LC-USZ62-47474

35 WHITE HOUSE
ILLUMINATED AT NIGHT
Library of Congress
LC-DIG-ggbain-09352

36 THE NORTHWESTERN
GATE TO THE WHITE
HOUSE
Library of Congress
LC-USZ62-131622

37 WORKMEN IN THE
HALLWAY OF THE
EXECUTIVE OFFICE
Library of Congress
LC-USZ62-127687

38 WOMAN SUFFRAGE
MARCH
Library of Congress
LC-DIG-npcc-19207

39 WOMAN SUFFRAGE
PICKETS AT THE WHITE
HOUSE
Library of Congress
LC-USZ62-10855

40 MAY DAY CELEBRATION
ON THE SOUTH LAWN
Library of Congress
LC-DIG-npcc-18593

41 PRESS PHOTOGRAPHERS
EATING LUNCH ON THE
SOUTH LAWN
Library of Congress
LC-USZ62-94541

42 WHITE HOUSE SHEEP
Library of Congress
LC-USZ62-105733

43 THE WIRE ROOM IN THE
WHITE HOUSE
Library of Congress
LC-USZ62-131522

44 RALLY AT THE EASTERN
ENTRANCE
Library of Congress
LC-USZ62-131914

45 ITALIAN AIRPLANE
Library of Congress
LC-DIG-npcc-28120

46 PICKETERS OUTSIDE THE
WHITE HOUSE GATES
DURING THANKSGIVING
Library of Congress
LC-USZ62-94580

47 PARADE IN FRONT OF
THE WHITE HOUSE
Library of Congress
LC-USZ62-132057

48 AERIAL PHOTOGRAPH OF
THE WHITE HOUSE
Library of Congress
LC-USZ62-124275

49 WHITE HOUSE SHEEP
Library of Congress
LC-USZ62-11417

50 JAMES M. COX
AND FRANKLIN D.
ROOSEVELT
Library of Congress
LC-USZ62-92408

52 MADAME MARIE CURIE
Library of Congress
LC-USZ62-2211

53 FIRST LADY FLORENCE
KLING HARDING
Library of Congress
LC-USZ62-132073

54 UNITED STATES MARINE
BAND PERFORMING AT
THE WHITE HOUSE
Library of Congress
LC-USZ62-93314

55 ROSE GARDEN AT THE
WHITE HOUSE
Library of Congress
LC-USZ62-90810
Photo by Frances Benjamin
Johnston

56 PRESIDENT HARDING
WITH NATURE-STUDY
STUDENTS
Library of Congress
LC-USZ62-132071

57 THE REFLECTING POOL
AT THE WHITE HOUSE
Library of Congress
LC-USZ62-90811
Photo by Frances Benjamin
Johnston

58 JOHN ROBINSON CIRCUS
ELEPHANTS
Library of Congress
LC-DIG-npcc-04120

59 BABE RUTH AT THE
WHITE HOUSE
Library of Congress
LC-DIG-npcc-05484

60 THE COOTIE
Library of Congress
LC-USZ62-33762

61 PUBLIC RECEIVING DAY
Library of Congress
LC-USZ62-131886

62 THE 1922 EASTER EGG
ROLL AT THE WHITE
HOUSE
Library of Congress
LC-USZ62-131890

63 WHITE HOUSE
POLICEMAN WITH LOST
CHILD
Library of Congress
LC-USZ62-131891

64 CHILDREN'S CRUSADE
Library of Congress
LC-USZ6-1820

65 EUROPEAN WORLD WAR
VETERANS
Library of Congress
LC-USZ62-131904

66 NORTH PORTICO OF THE
WHITE HOUSE
Library of Congress
LC-USZ62-44267

67 OHIO SHRINERS AT THE
WHITE HOUSE
Library of Congress
LC-DIG-npcc-08823

68 CHILDREN AT THE 1923
EASTER EGG ROLL
Library of Congress
LC-USZ62-131869

69 THE 1923 EASTER EGG
ROLL
Library of Congress
LC-USZ62-131867

70 EASTER BASKET
WINNER WARREN
SONNEMANN
Library of Congress
LC-USZ62-131864

71 RODEO PARADERS
Library of Congress
LC-DIG-npcc-08709

72 PRESIDENT AND MRS.
HARDING
Library of Congress
LC-USZ62-131873

73 REPAIRS ON THE WHITE
HOUSE
Library of Congress
LC-USZ62-131876

74 BODY OF PRESIDENT
HARDING LYING IN
STATE
Library of Congress
LC-USZ62-59425

75 HARDING'S FUNERAL
CORTEGE
Library of Congress
LC-USZ62-132074

76 PHOTOGRAPHERS ON THE
WHITE HOUSE LAWN
Library of Congress
LC-USZ62-122056

77 PRESIDENT CALVIN
COOLIDGE
Library of Congress
LC-DIG-npcc-24497

78 SIXTY-FOOT-HIGH
CHRISTMAS TREE AT THE
WHITE HOUSE
Library of Congress
LC-USZ62-122222

79 THE LIGHTING OF THE
NATIONAL CHRISTMAS
TREE
Library of Congress
LC-DIG-npcc-25157

80 PHOTOGRAPHERS
WAITING ON THE STEPS
OF THE WHITE HOUSE
Library of Congress
LC-USZ62-131882

81 GIRL SCOUTS
OF AMERICA
HEADQUARTERS MOVED
Library of Congress
LC-USZ62-131879

82 AUTOMOBILE ACCIDENT
Library of Congress
LC-DIG-npcc-25750

83 FRANCIS MAHONEY,
BOY SCOUT
Library of Congress
LC-DIG-npcc-11539

84 AMERICAN INDIANS
POSED AT THE WHITE
HOUSE
Library of Congress
LC-DIG-npcc-10583

85 CROWDS IN FRONT OF
THE WHITE HOUSE FOR
THE PRINCE OF WALES
Library of Congress
LC-DIG-npcc-26138

86 MILITARY PORTION OF
THE INAUGURAL PARADE
Library of Congress
LC-USZ62-93316

87 TOM MIX DAY
Library of Congress
LC-DIG-npcc-13627

88 SMALL EAST WING OF
THE WHITE HOUSE
Library of Congress
LC-USZ62-90908

89 AFTER THE 1926 EGG
ROLLING
Library of Congress
LC-USZ62-15954

90 RECORD-BREAKING
CROWD AT THE WHITE
HOUSE
Library of Congress
LC-DIG-npcc-27563

92 JOHN J. "BLACK
JACK" PERSHING WITH
VETERANS
Library of Congress
LC-DIG-npcc-15924

93 WHITE HOUSE GUESTS
ON NEW YEAR'S DAY
Library of Congress
LC-USZ62-111351

94 LOUIS B. MAYER
FAMILY
Library of Congress
LC-USZ62-124530

95 RENOVATING THE WHITE
HOUSE
Library of Congress
LC-USZ62-93283

96 PRESIDENT COOLIDGE
DRAWING FOR THE
DAVIS CUP
Library of Congress
LC-USZ62-131301

98 WORKING ON THE
REVIEWING STAND
Library of Congress
LC-USZ62-131282

99 TEXAS COWBOY BAND
Library of Congress
LC-USZ62-131284

100 HERBERT HOOVER
Library of Congress
LC-USZ62-131283

101 MEMBERS OF THE
SIOUX NATION AND THE
EVANGELINE GIRLS
Library of Congress
LC-USZ62-131285

102 MAGNOLIAS BLOOMING
AT THE WHITE HOUSE
Library of Congress
LC-USZ62-131288

103 GIRL SCOUTS
PERFORMING A MAY
POLE DANCE
Library of Congress
LC-DIG-npcc-17286

104 WOOD FOR THE
FIREPLACES IN THE
WHITE HOUSE
Library of Congress
LC-USZ62-131291

105 OFFICER BERTRAM E.
SNODGRASS AND BILLY
OPOSSUM
Library of Congress
LC-USZ62-131293

106 KELLOGG-BRIAND PACT
SIGNING
Library of Congress
LC-USZ62-131566

107 PRESIDENT HOOVER'S
DOGS
Library of Congress
LC-USZ62-131278

108 FIRE AT THE WHITE
HOUSE
Library of Congress
LC-USZ62-97298

109 REMOVING DEBRIS
AFTER THE FIRE
Library of Congress
LC-USZ62-97299

110 SOUND MOVIE TRUCKS
Library of Congress
LC-DIG-npcc-18174

111 REPAIRING THE FIRE
DAMAGE
Library of Congress
LC-USZ62-131626

112 AIRPLANE MODEL
LEAGUE
Library of Congress
LC-USZ62-132145

113 LOU HENRY HOOVER
Library of Congress
LC-USZ62-90052

114 GEORGE WASHINGTON
UNIVERSITY ARCHERS
Library of Congress
LC-USZ62-100846

115 AIRSHIP AKRON OVER
THE WHITE HOUSE
Library of Congress
LC-USZ62-127696

116 THE WORKER'S EX-
SERVICEMEN'S LEAGUE
Library of Congress
LC-USZ62-91907

117 PRESIDENT AND MRS.
HOOVER
Library of Congress
LC-USZ62-90053

118 GOVERNOR AND
MRS. FRANKLIN D.
ROOSEVELT
Library of Congress
LC-USZ62-91121

119 PRESIDENT AND
MRS. FRANKLIN D.
ROOSEVELT
Franklin D. Roosevelt
Presidential Library
51-115-139(1)

120 THE NORTH FRONT OF
THE WHITE HOUSE
Library of Congress
LC-USZ62-128042

121 PRESIDENT ROOSEVELT
IN THE OVAL OFFICE
Franklin D. Roosevelt
Presidential Library
57-648

122 PRESIDENT ROOSEVELT
AND CAPTAIN ALBERT
F. HEGENBERGER
Library of Congress
LC-USZ62-94375

123 DEMOCRATIC SENATORS
TOM CONNALLY AND
KEY PITTMAN
Library of Congress
LC-USZ62-104401

124 PEANUT AND POPCORN
VENDOR
Library of Congress
LC-DIG-fsa-8b31574
Photo by Edwin Rosskam

125 ELEANOR ROOSEVELT ON
EASTER MONDAY
Library of Congress
LC-USW3-38914
Photo by Barbara Wright

126 STEPHEN EARLY AND
PRESIDENT ROOSEVELT
Franklin D. Roosevelt
Presidential Library
78-36(39)

127 **THE WHITE HOUSE**
Library of Congress
LC-USF34-044921-D
Photo by Jack Delano

128 **PRESIDENT ROOSEVELT ADDRESSING THE NATION**
Franklin D. Roosevelt
Presidential Library
48-22 3713(92)

129 **PRESIDENT ROOSEVELT SIGNING THE JOINT RESOLUTION DECLARING WAR**
Franklin D. Roosevelt
Presidential Library
48-22 4041

130 **PRESIDENT ROOSEVELT LOOKING AT A GLOBE**
Franklin D. Roosevelt
Presidential Library
61-244

131 **FLAG DAY**
Library of Congress
LC-USW33-019074-C

132 **BASEBALL GAME ON THE SOUTH LAWN**
Library of Congress
LC-USF34-100294-D
Photo by Marjory Collins

133 **MADAME CHIANG KAI-SHEK AND MRS. ROOSEVELT**
Library of Congress
LC-USW3-17543

134 **PRESIDENT ROOSEVELT CELEBRATING HIS BIRTHDAY**
Library of Congress
LC-USZ62-50219

135 **PRESIDENT ROOSEVELT'S FOURTH INAUGURATION**
Library of Congress
LC-H212-1983

136 **DELIVERING A SHORT ADDRESS FROM THE SOUTH PORTICO**
National Archives and
Records Administration
RG79-AR-399P

137 **CROWD IN FRONT OF THE WHITE HOUSE AFTER THE DEATH OF PRESIDENT ROOSEVELT**
National Archives and
Records Administration
080-G-377605
Photo by Fenno Jacobs

138 **CROWD IN LAFAYETTE PARK**
National Archives and
Records Administration
RG79-AR-442E

139 **NEWSMEN AND VISITORS PILE HATS AND COATS ON TABLE**
National Park Service,
Abbie Rowe,
Courtesy of Harry S. Truman
Library
73-1927

140 **PRESIDENT TRUMAN ANNOUNCES VICTORY OVER GERMANY**
National Archives and
Records Administration
RG79-AR-451E

141 **PRESIDENT TRUMAN AND HIS CABINET IN THE WEST WING**
National Archives and
Records Administration
RG79-AR-057D

142 **NEWSREEL TECHNICIANS**
National Park Service,
Abbie Rowe,
Courtesy of Harry S. Truman
Library
73-2012

143 **PRESIDENT TRUMAN ANNOUNCING THE SURRENDER OF JAPAN**
National Archives and
Records Administration
079-AR-508Q
Photo by Abbie Rowe

144 **MEMBERS OF THE WHITE HOUSE PRESS CORPS**
National Park Service,
Abbie Rowe,
Courtesy of Harry S. Truman
Library
73-2018

145 **HUGE CROWDS ON PENNSYLVANIA AVENUE**
National Archives and
Records Administration
RG79-AR-508V

146 **MEDAL OF HONOR CEREMONY**
National Archives and
Records Administration
RG79-AR-513E

147 **PRESIDENT TRUMAN AND ADMIRAL WILLIAM F. HALSEY**
Library of Congress
LC-USZ62-85769

148 **CROWD GATHERING FOR CONCERT**
National Park Service,
Abbie Rowe,
Courtesy of Harry S. Truman
Library
73-2117

149 **NATIONAL COMMUNITY CHRISTMAS TREE ILLUMINATION**
National Archives and
Records Administration
RG79-AR-212B

150 **PRESIDENT TRUMAN AWARDING PRESIDENTIAL UNIT CITATIONS**
National Archives and
Records Administration
RG79-AR-548B

151 **COMIC-STRIP ARTISTS**
National Park Service,
Abbie Rowe,
Courtesy of Harry S. Truman
Library
73-3180

152 **PRESIDENT TRUMAN SPEAKING IN THE WHITE HOUSE ROSE GARDEN**
National Park Service,
Abbie Rowe,
Courtesy of Harry S. Truman
Library
73-3682

153 **THE RENOVATED WHITE HOUSE**
National Park Service,
Abbie Rowe,
Courtesy of Harry S. Truman
Library
73-3274

154 PRESIDENT TRUMAN
BUST BY NISON TREGOR
National Park Service,
Abbie Rowe,
Courtesy of Harry S. Truman
Library
73-3896

155 DWIGHT D.
EISENHOWER SPEAKING
TO REPORTERS
National Park Service,
Abbie Rowe,
Courtesy of Harry S. Truman
Library
73-3917

156 TRUMAN BEING
PRESENTED HONORARY
BADGES
National Park Service,
Abbie Rowe,
Courtesy of Harry S. Truman
Library
73-3959

158 PRESIDENT EISENHOWER
AND HIS WIFE, MAMIE
Library of Congress
LC-USZ62-90397

159 PRESIDENT EISENHOWER
GIVING A TELEVISED
ADDRESS
National Archives and
Records Administration
RG79-5236E

160 HOMER GRUENTHER
ACCEPTING A TURKEY
FROM MRS. LUCILLE
NORMAN
National Archives and
Records Administration
RG-79-4520C

161 CLARE BOOTHE LUCE
AND PRESIDENT
EISENHOWER
Library of Congress
LC-USZ62-77856
Photo by Abbie Rowe

162 EASTER EGG ROLL
RESUMPTION
National Archives and
Records Administration
RG79-AR-1906M

163 DAVID AND BARBARA
ANNE EISENHOWER
National Archives and
Records Administration
RG79-AR-1881C

164 SOVIET AMBASSADOR
MIKHAEL A. MENSHIKOV
Library of Congress
LC-DIG-ppmsca-03113
Photo by Marion S. Trikosko

165 PRESIDENT
EISENHOWER'S
HELICOPTER
National Archives and
Records Administration
RG79-4844A

166 PRESIDENT JOHN F.
KENNEDY AND VICE
PRESIDENT LYNDON B.
JOHNSON
National Archives and
Records Administration
RG79-6763F

167 HARRY S. TRUMAN AND
JOHN F. KENNEDY
National Archives and
Records Administration
RG79-6284C

168 PRESIDENT KENNEDY
WATCHING TELEVISED
COVERAGE OF SPACE
FLIGHT
The John F. Kennedy
Presidential Library and
Museum, Boston
ST-116-9-61
Photo by Cecil Stoughton

169 STATE DINING ROOM
National Archives and
Records Administration
RG79-AR-1849-3C

170 PRESIDENT AND MRS.
KENNEDY HOSTING
DINNER FOR TRUMAN
The John F. Kennedy
Presidential Library and
Museum, Boston
ST-251-12-61
Photo by Cecil Stoughton

171 MRS. KENNEDY AND
JOHN F. KENNEDY, JR.
The John F. Kennedy
Presidential Library and
Museum, Boston
ST-A28-30-62
Photo by Cecil Stoughton

172 MUSIC AND BALLET AT
THE WHITE HOUSE
National Archives and
Records Administration
RG79-7398L

173 PRESIDENT KENNEDY IN
FRONT OF THE WHITE
HOUSE
National Archives and
Records Administration
RG79-7476

174 PRESIDENT KENNEDY
GREETING PEACE CORPS
VOLUNTEERS
The John F. Kennedy
Presidential Library and
Museum, Boston
AR7405D
Photo by Abbie Rowe

175 THE KENNEDY
CHILDREN IN THE OVAL
OFFICE
The John F. Kennedy
Presidential Library and
Museum, Boston
ST-441-10-62
Photo by Cecil Stoughton

176 THE TREATY ROOM
National Archives and
Records Administration
RG79-7325D

177 PRESIDENT KENNEDY
SEATED AT THE
RESOLUTE DESK
National Archives and
Records Administration
RG79-6456D

178 WEST WING AT NIGHT
DURING CUBAN MISSILE
CRISIS
National Archives and
Records Administration
306-N-64-818

179 PRESIDENT KENNEDY
SIGNING THE
PROCLAMATION FOR
INTERDICTION OF THE
DELIVERY OF OFFENSIVE
WEAPONS
The John F. Kennedy
Presidential Library and
Museum, Boston
ST-459-10-62
Photo by Cecil Stoughton

180 PRESIDENT KENNEDY CELEBRATING HIS 46TH BIRTHDAY
The John F. Kennedy Presidential Library and Museum, Boston
C28785
Photo by Robert Knudsen

181 ROBERT F. KENNEDY WITH CIVIL RIGHTS LEADERS
The John F. Kennedy Presidential Library and Museum, Boston
AR7993B

182 PRESIDENT KENNEDY ADDRESSING A MEETING IN THE EAST ROOM
National Archives and Records Administration
RG79-6424H

183 JACQUELINE KENNEDY AND CHILDREN WAITING TO LEAVE THE WHITE HOUSE FOR THE CAPITOL
National Park Service, Abbie Rowe, Courtesy of Harry S. Truman Library
73-4074

184 BODY OF PRESIDENT KENNEDY BORNE ON AN ARTILLERY CAISSON
National Park Service, Abbie Rowe, Courtesy of Harry S. Truman Library
73-4139

186 PRESIDENT LYNDON B. JOHNSON WITH JOINT CHIEFS OF STAFF
Lyndon Baines Johnson Library and Museum
2115
Photo by Yoichi R. Okamoto

187 SECRETARY OF DEFENSE ROBERT McNAMARA
Lyndon Baines Johnson Library and Museum
1067
Photo by Yoichi R. Okamoto

188 McGEORGE BUNDY AND PRESIDENT JOHNSON
Lyndon Baines Johnson Library and Museum
5650
Photo by Yoichi R. Okamoto

189 GENERAL WILLIAM C. WESTMORELAND AND PRESIDENT JOHNSON
Lyndon Baines Johnson Library and Museum
10821
Photo by Yoichi R. Okamoto

190 GENERAL CREIGHTON W. ABRAMS AND PRESIDENT JOHNSON
National Archives and Records Administration
306-PSA-68-3528

191 RICHARD M. NIXON
National Archives and Records Administration/ Nixon Presidential Library and Museum
1306-12
Photo by Jack E. Kightlinger

192 TELEGRAMS OF SUPPORT FOR NIXON SPEECH
National Archives and Records Administration/ Nixon Presidential Library and Museum
2345-10A
Photo by Oliver F. Atkins

193 TRICIA NIXON'S WEDDING AT THE WHITE HOUSE
Library of Congress
LC-DIG-ppmsca-03410
Photo by Warren K. Leffler

194 GERALD R. FORD IN THE OVAL OFFICE
Library of Congress
LC-DIG-ppmsca-08467
Photo by Marion S. Trikosko

195 CHRISTMAS PARTY FOR CHILDREN OF MEMBERS OF THE DIPLOMATIC CORPS
Library of Congress
LC-DIG-ppmsca-08483
Photo by Thomas J. O'Halloran

196 ROSALYNN CARTER AND DAUGHTER AMY PREPARING TO BOARD MARINE ONE
Library of Congress
LC-DIG-ppmsca-09767
Photo by Thomas J. O'Halloran

198 ANTI-ERA DEMONSTRATORS
Library of Congress
LC-DIG-ppmsca-01952
Photo by Warren K. Leffler

199 PRESIDENT JIMMY CARTER AND MUHAMMAD ALI
Library of Congress
LC-DIG-ppmsca-09784
Photo by Marion S. Trikosko